Modern & Contemporary Art

Michele Dantini

Modern & Contemporary Art

Modern & Contemporary Art

STERLING

New York / London
www.sterlingpublishing.com

Acknowledgments

Thanks are due to all the artists, museums, archives, foundations, collectors (including those who preferred to remain anonymous), and galleries who have assisted me, and in particular: Astrup Fearnley Museet for Moderne Kunst,Oslo; Barbara Gladstone Gallery, NewYork; Dunker Culture Centre, Helsingborg; Galerie Chantal Crousel, Paris; Galerie Eigen+Art, Berlin; Galleria Continua, San Gimignano-Beijing; Galleria Emy Fontana, Milan; Galleria Francesca Kaufmann, Milan; Galleria Massimo De Carlo, Milan; Galleria Monica De Cardenas, Milan; Galleria Raffaella Cortese, Milan; Insite, San Diego, California/Tijuana, Mexico; Interim Art, London; Jay Jopling/ White Cube Gallery, London; Kehrer Verlag, Heidelberg; Kunsthalle Basel; Kunstmuseum Wolfsburg; Magasin3, Stockholm; Malmö Konsthall; Marian Goodman Gallery, New York; Schirn Kunsthalle, Frankfurt; Sonnabend Gallery, New York; Studio Guenzani, Milan; Thyssen-Bornemisza Art Contemporary (T-B A21), Vienna; Ufficio Stampa Arti Visive, Biennale di Venezia, 51. Esposizione Internazionale d'Arte. In addition, for their valuable assistance: Giovanni Bartoli; Wanda de Guébriant; Gwenaëlle Fossard; Sophie Greig; Simone Krämer; Francesca von Habsburg; Lena Leeb-Lundberg; Gerd Harry Lybke; Sara MacDonald; Antonella Nicola; Silvia Pichini; Janne Schaefer; Anne-Mette Villumsen; Papus von Sänger; and Christina Werner.

Translated from the Italian by Timothy Stroud

Italian edition: senior editor, Gloria Fossi; graphic design of series and cover, Lorenzo Pacini; layout, Laura Venturi; iconographic assistant, Claudia Hendel.
English edition: translated from the Italian by Timothy Stroud; edited by Sterling.

Library of Congress Cataloging-in-Publication Data Available

10 9 8 7 6 5 4 3 2 1

Original Italian edition *Arte contemporanea* by Michele Dantini
Published by Giunti Editore S.p.A.
© 2005 by Giunti Editore S.p.A., Florence-Milan, Italy
www.giunti.it

English translation published by Sterling Publishing Co., Inc.
387 Park Avenue South, New York, NY 10016
© 2008 by Sterling Publishing Co., Inc.
Distributed in Canada by Sterling Publishing
c/o Canadian Manda Group, 165 Dufferin Street
Toronto, Ontario, Canada M6K 3H6
Distributed in the United Kingdom by GMC Distribution Services
Castle Place, 166 High Street, Lewes, East Sussex, England BN7 1XU
Distributed in Australia by Capricorn Link (Australia) Pty. Ltd.
P.O. Box 704, Windsor, NSW 2756, Australia

Printed in China
All rights reserved

Sterling ISBN 978-1-4027-5921-5

For information about custom editions, special sales, premium and corporate purchases, please contact Sterling Special Sales Department at 800-805-5489 or specialsales@sterlingpublishing.com.

The Historic
Avant-Gardes

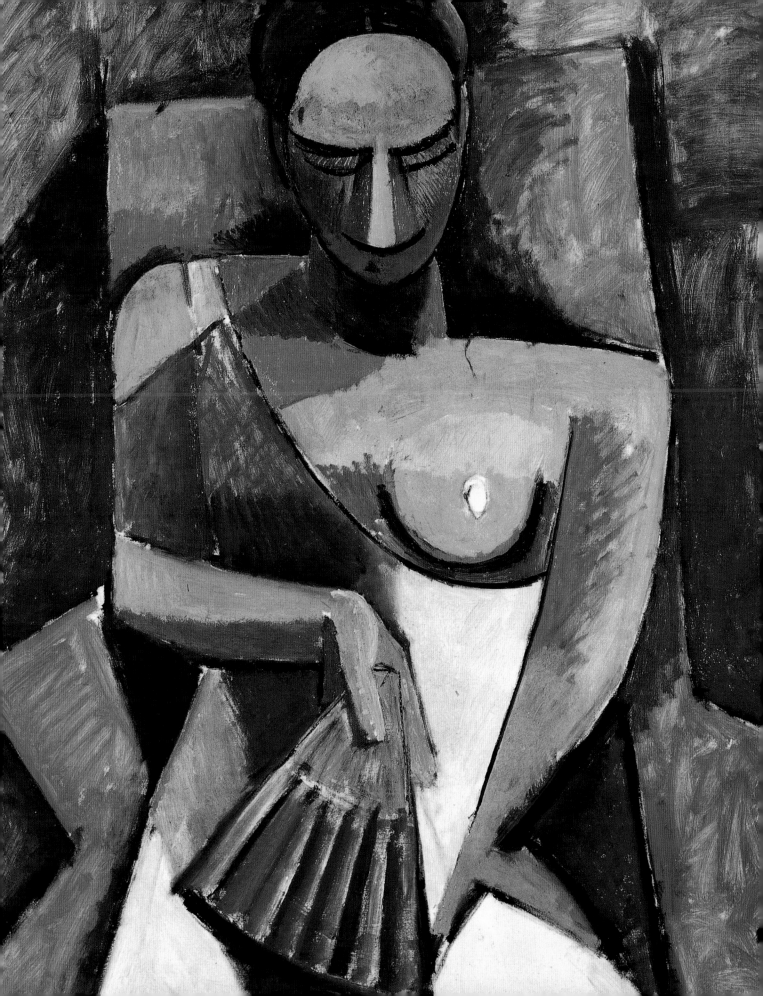

Previous page:
Pablo Picasso
Woman with a Fan, detail
1908, oil on canvas.
State Hermitage Museum,
Saint Petersburg
(full image on page 12).

Henri Matisse
View of Collioure
1905, oil on canvas.
State Hermitage Museum,
Saint Petersburg.
© Succession H. Matisse/
SIAE 2005.

The Fauves at the Salon d'Automne: Wild Beasts or Children?

The first "scandalous statement" in European art in the twentieth century occurred almost unexpectedly in 1905: neither Henri Matisse, who caused the scandal when he exhibited new paintings at the Salon d'Automne, nor art critics nor the public had foreseen it or were prepared for it. Matisse cannot in any way be considered an unskilled painter or a beginner who was seeking to cause a sensation: the pupil of Gustave Moreau, he was cultured and a friend of luminaries such as the writer André Gide and the art critic Félix Fénéon. In the fall of 1905 his career seemed to be already well under way, despite financial difficulties: he exhibited regularly at the Salon d'Automne and Salon des Indépendants, and had had his first solo exhibition a little more than

a year earlier when, in June 1904, he had presented 45 paintings and a drawing in the prestigious gallery belonging to Ambroise Vollard. Yet numerous visitors to the exhibition, said Gide, including art connoisseurs and members of the public, angrily turned away from his canvases, referring to them as "madness." Louis Vauxcelles, an art critic with progressive tendencies who usually viewed Matisse with favor, found a metaphor that rapidly came to signify those artists who were exhibiting with the master and whose work was following the same direction. Hung in a small room that had at its center a demure marble bust in neo-fifteenth-century style sculpted by Albert Marquet, the paintings of Matisse, André Derain, Maurice de Vlaminck, Raoul Dufy, and Othon Friesz seemed to Vauxcelles like "fauves" ("wild beasts"), ready to spring upon the exquisite product of civilization

Henri Matisse
Joie de Vivre
1905–06, oil on canvas.
Barnes Foundation,
Merion, PA.
© Succession H. Matisse/
SIAE 2005.

Henri Matisse
Luxe, Calme, Volupté
1904, oil on canvas.
Centre Georges
Pompidou, Musée
National d'Art Moderne,
Paris.
© Succession H. Matisse/
SIAE 2005.

at its center. "Donatello among wild beasts" the critic ironically concluded, deploring the chromatic excesses and linear deformations that made the works on show—for the most part landscapes and portraits—similar to colored daubs seen in a "child's bedroom."

The Fauvists were connected by personal friendships and common educational upbringing, and their works, though dissimilar, shared a similarity of approach, at least in terms of technique and style; for example, they employed the neo-Impressionist technique of separately spaced brushstrokes, but their use of complementary colors was anything but rigorous, and, as the painter Maurice Denis pointed out, their common intention of replacing the precepts of painting with "emotion" could not be more obvious. What irritated the visitors to the Salon most of all were the extreme use of color and the "deliberate disharmonies" (as Derain wrote) of the compositions. Matisse—who spent the summer of 1905 in the small fishing village of

Collioure on the Mediterranean, and who painted many of the Fauve works exhibited at the Salon d'Automne—remembered how the sheer magnificence of the southern landscape and sensual abundance of the summer had prompted him to drastically simplify his figurative language and dispense with literary subtleties or simple ornamental indulgences: "I no longer [thought] of anything but making the colors sing, without worrying about rules and prohibitions."

Henri Matisse
Dance II
1909–10, oil on canvas.
State Hermitage Museum,
Saint Petersburg.
© Succession H. Matisse/
SIAE 2005.

When compared to works Matisse had produced just a little earlier, the landscapes of Collioure are striking for the blatant sharpness and brightness of their color contrasts, the emphasis on the depiction of depth, and the consistency of the various figurative elements—buildings, promontories, faces, human figures, tree masses—almost as though the artist was attempting to imbue the figures, landscape, and "spontaneous" architecture with the vigor of an archaic, plastic, elementary compactness. Phallic shapes appear in the landscape in the form of rocks and bell towers, almost symbolic of the "over-excitation" of which Matisse himself spoke, and of the neo-pagan theme, dear to Gide, of art as the "glorification of desire and instinct." "Fauvism liberated itself from the tyranny of Divisionism," the artist was to claim more than two decades later, in 1929. "We cannot live in a house that is too neat and tidy, a house belonging to old, provincial aunts. And thus: we set out on our adventure."

Pastorales and Primitive Nudes: Matisse between 1905 and 1907

Partly in reaction to the harsh criticism visited upon the landscapes and seascapes he had painted *en plein air* in the south of France, from fall 1905 Matisse turned his attention towards more composed works. With *Joie de Vivre*, painted in 1905–06, he began a series of large ornamental panels that would include the two versions of *Dance* painted in 1909 and 1910: in these he reinterpreted the classical Renaissance tradition of the landscape with figures, basing his composition on an arabesque design and large blocks of uniform color like those seen in Paul Gauguin's Polynesian idylls. He displayed a timely and refined eclecticism typical of an avant-garde aesthete: other inspirations for the *Joie de Vivre* are Persian miniatures and vase paintings, oriental enamels, and even the first known examples of cave art, which are particularly evident in the figures of the goats on the right. From spring–summer 1906 Matisse's attention shifted from simple landscapes to the nude, and he had no

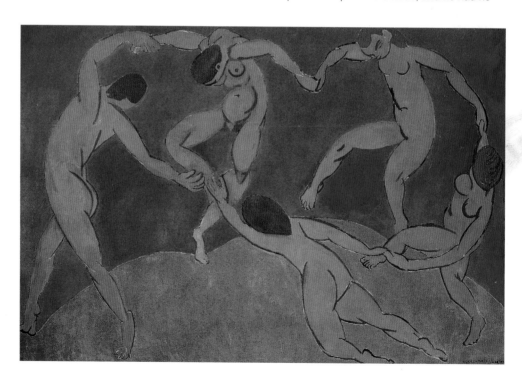

hesitation in experimenting with sculpture: modeling, he explained, helped him to understand how the human body could be adapted to fit a precise organization of the space without being reduced to a simple ornamental motif. Through the works of Paul Cézanne—whose late compositions of bathers were "discovered" by the artists of the most recent generation as a result of several exhibitions in Paris in 1905 and 1906 (and again in 1907)— Matisse was able to judge his own research against the most recent sculptural developments in France, especially those of Auguste Rodin and his school, and even African and Oceanic sculpture, which was so thoroughly represented in the collections of "primitive" art in the Musée d'Ethnographie du Trocadéro. In *Reclining Nude (Aurora)*, the unnatural torsion of the figure and the primitivist fullness of the limbs reveal the artist's intention to create a plastic expression of the human figure through affected, even exaggerated, figuration that is markedly anti-manneristic, and which "blocks" or breaks down all movement, denying it fluency. At the same time all trace of psychology is eliminated from the image. Rodin claimed that "the art of sculpture lies entirely in the modeling, not in the [rendition of] movement or character," and Matisse seems to have observed this remark scrupulously. At this time the relationship between painting and sculpture was so close for Matisse that he transposed his *Reclining Nude* into the exoticizing *Blue Nude (Souvenir of Biskra)*, a variation on the theme of the odalisque. In the painting, the limbs of the model seem out of joint and to press against the plane of representation to the point of bending it outwards, as though straining against the two-dimensional constraint of the canvas. Besides the oriental style predictably associated with the painting, there is also an extreme plastic tension: apparent is the visual and symbolic drama that, during the last years of his life, Cézanne made reference to, exalting the "polychrome ornamental plasticity" of his *Bathers*, in which powerfully fore-shortened nudes, characterized by athletic movements and locked poses, stage simple, enigmatic pantomimes against a magnificent Provençal landscape. As has been observed on several occasions, in both his *Reclining Nude* and *Blue Nude* Matisse has reinterpreted Michelangelo's

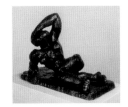

Henri Matisse,
Reclining Nude (Aurora)
1907, bronze.
Centre Georges
Pompidou, Musée
National d'Art Moderne,
Paris.
© Succession H. Matisse/
SIAE 2005.

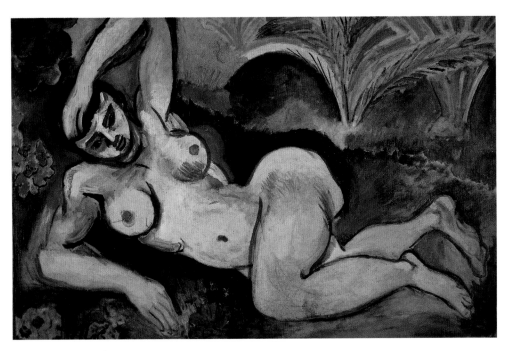

Henri Matisse,
Blue Nude
(Souvenir of Biskra)
1907, oil on canvas.
Museum of Art, Baltimore.
Cone Collection, formerly
belonging to Claribel and
Etta Cone, Baltimore, MD.
© Succession H. Matisse/
SIAE 2005.

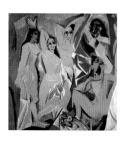

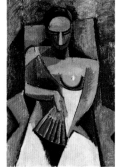

Pablo Picasso
Les Demoiselles d'Avignon
1907, oil on canvas.
The Museum of Modern Art, New York.
Acquired through the Lillie P. Bliss Estate.

Pablo Picasso
Composition: The Peasants
1906, oil on canvas.
Barnes Foundation, Merion, PA.

Pablo Picasso
Dance of the Veils
1907, oil on canvas.
State Hermitage Museum, Saint Petersburg.

Pablo Picasso
Woman with a Fan
1908, oil on canvas.
State Hermitage Museum, Saint Petersburg
(detail on page 7).

female figures in the Medici chapels in Florence: he chose a markedly antithetical pose and endowed the nude with an androgynous, muscular appearance. He also set his figure in a space with an "architectural" nature. In both works the theme of the odalisque is no more than a pretext: in fact, what he modeled and painted was a paradoxical *Prison*, a personification of the tensions that exist on a formal level between the organic, living reality of the bodies and the conditions imposed by their representation. "What interests me," Matisse confided in 1908, "is the figure: not the landscape nor a still life. Only the human figure allows me to best express the in some way religious feeling that I have for life."

Picasso and the "Idols": The Proto-Cubist Period

It is probable that the dramatic turn undertaken by Matisse in 1906–07 was decisive for the development of the young Pablo Picasso, and convinced

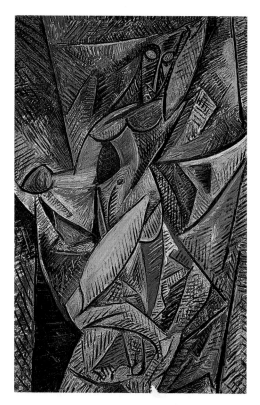

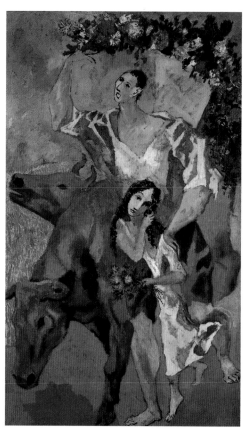

him to leave behind the refined archaicizing approach of his pink period that he had worked on during a summer in the village of Gosol in the Pyrenees. Both *Les Demoiselles d'Avignon* and *Dance of the Veils*, painted immediately after *Demoiselles* in summer 1907, can be considered at least partly a response to Matisse's *Blue Nude*, which Picasso saw in the Salon des Indépendants of 1907 and commented upon with irritated embarrassment. Matisse's painting broke the norms of the genre and crossed the aesthetic boundaries then current: it was not a simple "naturalistic nude," in Picasso's words, nor "an ornamental rhythm. It lies between the two." The embarrassment seems to have been relatively short-lived. The series of preparatory temperas, pastels, and watercolors made for *Dance of the Veils* reveals an improvised extension of the hatching technique, which Picasso not only applied to faces and half-shadows but turned into a princi-

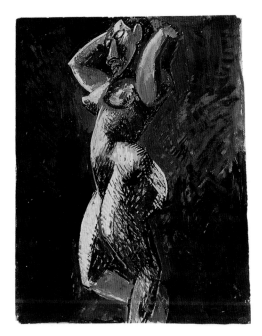

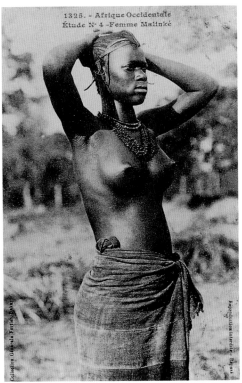

ture that both clutches at them and accentuates the dislocated nature of their limbs. Their faces are marked with the ritual scarifications of primitive "idols." This alienating, arbitrary approach hybridizes anatomical depiction and ornamental patterning without emphasizing either. At the start of a two-year period of strong primitivist experimentation (referred to as his "proto-Cubist" period), Picasso created a hybrid image that appeared "monstrous" from the standpoint of modern Western aesthetics (it was Derain who used the word in relation to *Demoiselles*). Providing a variation on the theme of the prostitute, *Demoiselles* and *Dance of the Veils* pay homage to the young Picasso's predilection for uncertain, destructive, twilight lives existing on the social and economic margins of the modern age.

Die Brücke: A Manifesto Aimed at "the New Generation of Artists and Connoisseurs"

At the start of the twentieth century Germany was the largest art market in the world and the biggest cities were home to progressive cultural institutions, important art events, and innovative artistic, musical, and literary circles. German society was racked by conflict and tension, and a notable division existed between the generations. The hostility or indifference that surrounded independent art led painters, sculptors, and architects to unite to support their own causes more effectively: they promoted exhibitions and publications to challenge Wilhelmine classicism, the style representative of the state. Founded in 1905 in Dresden, Die Brücke ("The Bridge") was in many ways the first twentieth-century avantgarde movement, and was founded to a certain extent on the model of the Secessions. A coalition of artists, it adopted specific strategies to promote contemporary art through organizational and communicative means just as much as through producing artworks. Among the first

pal feature of the composition: the images appear to be "woven," designed with color. The female figures are simplified geometrically, distorted, and placed insidiously at the center of a web-like struc-

Pablo Picasso
Nude with Raised Arms
1908, oil on canvas.
Musée Picasso, Paris.

Edmond Fortier
Malinké Woman
postcard belonging
to Picasso.
Musée Picasso, Paris.

Below:
Karl Schmidt-Rottluff
Two Nudes
1913, oil on canvas.
Sammlung Firmengruppe
Ahlers.

Above:
Karl Schmidt-Rottluff
Seated Nude
1909, wood engraving.
Museum Folkwang,
Essen.

Right:
Eric Heckel
Windmill at Dangast
1909, oil on canvas.
Wilhelm Lehmbruck
Museum, Duisburg.

Eric Heckel
Crystalline Day
1908, oil on canvas.
Staatsgalerie Moderner
Kunst, Munich.

Below:
Ernst Ludwig Kirchner
Die Brücke Manifesto
1906, wood engraving.
Brücke Museum, Berlin.

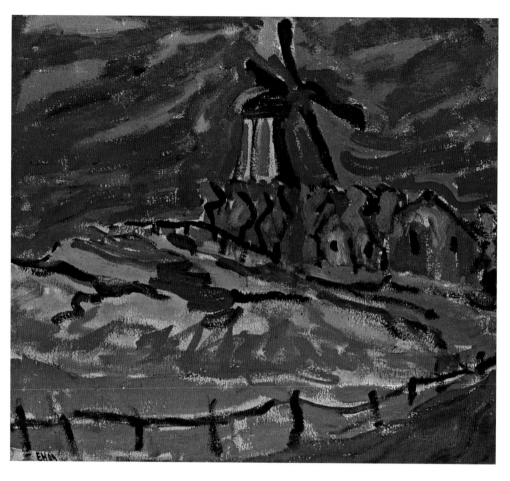

and most famous wood engravings by Ernst Ludwig Kirchner, an artist of reference and one of the founders of Die Brücke, is the group's manifesto. It was an engraved text that united poetry and cultural criticism, and so was not an image in the usual sense. "With a belief in continuing evolution, in a new generation of creators as well as appreciators, we call together all youth….Whoever renders directly and authentically what impels him to create, is one of us." Rural views and nudes *en plein air* were recurrent themes in the works by the artists of Die Brücke. The female nudes painted in the studio dialogue openly with the modern tradition of Edgar Degas and Henri de Toulouse-Lautrec, even being comparable to the watercolors and temperas of Egon Schiele though in positions

that are more chaste. Neo-Impressionist techniques were gradually abandoned in favor of large solid tints that were Fauve in nature.

During the winter months the artists shared a studio and painted together. In summer they moved out into the fields, clearings, and villages of the countryside around Dresden. Emphasis was placed on shared experiences and new cultural models: they danced nude, cross-dressed, and indulged in a provocative and promiscuous sexuality while presenting narratives that expressed outsider (*maudit*) ideas and images.

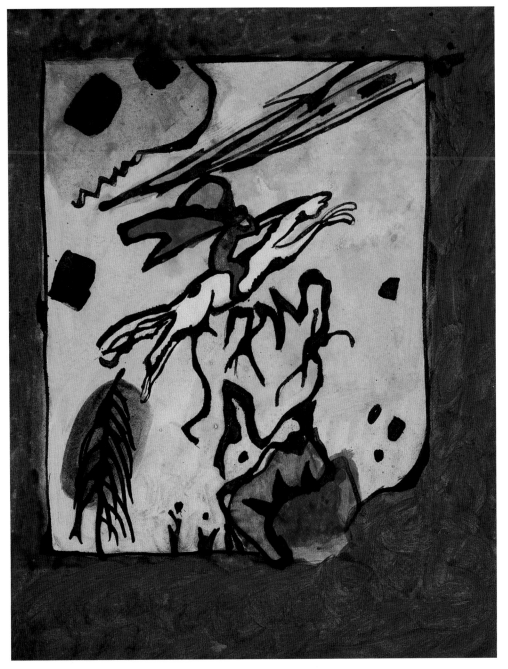

Wassily Kandinsky
Trial Cover for the Blaue Reiter Almanac
1911, tempera on paper.

Franz Marc
Byzantine Saint
postcard to Kandinsky,
1913, tempera on paper.
Städtische Galerie im
Lenbachhaus, Munich.

Wassily Kandinsky
Study for
"Composition II"
1910, oil on canvas.
The Solomon R.
Guggenheim Museum,
New York.

Franz Marc
Blue Horse II
1911, oil on canvas.
Kunstmuseum, Berne.
Gift of Othmar Huber.

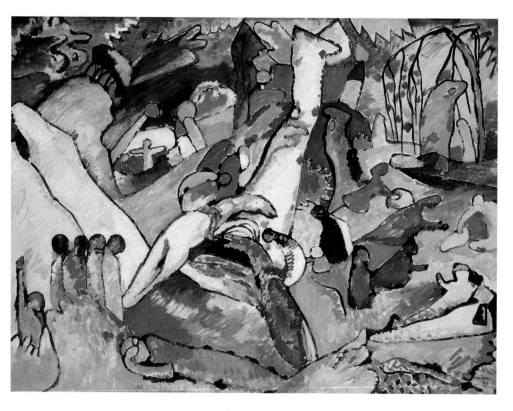

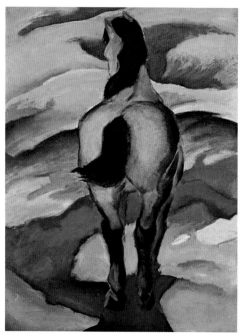

Blue Knights: Kandinsky and the "Spiritual" Avant-Garde

The youth, exuberance, and belligerence of Die Brücke were not typical of the other Expressionist avant-garde, Der Blaue Reiter ("The Blue Rider"), which was founded in Munich in 1911 around the activities of Wassily Kandinsky and Franz Marc. The latter was interested in the renewal of art through lyrical and "spiritual" dimensions, as Kandinsky explained in his essay "Concerning the Spiritual in Art." Important instances of continuity existed between the French neorealism of the Nabis and Blaue Reiter, in addition to cultural exchanges and close relations; for example, Jan Verkade, a converted Nabi, studied in Munich in 1907 with Alexej Jawlensky, who was in turn in close contact with Kandinsky.

Kandinsky wished to reevaluate the Slav Orthodox figurative traditions by comparing them against the modern developments in French art, Vincent van Gogh and Gauguin in particular, and,

from 1906, also Matisse. He was not, however, interested in the semi-serious, erotic themes, nor the aggressiveness of the cultural criticism that all typified the French tradition. In 1913 Marc portrayed Kandinsky as a Byzantine saint in an image we should consider an indulgent caricature. In 1911 the artist was relatively isolated as a result of his personal detachment and severe nature, which at times mutated into intransigence: the notoriety of Schiele and particularly Oskar Kokoschka in Central Europe (Kokoschka had moved from Vienna to Berlin) made it increasingly difficult to produce exclusively an art detached from both reality and deliberate provocation. The unexpected success of the Futurists in Germany in 1912–13 increased the tension existing in the German avant-garde, pushed Kirchner to move to Berlin to tackle the themes of the great city, and prompted the younger members of the Blaue Reiter (for example, Marc) to move on from the Fauve idylls of his youth.

"An Enormous Unexpected Toy": Futurism in Italy and Europe

With the publication of the "Futurist Manifesto" in *Le Figaro* on February 20, 1909, the man of letters and orator Filippo Tommaso Marinetti met with immediate support among a young generation disappointed by the slow, arduous evolution of post-Risorgimento Italy. Almost fifty years after unification the country had not yet developed into a modern, industrial nation able to compete on a European level. The impetus that led to unification seemed to have been exhausted, the monarchy was not moving with the times (in the opinion of the young liberal intellectuals), the process of industrialization was concentrated mostly in the northwest of the country, and the best opportunity available to manual workers and farm laborers was emigration. Marinetti argued for a national art that took its themes from the worlds of work, social conflict, infrastructural transformation, and the urban landscape that was gradually replacing its

Carlo Carrà
The Funeral of the Anarchist Galli
1910–11, oil on canvas.
The Metropolitan Museum of Art,
New York.

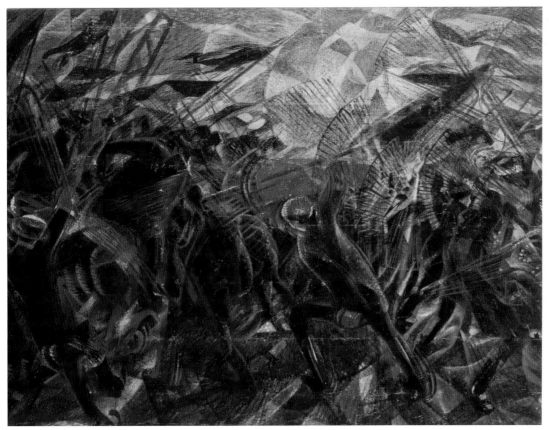

Ludwig Meidner
Apocalyptic Landscape
1912–13, oil on canvas.
Staatsgalerie, Stuttgart.

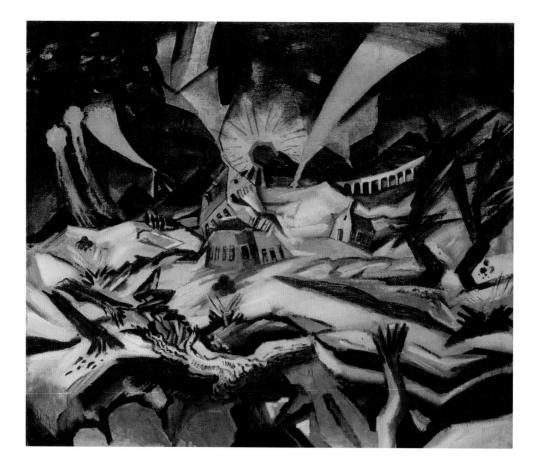

Giacomo Balla
Dynamic Expansion +
Speed, signed
"Futurballa"
1913, tempera on
canvas paper.
Galleria Nazionale d'Arte
Moderna, Rome. Gift of
Luce and Elica Balla.

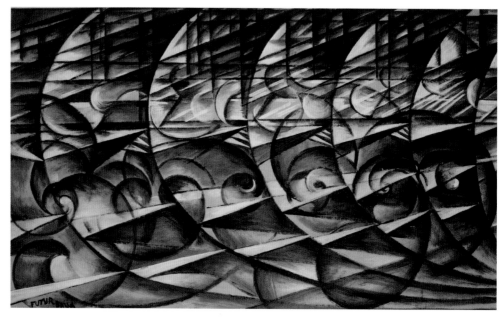

rural counterpart. He first appealed to those of his own age, and, among this group, to those who might choose to describe themselves as "friends," in other words, those who shared a common distaste for the present, a desire for group participation and adventure, and an ambitious project for social and cultural renewal. The "enormous unexpected toy," to which Marinetti likened Futurism, was their destiny, and one evening in March 1910 at the Teatro Politeama Chiarella in Turin the hoped-for movement became a reality. Five young artists gathered around Marinetti— Umberto Boccioni, Carlo Carrà, Luigi Rossolo, Giacomo Balla, and Gino Severini—and read the "Technical Manifesto of Futurist Painting" in public. Boccioni was the strongest advocate of Marinetti's arguments: the pair, who had met only two months before, formed a strong partnership to champion Futurism, not just in Italy but also abroad, particularly in England, France, Russia, and Germany. In England, the spread of Futurist ideas and works later contributed to the birth of Vorticism; in France to Orphism; in Germany first to Die Pathetiker ("the Exponents of Pathos") then Neue Sachlichkeit (New Objectivity, literally "New Dispassion"); and in Russia to Rayism. In 1911 Futurism provided Kazimir Malevich a powerful boost to turn away from primitivist-Fauve techniques and styles.

Kasimir Malevič
An Englishman in Moscow
1914, oil on canvas.
Stedelijk Museum,
Amsterdam.

Mikhail Larionov
Glass
1912, oil on canvas.
The Solomon R.
Guggenheim Museum,
New York.

Below:
Percy Wyndham Lewis
Composition
1913, pen, watercolor,
and pencil on paper.
Tate Britain, London.

Wassily Kandinsky, 1913.

Wassily Kandinsky
(Moscow 1866–1944 Neuilly-sur-Seine)

Kandinsky studied law in Odessa; in 1889 he researched unwritten law in the Vologda region. From 1893 to 1896, he was a university researcher but when seeing a Monet *Haystack* variation, he decided to paint and moved to Munich, where he began landscape painting and engraving. In 1903 he visited Venice, Vienna, Odessa, and Moscow; in 1904, Berlin, then Paris, where he exhibited at the Salon d'Automme. In Sèvres in 1906–07, he was in contact with Utopianists and Symbolists. From 1908 he divided his time between Munich and Murnau and became interested in popular religious and votive art. In 1909 he became a founding member of Neue Künstlervereinigung ("Munich New Artists' Association") and organized the first exhibition Blaue Reiter. He moved to Moscow in 1914 and had an administrative post in the Beaux Arts in 1918–22, then moved to the Bauhaus to teach. He went back to Berlin in 1932 and then to Neuilly-sur-Seine in 1933.

Wassily Kandinsky
Before the City
1908, oil on cardboard.
Städtische Galerie im Lenbachhaus, Munich.

From the summer of 1908, Kandinsky often resided in Murnau, in the countryside around Munich. Here his ideas took form to create an art freed from the motif, an expression of lines and pure colors supported uniquely by "internal necessity." *Before the City* shows a suburb of Munich: Kandinsky's touch is rapid and fluent, accompanied by long brushstrokes loaded with color. The horizon is high, the colors are bright and play on the contrast between complementaries. The scene is shown at dusk on a very clear day, the air is prodigiously transparent, and the shadows lengthening on the ground and walls of the houses are rendered in the same blue tonality as the sky. The artist staked the success of the painting on the transfiguring and slightly magical capacity of the light to elevate a motif from everyday life into a joyous episode of revelation: the forms appear to blend into in one another and almost to levitate, freed of their customary gravity; the clouds, rendered in the forms of divinities, look as though they are made from spun sugar, and the surfaces of the buildings are like enamel.

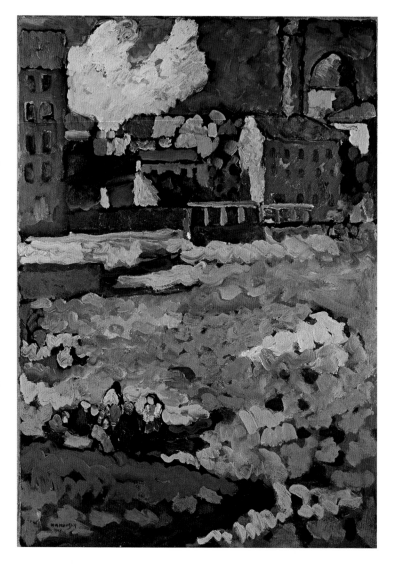

Wassily Kandinsky
Improvisation 19a
1911, oil on canvas.
Städtische Galerie im
Lenbachhaus, Munich.

At the end of 1911 and
start of 1912 Kandinsky
began to paint large
canvases with greater
compositional strictness:
the narrative elements
became rarer, the fields of
pure color increased in
size, and outlines became
thicker and took on com-
positional autonomy. He
organized two exhibitions
in rapid succession,
inviting the most radical
artists of the period to
participate: Picasso,
Georges Braque,
Kokoschka, and Alfred
Kubin. He also published
an almanac containing
images and text, and made
a wood engraving for the
cover. The Blaue Reiter
("Blue Rider") movement
formed around his proj-
ects; its members included
Franz Marc, August
Macke, and Paul Klee.
Kandinsky invited musi-
cians, painters, and poets
to join in and assist in
creating the total work
of art, a form of the
"spiritual." In the Russian
painter's experience a
total work of art was
realized in symbolic
theater, with the contri-
butions of dance, mime,
music, and singing.

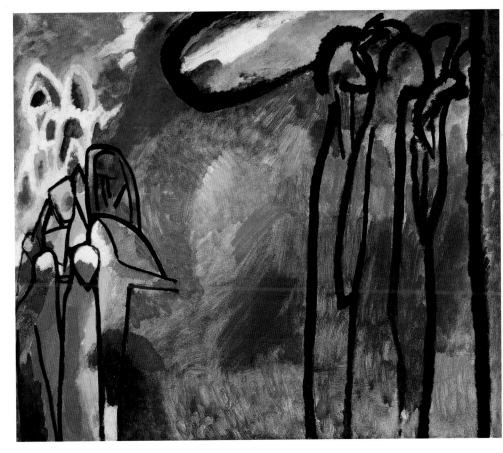

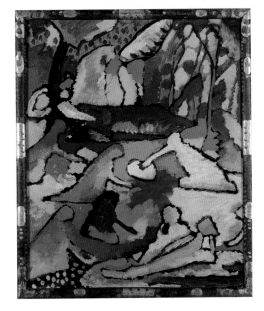

Wassily Kandinsky
Study for "Composition II"
1910, oil on cardboard.

In 1910–11 Kandinsky's images took on a delicate,
ironic balance that lay between playfulness and
sublimity. Careful to avoid the empty magniloquence
of the Symbolist religious *grand genre*, which he knew
and sometimes parodied, he was not afraid to indulge
in the "ingenuous" attraction of excessive color, and
the agreeable feelings and sense of intimacy aroused by
a sacred image and an ornament of a simple, everyday
religiosity. Prophets and sword-wielding angels, knights
of the faith and hermits, pious women, the faithful
resurrected, sacred mountains, figures, mangers, sweet-
breads, and rural villages and churches were imbued
with the attractive and whimsical appearance of toys.

Henri Matisse in his studio in Issy-les-Moulineaux, detail of a photograph by Alvin Langdon Coburn, May 1913.

Henri Matisse
The Open Window
1905, oil on canvas.
© Succession H. Matisse/
SIAE 2005.

This painting was one of the most contested at the 1905 Salon d'Automne, yet to our eyes it is one of the most successful works from his memorable Fauve summer. The window is open, looking onto several vases of flowers on the wrought-iron balcony; in the distance brightly colored sailboats bob on the water. Matisse seems to be enjoying himself making a painting within a painting: framed by the window on three sides and the balcony at the bottom, the marina with boats was—as the artist suggested— a "discovered" painting that only needed to be transferred onto canvas. Also, the sea reflected in the windows of the doors produces other possible paintings, as do the small panes above the door. In singing the splendor of the Mediterranean view the artist has no hesitations or difficulties: the beauty of nature is offered on all sides, and all that is required is to open a window to be inundated with light, color, and motifs.

Henri Matisse
(Le Cateau 1869–1954 Cimiez)

In Paris in 1892 to study law, Matisse enrolled at the Académie des Beaux-Arts. A pupil of Gustave Moreau, he exhibited at the Salon de la Société Nationale des Beaux-Arts starting in 1896. He visited Corsica in 1898, Saint-Tropez with Signac in 1904, Collioure with Derain in 1905, and Algeria in 1906. He won notoriety at the 1905 Salon d'Automne. In December 1908 he published "Notes d'un Peintre." From 1908 to 1911 he ran a private school for painting. He was contracted to sell his work through Bernheim-Jeune. In 1910 he visited Munich, in 1911 Moscow, and in 1912 and 1913 Morocco. He experimented a little with Cubism. In the 1920s he lived in Nice but traveled in Italy, Spain, Germany, England, and Russia. In 1930–31 he toured Oceania (3 months in Tahiti). He remained in France during World War II, mostly in Nice. He produced collages and decorated the Dominican chapel in Vence, consecrated in 1951.

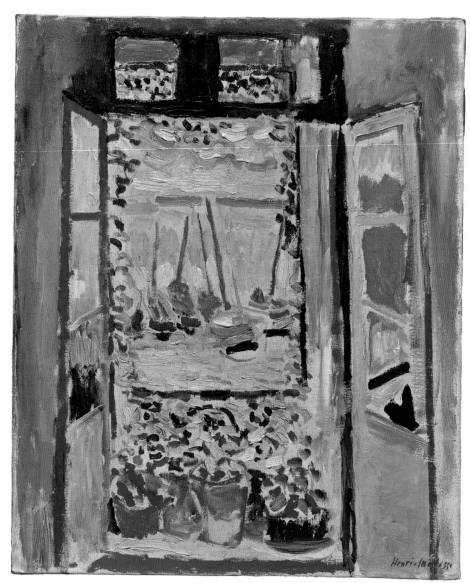

Henri Matisse
Music
1910, oil on canvas.
State Hermitage Museum, Saint Petersburg
© Succession H. Matisse/SIAE 2005.

In autumn 1905, perhaps as a reaction to the harsh criticism he had aroused with his landscapes and portraits painted *en plein air*, Matisse returned to composed works. With *Joie de Vivre* (page 9), he began major restructuring of his compositions, which he found, through the late works of Cézanne, in the classical-naturalistic tradition of the figured landscape and museum painting; this new approach resulted in the large panels called *Dance* painted in 1909–10. The human figure was at the center of the artist's interest, in particular the manner in which lines and color could coexist in dynamic unity without being reduced to the level of ornamental arrangement. "Only the human figure," he declared in 1908, "allows me to best express the in some way religious feeling that I have for life." Presented at the 1910 Salon d'Automne, the second version of *Dance* (ill. on page 10) and *Music* aroused widespread hostility among the critics, with the sole exception of Guillaume Apollinaire: their extremely simplified forms, vivid colors, and anti-narrative poses were not understood. Even the Russian client of the two large panels, Sergei Shchukin, refused them after seeing them at the Salon, but he changed his mind on his return journey to Moscow. *Dance II* and *Music* reached Russia in December.

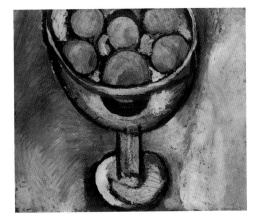

Henri Matisse
Bowl of Oranges
1916, oil on canvas.
© Succession H. Matisse/
SIAE 2005.

Ada and Emil Nolde on their wedding day, 1902.

Emil Nolde
(Nolde 1867–1956 Seebüll)

The artist's real name was Emil Hansen, born in Nolde, Denmark. Trained as a wood engraver in Flensburg, Nolde enrolled at the school of industrial arts in Karlsruhe. He taught drawing from 1892 to 1898 in Saint Gallen. From 1898 he devoted his time to painting; he moved to Munich and studied with Adolf Hölzel. He lived in Paris from 1899 to 1900 and summered in Lildstrand, a fishing village on the northwest coast of Denmark. He visited Berlin in 1902, the island of Alsen in 1903, and Sicily and Ischia in 1904–05. As a member of Die Brücke (the Bridge), in 1906–07, he met Edvard Munch. In 1908 he exhibited in Berlin in Paul Cassirer's gallery, and in 1911 he published, with author Gustav Schiefler, a volume of graphic art. He traveled in the South Seas in 1913–14, and in 1918 joined the revolutionary art councils. Nolde was a member of the Prussian Academy of Arts from 1931, and his work was included in the Nazi's Degenerate Art exhibition in 1937.

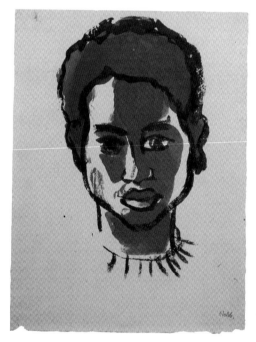

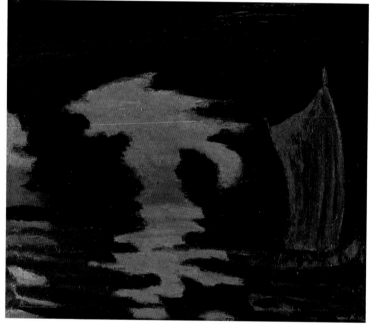

Emil Nolde
Young Islander in the South Seas
1914, watercolor on paper.
Fondation Nolde, Seebüll.

Nolde made a long voyage in the South Seas in 1913–14 as part of an official expedition to study the health of indigenous peoples in New Guinea and the Micronesian archipelagoes under German rule. Nolde was a careful traveler, though ambivalent by nature. He was fascinated by the splendor of the places he visited and attracted by their historical and social aspects. "Almost no plantation owner," he reported, "is interested in the local decorative customs or cultural values. Nothing but commercial and economic interests or the brute concept of money exists in the eyes of the colonists." Nolde painted watercolors of attractive tropical seascapes, scenes of everyday life, and ethnographic portraits that reveal his admiration for the elegance and beauty of his models. In later years he used these watercolors as the basis for his tropical landscapes in oils.

Emil Nolde
Evening Sea
1919, oil on canvas.
Wilhelm Lehmbruck Museum, Duisburg.

Paul Klee
(Münchensbuchsee 1879–1940 Muralto)

Paul Klee, 1911.

One of von Stuck's pupils in Munich, in 1901 Klee visited Florence and Naples and lived in Rome. Between 1903 and 1905 he made grotesque engravings and in 1905 visited Paris. He learned about Impressionism and post-Impressionism and drew landscapes *en plein air* (1909–10). In 1911 he illustrated Voltaire's *Candide*, arousing Kubin's admiration and met Marc and Kandinsky; a year later he met Robert Delaunay in Paris. He visited Tunisia in April 1914 with Macke and was mobilized in 1916. He exhibited at the Galerie Dada in Zurich in 1917. From 1921 he taught at the Bauhaus in Weimar. In 1925 he exhibited with the Surrealists in Paris; his international fame grew. In the 1920s he visited Sicily, Elba, and southern France. In 1928–29 he was in Egypt. In 1931 he left the Bauhaus to go to the Academy in Düsseldorf. Fired by the Nazis in 1933 after refusing to declare himself Aryan, Klee moved to Berne.

Paul Klee
Primary Route and Bypasses
1929, oil on canvas.
Museum Ludwig, Cologne.

Klee's involvement with Blaue Reiter was only marginal at first. Interest in the art of "primitives," children, and the mentally ill, and in the autonomy of expression of the sign, organic growth, ancient Mediterranean cultures, and funerary architecture characterized Klee's art in the 1920s and 1930s, and are linked to "expression," "sublime" spiritual states, or "prophetic" viewpoints that he manifested more vigorously in Munich in the period of Blaue Reiter and the early years of World War I.

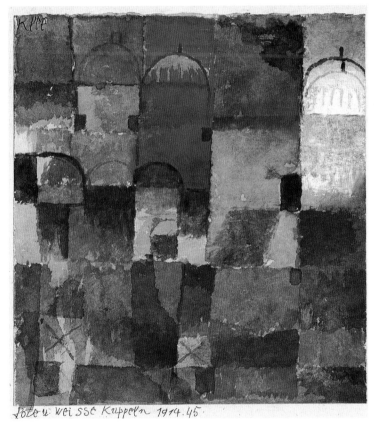

Paul Klee
Red and White Domes
1914, watercolor on paper.
Kunstsammlung Nordrhein-Westfalen, Düsseldorf.

His trip to Tunisia marked a turning point: as a result of the simplified landscapes of flower and vegetable gardens, the attractions of exotic dress and sights, and the time he spent with Macke, Klee discovered he was a "colorist," happy using watercolors and drawing: "I am following an impulse of great quiet and depth," he noted lyrically in his *Diary*. "I feel it, I become increasingly sure. Color possesses me."

André Derain, *Self-portrait in a Cap*, detail c. 1905–06.

André Derain
(Chatou 1880–1954 Garches)

As a pupil of Eugène Carrière, Derain met Matisse. During military service from 1901 to 1904, he painted views of Chatou with Vlaminck. He was linked to the gallery-owner Vollard from 1905; he spent summers at Collioure. In the autumn of 1905, he was in London, and in the following spring of 1906, he was at L'Estaque. In 1907 he was at Cassis and in 1908 at Martigues. His discovery of African and Oceanic art, in the spring–summer of 1906, and Cézanne's retrospective show (autumn 1907) at the Salon d'Automne, led him to try his hand at painting large-scale nudes. In the summer of 1909 he began his association with the Cubists Braque and Picasso; he was at Cadaqués with the latter, in 1910. In about 1912, he had his "Gothic" and "Byzantine" watershed. Called up by the military, he fights at Verdun. In 1919 he worked with Sergei Diaghilev on the Ballets Russes. In the 1920s, he painted landscapes and *commedia dell'arte* figures. In 1941 he went to Germany, invited by the Reich—a journey that is viewed with great suspicion after the War.

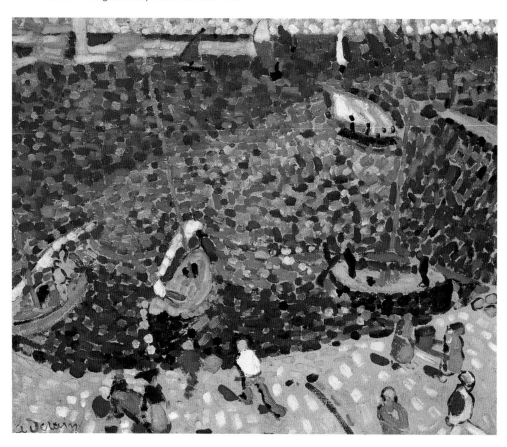

André Derain
Boats at Collioure
1905, oil on canvas.
Kunstsammlung
Nordrhein-Westfalen,
Düsseldorf.

In July 1905 Derain joined Matisse in Collioure (on the French Mediterranean coast by the Pyrenees) to exchange and develop their art together during a period of great renewal. This marked the start of the Fauve period. They also made a short trip to Spain where they met the painter Georges-Daniel de Monfreid, custodian of the Gauguin archives and his last Polynesian paintings. When Derain and Matisse visited Collioure the first time, the place was a simple fishing village,

not the elegant holiday resort it has become today. Around the end of the nineteenth century Collioure began to attract tourists from the cities (in particular Paris) in search of unspoiled surroundings and wishing to spend time in a simpler, unaffected social environment. Those who journeyed to Collioure were in search of something very different from the refined, worldly bourgeoisie filling the hotels along France's north coast (the people painted by the Impressionists).

André Derain
Portrait of an Unknown Man Reading a Newspaper (Chevalier X)
1911–13, oil on canvas.
State Hermitage Museum, Saint Petersburg.

The daily newspaper established an intimacy between art and its time: despite the austere, pseudo-archaic appearance, it is clear that in Derain's eyes the image had its own specific modernity. The pose of the mysterious Chevalier X in his red armchair is that of an antique miniature of an Evangelist, taken by surprise as he listens: he is a messenger, a "primitive" with a new "sensitivity." Like Picasso, Derain often added drapes pulled back to one side of his images: the figures thus appear as if on a theatrical stage after the curtain has gone up. The artist insists on the artificial, constructed scene depicted, which is no longer a naturalist "glimpse of life" but a carefully prepared scene from it.

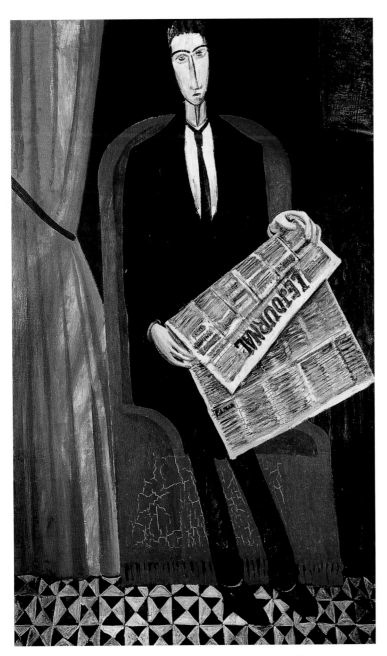

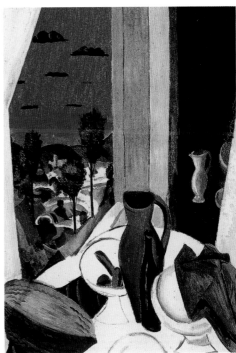

André Derain
Still Life by the Window
1912, oil on canvas.
State Pushkin Museum, Moscow.

Derain's distrust of the experimental excesses of Braque and Picasso became clear in 1911, during his "Byzantine" or "Gothic" period. This was characterized by archaized techniques and styles, while his portraits and landscapes were equally influenced by the works of Henri Rousseau, pre-Cubist Picasso, and the Italian primitives. Derain simplified his figures and objects, inclined the planes, and reduced his color range. In his backgrounds— almost as though to reinstate the Albertian use of the image-window so sensationally contradicted by Cubist compositions in 1910 and 1911—he inserted glimpses of landscapes. He also inserted ironic, popular images in his cultured, well-planned paintings, such as prints, inn signs, and playing and tarot cards.

Ernst Ludwig Kirchner,
Self-Portrait, c. 1919, modern
photographic print. Kirchner
Museum, Davos, donated by
Nachlass Ernst Ludwig Kirchner.

Ernst Ludwig Kirchner
(Aschaffenburg 1880–1938 Davos)

A pupil at the Technische Hochschule in Dresden, Kirchner was impressed by the woodcuts of Albrecht Dürer during a trip to Nuremberg. In 1903 to 1904, he was in Munich and studied with Hermann Obrist, an innovative designer of the Bavarian Jugendstil (Art Nouveau). As one of the founders of Die Brücke (1905), Kirchner contributed to a partnership among talented, culturally and socially experimental young artists. In 1908 he spent the summer months on Fehmarn, an island in the Baltic Sea with Emmy Frisch, who introduced him to photography. Kirchner moved to Berlin in October 1911, opened a painting school with Max Pechstein, published ten wood engravings in *Der Sturm*, and took part in the second Blaue Reiter exhibition. He was drafted in the army in 1915. Two years later he was living in Davos, Switzerland, and in the 1920s he painted alpine landscapes and rustic figures. In 1933 the Nazis confiscated 639 of his works. He committed suicide in 1938.

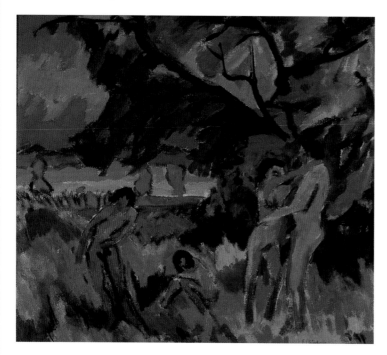

Ernst Ludwig Kirchner
Nudes Playing beneath a Tree
1910, oil on canvas.
Staatsgalerie Moderner Kunst, Munich (on loan from a private collection).

During the summer trips of the artists into the countryside, the models followed, posing nude in the open countryside (thus infringing on the current moral strictures) and moving freely at the request of the artists who wished to depict the human figure in motion. The myth of an openly sexual Eden underlies the paintings. Pechstein described the summer of 1910, which he spent with Kirchner and Erich Heckel painting by the lakes of Mortizburg (close to Dresden): "We would set out early in the morning loaded with our materials, behind the girls with bags full of things to eat and drink. We lived in absolute harmony, worked and bathed together."

Ernst Ludwig Kirchner
Girl with a Japanese Parasol
c. 1909, oil on canvas.
Kunstsammlung Nordrhein-Westfalen, Düsseldorf.

Adorned with erotic paintings and "primitive" weavings and sculptures, the studio of Die Brücke in Dresden became the setting for staged events: the participants exhibited themselves licentiously, danced nude, cross-dressed, and invited girls hardly past puberty to portray them with older models. Everything occured, or seemed to occur, with extreme ease, as a result of a vitalistic and "damned" aestheticism in an attempt to marry art and life. Talent, deviance, and experimentation were the various elements in an account told in pictures (not just paintings, photographs too) in which the artists themselves were the leading characters and provocation was the goal. In his diary, Kirchner recalls, "The most important thing for us was to paint the model at liberty. We drew and painted hundreds of sheets each day, but we also talked and played, the painters would pose and the models paint. Our daily meetings were shifted into the realm of art, and turned into paintings. The studio became like the home of the people we portrayed: in this way the images took on a rich and immediate life."

Franz Marc
(Munich 1880–1916 Verdun)

Franz Marc, early twentieth century.

Franz Marc studied philology at Munich University and enrolled at the Academy of Fine Arts in 1899. In 1901 he was in Italy with his brother, a scholar of Byzantine art. In 1903 he was in France where he discovered painting *en plein air*, and Japanese art. In 1906 he visited Mount Athos. An admirer of the art of Gauguin and Van Gogh, he met Macke in 1910 and Kandinsky in 1911. Co-editor of the Blaue Reiter almanac, he was in contact with the Expressionist community of Berlin and worked hard to set up a transnational artistic avant-garde. In 1912 he was in Paris with Macke, where he met Delaunay. Contrary to Kandinsky's opinions, Marc supported the Futurists. In the Tyrol in 1913, he invited artists close to him to illustrate the Bible. A second Blaue Reiter almanac dedicated to avant-garde theater did not get past the planning stage. Called up in 1914, he drew and wrote aphorisms in the pauses in battle. He died at Verdun in 1916.

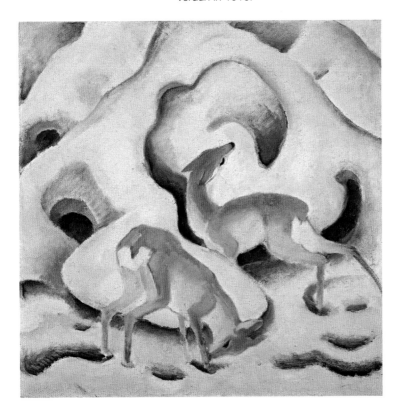

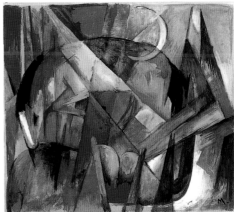

Franz Marc
Imaginary Animal II
1913, tempera on cardboard.
Sammlung Firmengruppe Ahlers.

Franz Marc
Roe Deer in the Snow
1911, oil on canvas.
Städtische Galerie im Lenbachhaus, Munich.

Between 1910 and 1912, Marc painted his most touching images of wild animals and exotic beasts in primordial nature: fawns, wild horses, and tigers filled his works during a period characterized by rapid changes in style. He was a passionate enthusiast of Persian art, and his models were miniatures, carpets, and incised metals and leathers, fluid, ornamental, and arabesque, i.e., generically Fauve. His interest in Cubism (or "proto-Cubism") gave way first to compact, geometric forms, then, just a few months later, to the shattered style of Futurist and Rayist motifs.

Carlo Carrà, 1910.

Carlo Carrà
(Quargnento/Alessandria 1881–1966 Milan)

Carrà was of humble origins and came to painting in 1906 when he enrolled at the Accademia di Brera. Initially, he worked as a decorator, but he was quick and increasingly aware of his avant-garde participation. In 1910 he was already one of the major figures in Futurism. His metaphysical period began in 1917, and this brought him into close contact with Giorgio de Chirico, Alberto Savinio, and Filippo de Pisis. In the decades between the two wars, Carrà was committed to a style of painting reminiscent of tradition and with severe civil-ethical implications. A distinct desire for solidity and compositional order prevailed in his work, interwoven with interest in historical and social themes of his time. The artist did not fall prey to the desire to exhibit prodigious techniques or to daze with theory or peculiarity. As Carrà said, his attention lay with the mystery of "ordinary things."

Carlo Carrà
Simultaneity—The Woman on the Balcony
1912, oil on canvas.

This composition—which dates from the most experimental period of Carrà's Cubist-Futurist phase—oscillates significantly between the ancient and the modern. Ostensibly he depicted a model on a balcony, a favored setting to watch what is happening in the street in the heart of the city; thus he was taking the stance, at least in part, of a "painter of modern life," an enthusiastic and acute interpreter of cultural, social, and urban transformation. At the same time he was painting a nude, a classical theme, choosing to group himself among the great masters and not those—Romantics, naturalists, Impressionists, and Symbolists—who preferred to document the evolution of manners, tastes, and psychologies by painting figures in contemporary dress.

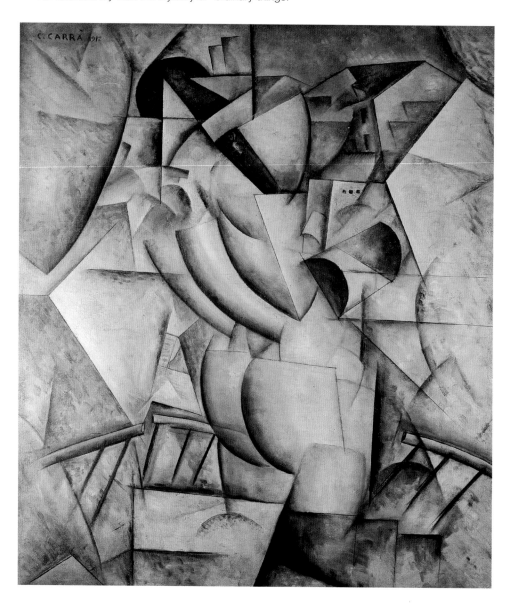

Fernand Léger
(Argentan 1881–1955 Gif-sur-Yvette)

Fernand Léger on his arrival in Paris.

In Paris, Léger studied at the École des Arts Décoratifs. He discovered Cézanne at the Salon d'Automne of 1907. He met Robert Delaunay and saw the Braque exhibition at Daniel-Henri Kahnweiler's gallery in 1908. His Cubist period began. He exhibited at the Salon des Independants and Salon d'Automne in 1911. Apollinaire praised him for his "difficult art." He broadened his literary and artistic acquaintanceship and took part in meetings organized by Albert Gleizes and Jacques Villon. He was a friend of Blaise Cendrars. He took part at the Cubist salon in the Section d'Or. In 1913 he contracted to sell all his works through Kahnweiler. Mobilized in 1914, he distinguished himself for his courage. His first solo exhibition was held in 1919 at Léonce Rosenberg's gallery. In the 1920s and 1930s, he exhibited in Berlin and New York. Léger was among the masters of abstract art and was a friend of Charles Le Corbusier and interested in avant-garde cinema. In 1929 he joined the art collective Cercle et Carré ("Circle and Square").

Fernand Léger
Nudes in the Forest
1909–11, oil on canvas.
Rijksmuseum Kröller-Müller, Otterlo.

The particularly long and elaborate execution of this painting, in part based on the most recent developments in Cubism, shows Léger attempting to win himself a reputation as a daring and brutal innovator: several primitivist nudes seem intent on cutting down trees in the heart of a thick forest. It might be considered an avant-garde variant on the theme of bathers. The cylindrical geometric simplifications introduced into the composition earned Léger the mocking epithet of "tubist" (as opposed to Cubist), given by the more malevolent critics.

Fernand Léger,
The Wedding
1910–11, oil on canvas.
Centre Georges Pompidou, Paris.

Léger simultaneously distributes the surface of figurative details such as faces and houses and creates a non-narrative composition that, rather like a poem, makes allusions and suggestions rather than offers a recital. Glimpses of city suburbs, parts of bodies and faces, and flashes of clothing contrast strongly with blocks of pure color and modular plastic elements. He allows an image to pass before us that has order and duration, almost in the same way as a dream or movie. The delicate shading of the bodies seems to hint at the processes and persistence of memories.

Pablo Picasso
(Malaga 1881–1973 Mougins)

Picasso studied at the Academia in Barcelona. He visited Paris three times between 1900 and 1902 and finally moved there in 1904. A friend of Max Jacob, Andre Salmon, and Guillaume Apollinaire, in 1906 Picasso met Matisse at the house of Gertrude Stein. In 1906 he was in Gosol in the Spanish Pyrenees, where he painted archaized nudes. In 1907 he painted *Les Demoiselles d'Avignon*. He was in contact with Georges Braque during the winter of 1908–09 and together they initiated the Cubist period. From 1914 he adopted a classical-archaic style similar to that of Jean Ingres. In 1917 he painted the sets of the Ballets Russes. Picasso became close to the Surrealists in the late 1920s into the 1930s; attempted sculpture; and with his 1937 painting *Guernica*, became a champion of political art. He was in Paris during the German occupation. After the war he took up pottery, engraving, and a series of pictorial tributes to past masters. He produced a series of compositions on the theme of peace.

Picasso in his studio at Sorguers, summer–fall 1912.

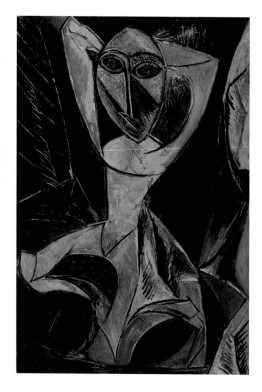

Pablo Picasso
Nude with Raised Arms
1907, oil on canvas.

In compressing this female nude unnaturally, forcing the figure to adapt to the surface of the painting, Picasso avoided the loss of erotic and psychological tension: the figure's gaze fixed on the observer creates a visual and narrative climax incompatible with the requirements of calm, reassurance, and repetition associated with ornamental motifs. The face has the same disturbing fixity of fetishes and tribal masks.

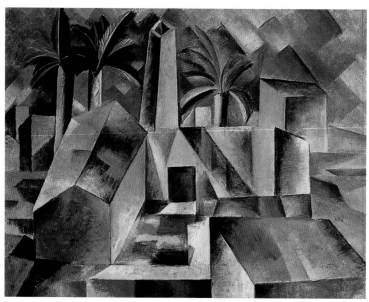

Pablo Picasso
Brick Factory at Tortosa
1909, oil on canvas.
State Hermitage Museum, Saint Petersburg.

Picasso spent the summer of 1909 alone at Horta de Hebro, a small village in Catalonia, to concentrate undisturbed on painting. He painted a series of views that could be considered first examples of early Cubism. The reduction of the houses and landscape to prisms combined with Cézanne's technique of passage produces admirable effects of atmosphere and transparency.

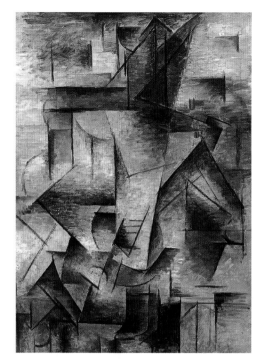

Pablo Picasso
The Guitarist
1910, canvas. Centre Georges Pompidou,
Musée National d'Art Moderne, Paris.

Characterized by the rarefaction of figurative details
and their dissemination across the pictorial surface, still
lifes, landscapes, and figures painted by Picasso in
spring-summer 1910 reveal a remarkable delicacy in the
tonal and atmospheric passages. Generally recognized
as being the stimulus for the paintings of Piet Mondrian
(who arrived in Paris in 1911), the compositions
of this period represent an extreme point
of abstraction and formalistic rigor in
the evolution of Picasso's Cubism.

Pablo Picasso
Glass, Guitar, and Music Score
1912, collage. Marion Koogler McNay Art Museum, San Antonio.

In 1912–13 the fragmentation of objects became less marked, often accompanied by experimentation in representation: vivid polychromy was combined with pungent concessions to caricature and renewed decorative invention. Atmospheric effects were toned down and the forms were opaque rather than transparent. In his collages, Picasso's use of wallpaper and upholstery was versatile and playful: his attempts to find the right wallpaper—an element that is surprising, amusing, and popular—seemed to take up much of the artist's time, as he searched among local markets, secondhand dealers, and passementerie workshops.

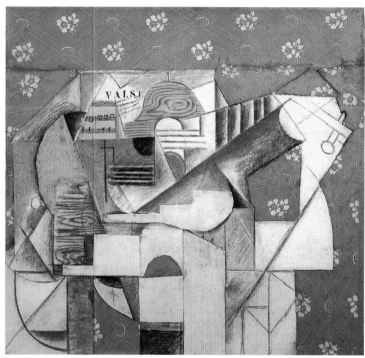

Pablo Picasso
Still Life
1914, assemblage.
Tate Modern, London.

Picasso's interest in painted sculpture produced particularly successful results in his wooden "do-it-yourself" still lifes in spring 1914. It seems he considered his assemblages toys, and used small pieces of wood or fabric trimmings to bring life to figurative experiments as ingenious as they were lighthearted and intimately ritual. During the early years of the century his toys were not yet, or rarely, industrial objects. They were more like objects produced for fun in the workshops of a blacksmith or carpenter, made from rejected or leftover materials. Their comical, haphazard appearances were not very different from those of some idols in ethnographic collections.

Umberto Boccioni
(Reggio Calabria 1882–1916 Verona)

Umberto Boccioni,
Self-portrait, detail, 1908.
Pinacoteca di Brera, Milan.

A friend and admirer of Giacomo Balla, Boccioni was given an apprenticeship in Divisionism in Rome, but, after several visits to Paris, he chose to live in Milan. A keen observer of the contemporary world, he quickly became a typical avant-garde artist, torn between high hopes and disappointment at the reality of Italy's situation. He joined the Futurist movement and, along with Marinetti, became its leading exponent before the war. A painter and sculptor, Boccioni contributed to Futurist manifestos and was active in the debate with the Cubists and Expressionists over the role of the avant-garde. He championed new trends and took on the responsibilities of a cultural organizer. He enlisted in the army as a volunteer but continued his art, finding greater balance in his compositions, a legacy of the plasticism and use of color of Cézanne.

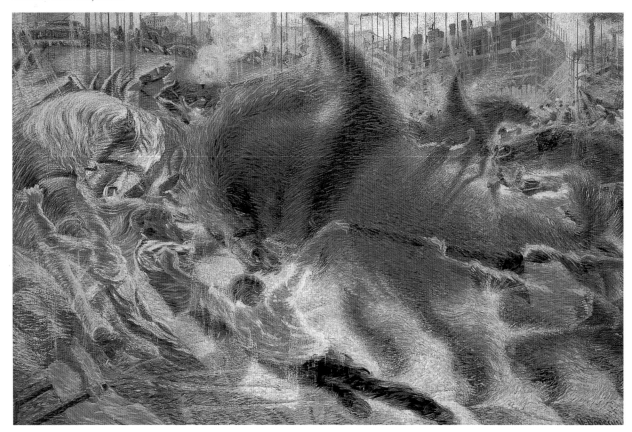

Umberto Boccioni
The City Rises
1910–11, oil on canvas.
The Museum of Modern Art, New York.

This painting describes and celebrates construction as an example of group activity. It shows a crowd of laborers working with fiery horses on the building site. Executed using the Divisionist technique, in the background it shows the great city of the future, the goal and symbol of a dramatic and keenly contested battle (specifically in Italy) for modernity. A young nation formed by regions of disparate wealth and held together by fragile institutions and a largely unrepresentative monarchy, Italy (in the opinions of early twentieth-century observers) is economically and politically backward among the nations of Western Europe. In *The City Rises* Boccioni portrays early twentieth-century Milan, a city, in the eyes of the artist, both utopian and real.

Umberto Boccioni
States of Mind II: Those Who Go
1911, oil on canvas.
The Museum of Modern Art, New York.

This painting, the second version of *States of Mind*, is part of a triptych that illustrates places and emotions typical of the modern age. The setting is a railway station. A crowd pulls back on two sides as a menacing locomotive steams forward beneath a low, gray sky. In the background we catch a glimpse of the suburbs with electric pylons and railway buildings. The entire composition appears as a series of independent elements endowed with a narrative power. The image is not unified and exists as a result of the associations the artist (first) and observer (second) establish among the landscape, figures, and concomitant (Boccioni calls them "simultaneous") circumstances.

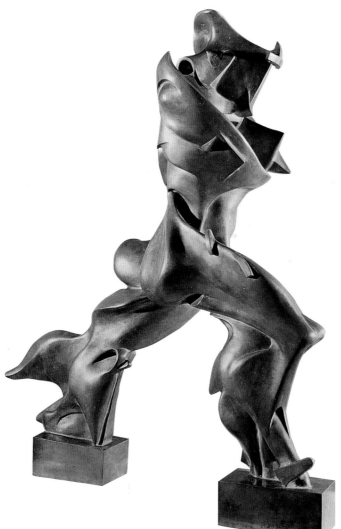

Umberto Boccioni
Unique Forms in the Continuity of Space
1913, bronze.
The Museum of Modern Art, New York.

The decision to take up sculpture arose from Boccioni's belief that painting had lost contact with reality following the advent of Cubism. The level of abstraction in the triptych *States of Mind* represents the limit to which Boccioni was prepared to go. His statue shows a male figure striding vigorously forward—perhaps the figure of a titan, a hero, or, more probably, an athlete. Boccioni interpreted the space surrounding the figure as part of the figure itself, and the figure as part of the space, in accordance with the principles of fluid, "neo-Baroque" continuity: the movement itself has body and is evidenced in large, consistent volutes and lateral curling forms on parallel, closely set planes included for emphasis.

Georges Braque in Boxing Gloves, c. 1904–05.

Georges Braque
(Argenteuil 1882–1963 Paris)

Trained as a house painter and interior decorator, Braque visited Paris in 1900 and studied at the Academie Humbert in 1902. He was close to Raoul Dufy, and from 1902 began painting full time. In 1905, during his Fauve period, he was in Honfleur and Le Havre; in 1906 in Antwerp with Othon Friesz; at L'Estaque in 1906 and 1907; and at La Ciotat also in 1907 with Friesz. He moved away from Fauvism in 1907 after the Cezanne retrospective at the Salon d' Automne. His first Cubist compositions were painted at L'Estaque in the summer of 1908, but the salon's panel (which included Matisse) was unimpressed. In December 1908 he had his first solo exhibition at Kahnweiler's gallery. He struck up a friendship with Picasso. A soldier in the war, Braque was injured in 1915 and discharged in 1916. Between the wars he painted interiors and still lifes. In Paris during World War II, he painted his *Studios* series in a large format with simplified figuration.

Georges Braque
Viaduct at L'Estaque
1908, oil on canvas.

In 1907 and 1908 Braque was one of the first painters in Paris to reinterpret the landscape on the basis of Cézanne's legacy. His landscapes and figures became more grandiose and severe, and his range of colors was reduced. *Viaduct at L'Estaque* is in some ways more programmatic, as though conceived to announce a new direction. There are still motifs and techniques typical of Cézanne: the silhouette of the Provencal village and chimney (painted by Cézanne in 1878 and 1879), the curtain of trees on either side of the view, the aqueduct with its arches standing heroically in a southern setting, and above all the innovative two-dimensional nature of the image, which does away with the customary relationship between foreground and background. Cézanne wrote to Pissarro in 1876 as follows: "I imagine that the setting…is ideal. It is like a playing card….Red roofs on the blue sea….The sun is so terrifying that it seems as though the objects are silhouetted, not only in black and white, but in blue, red, brown, and violet. I may be mistaken, but it seems to me the very opposite of modeling." Braque certainly did not know of Cézanne's letter but the reference to a playing card is also valid of this view: the mutual movement of the planes and layering of objects on top of one another are indications of a changed perception of pictorial space.

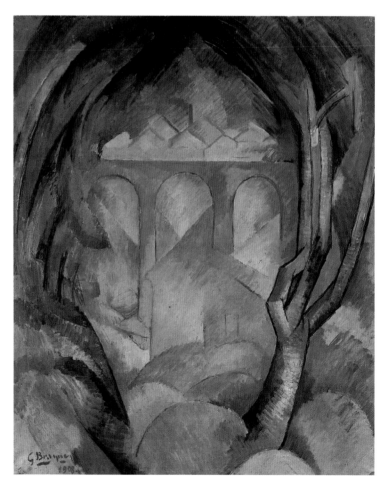

Robert Delaunay
(Paris 1885–1941 Montpellier)

Beginning in 1905 Delaunay painted Fauve landscapes and still lifes, but in 1908–09 he moved toward Cubism and the art of Henri Rousseau. In 1911 he was invited by Kandinsky to exhibit at the first Blaue Reiter show; his fame grew among the Expressionists. Macke, Marc, and Klee visited his studio, and Klee translated Delaunay's short essay "On Light" for *Der Sturm*. In the spring of 1912 Delaunay presented works at the Salon des Indépendants and Galerie Barbazanges. In January 1913 he was in Berlin with Apollinaire for a solo exhibition in the Der Sturm gallery. The same year he participated in the first German Salon d'Automne. During the war, which surprised him, he was in Spain and Portugal, leaving in 1922. In 1931 he became a member of Abstraction-Creation but left the group three years later. In 1937 he decorated the Pavilion des Chemins de Fer and Pavilion de l'Air at the Universal Exhibition in Paris.

Robert Delaunay, 1935, photograph by Florence Henri. Bibliothéque Nationale, Paris.

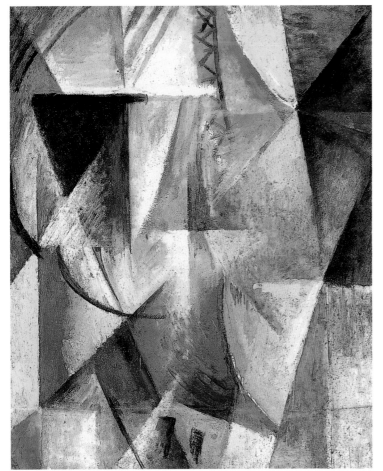

Robert Delaunay
Window (a study for The Three Windows)
1912–13, oil on canvas.
Centre Georges Pompidou, Musée National d'Art Moderne, Paris.

The artist's first compositions for the *Studio* series date from 1912 and mark a decisive turn away from figurative tradition in the direction of abstraction. Natural light seems decomposed into the colors of the spectrum and reinterpreted through the law of complementary colors. Delaunay aimed to create works that had within them the "movement" and "depth" of solar radiation. Partial views and details of the ironwork of the Eiffel Tower are shown about to dissolve in the clear light of day, and images begin to pulsate. Apollinaire called Delaunay's Cubism "Orphic," alluding to the evocative characteristics of the composition that seem to offer a figurative reinterpretation of the myth of the harmony of the celestial spheres.

Right:
Robert Delaunay
Portuguese Still Life
1916, oil on canvas.
Marian von Castelberg Collection, Zurich.

Leading Figures *Robert Delaunay*

Oskar Kokoschka
(Pöchlarn 1886–1980 Villeneuve)

Oskar Kokoschka, 1909.

In Vienna, Kokoschka studied at the School of Applied Arts, drew and painted, and wrote plays and poems. Adolf Loos introduced him to the literary circle of Karl Kraus and Peter Attenberg. In 1909–10 he painted "psychological" portraits. *Murderer, the Hope of Women* (1910) was acclaimed as the first Expressionist play. The same year he moved to Berlin to become editor of the magazine *Der Sturm*, published by Herwarth Walden. He had his first solo exhibition in Paul Cassirer's gallery. He exhibited with the Blaue Reiter in 1912 and visited Italy in 1913 with Alma Mahler. In Venice he discovered the art of Tintoretto (Jacopo Robusti). A volunteer in the war, Kokoschka was seriously injured. He exhibited at Der Sturm in 1916 and a year later was in Dresden. He exhibited at the Dada gallery with Klee, Kandinsky, and Ernst. From 1919 to 1924 he taught at the Dresden Academy and from 1924 was in Paris. He spent 1933 in Vienna but then moved to Prague, London, and the U.S. He settled in Switzerland in 1947.

Oskar Kokoschka
Self-Portrait with Raised Brush
1913, oil on canvas.
Kunstsammlung Nordrhein-Westfalen, Düsseldorf.

In 1913–14 Kokoschka repeatedly returned to the theme of the self-portrait, often depicting himself nude and severe, and the ground inevitably dark. Here his face is ascetic, the figure lean, the tool of his trade in his raised right hand. Kokoschka seems to be conversing with El Greco and Tintoretto, whose work was known and admired in Expressionist circles: in addition, Derain's "Byzantine" self-portraits were not unfamiliar to him. In the years immediately preceding the war, communication between artists was as intense as their activity in promoting and organizing cultural events was fervid. At this time self-portraits were used to depict a facet of the artist, his figurative and poetic dimension: the refined image seen in the intimacy of the studio was only a façade.

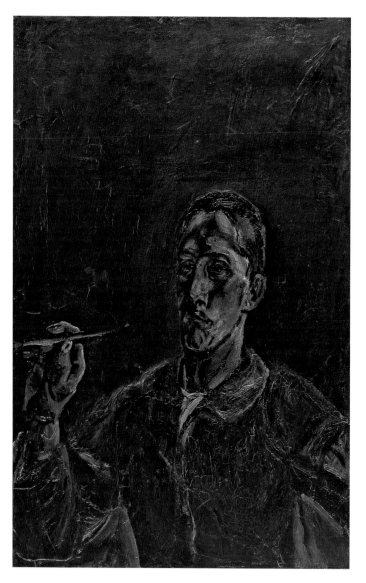

Juan Gris
(Madrid 1887–1927 Boulogne-sur-Seine)

In France from 1900, Gris began as a draftsman and caricaturist. He worked in Paris for the humor magazines *L'Assiette au Beurre* and *Le Charivari*. Close to Picasso at the Bateau-Lavoir, around 1910 he gave up illustration for painting. He produced his *Portrait of Picasso* (dated 1912), a painting by which he wished to be known as a Cubist. Irritated by this homage, Picasso distanced himself from his protégé. Gris's formal control, stylized elegance, and prevalently graphic skills make his work close to the "minor" Cubists Jean Metzinger and Albert Gleizes. He exhibited with the Section d'Or at the Galerie La Boëtie in October 1912. He used a set square, compass, and ruler and employed mathematical precepts. As he achieved success, he exhibited his Cubist collages and allowed Kahnweiler the exclusive right to sell his works (February 1913). After the war he also became a publicist for and theoretician of abstraction.

Juan Gris, c. 1924.

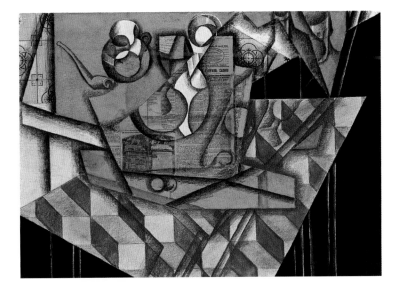

Above:
Juan Gris
Teacups
1914, collage, oils, and charcoal on canvas.
Kunstsammlung Nordrhein-Westfalen, Düsseldorf.

This composition is characterized by "simultaneous" views and deliberate fragmentariness. The view suddenly shifts between points, the objects seen either close together, as though in close-up, or farther apart. They are shown from above and below, frontally and with lateral cuts. Drawing, collage, and photography contribute to create the skillfully formed illusion, which is also both partially concealed and revealed. In imitation of Braque's and Picasso's wood and marble surfaces, Gris included a ceramic tile flooring. In his playful recreation of an interior through fragments, he demonstrated an interest in the applied arts.

Below:
Juan Gris
Composition with Violin
1915, collage, tempera and pencil on book cover. Sotheby's auction in London, November 30, 1993 (no. 18), formerly Pierre Berès Collection.

The poet Pierre Reverdy was one of Gris's friends during the years of World War I. The volume *Poèmes en Prose* was published on October 12, 1915: Juan Gris and Henri Laurens painted the cover of the first six copies.

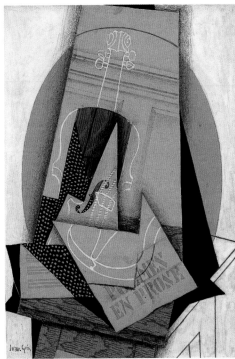

Nymphs, Amazons, and Bathers: Primitivist Nudes *en Plein Air*, 1907–09

When he saw the large nudes exhibited by Georges Braque at the Salon des Indépendants in 1908, Picasso was struck by the primitivist turn taken by an artist who was above all known for his Fauve landscapes, and was even "indignant" (according to Fernande Olivier) at his colleague. Picasso had known Braque for several years, and in November and December the two artists had spent a lot of time together exchanging ideas and thoughts. The period of their most intense collaboration had not yet begun—that would take place in the winter of 1908—but their mutual esteem and friendship were already established. Why then had Braque

kept secret his change in direction from the person who, in the opinion of most, had greatly contributed to it?

Between fall 1907 and winter 1908 Picasso was busy on physically strong, sculptural, primitivist female nudes, and it was these figures that had given Braque his proto-Cubist inspiration. In painting "dryads" and "bathers" (and in sculpting caryatids), Picasso was reacting with vigor to the disappointing response given his most ambitious painting, an allegory on the themes of the nude and painting that was to become known as *Les Demoiselles d'Avignon* (ill. on page 12). Its preparation and execution had taken him a long time but it had not achieved the recognition he had expected. Frequently placed in natural settings and painted in mono-

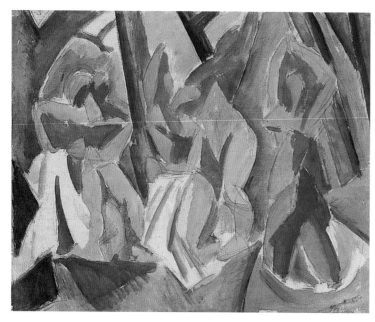

Pablo Picasso
Bathers in the Forest
spring 1908, watercolor
and pencil on paper,
mounted on canvas.
Hillman Periodicals
Fund, The Museum of
Modern Art, New York.

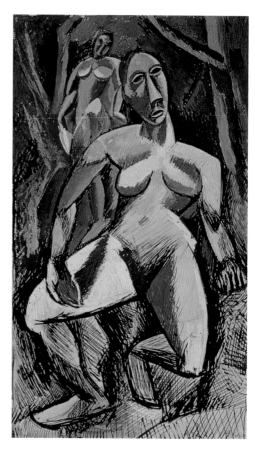

Pablo Picasso
Nude in the Forest (Dryad)
1908, tempera, ink,
and pencil on paper.

chrome, Picasso's female figures during his post-*Demoiselles* period reflect his discovery of African and Oceanic art in June 1907 during a visit to the Musée d'Ethnographie du Trocadéro. He carved the flesh out from their bodies, gave them the appearance of compact wooden idols, narrowed and reduced their limbs geometrically, made them androgynous-looking, and treated their faces like masks. Their eyes are shut, their expressions those of dreamers, closed and slightly melancholic. However, the compositions of Picasso's primitivist period are dominated—as are those of the bathers of Derain, Vlaminck, and Léger, and in later years by those of Marcel Duchamp—by considerations of a Cézanne (and post-Impressionist) nature or the relationship between

painting and sculpture. His fascination with "primitive" art faded away to be replaced by research and experimentation inherent in the tradition of Western art; an eclecticism prevailed in which certain themes were favored, for example Iberian sculpture from the Iron Age, Mozarabic miniatures, and Catalan Romanesque architecture, all of which could be interpreted as the artist's claim to an Iberian and even Catalan identity.

The compact nature of the *Three Figures under a Tree* is already established by the unusual square format of the composition: in the primitivistic reinterpretation of the theme of the bather or nymph, Picasso seems fascinated by the expressive possibilities offered by Cézanne's technique of *passage*.

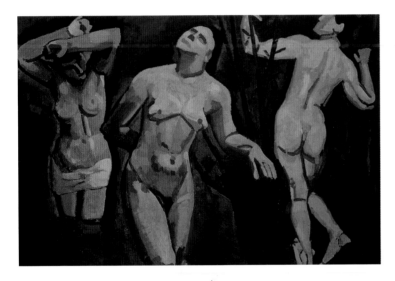

Above:
André Derain
Bathers
1907, oil on canvas.
The Museum of Modern
Art, New York.

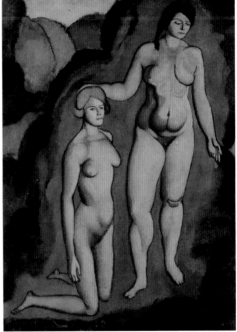

**Gabon or
Equatorial Guinea**
Fang Reliquary
unknown date, wood.

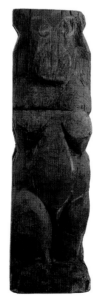

Left:
Pablo Picasso
Caryatid
1907, painted wood.
Musée Picasso, Paris.

Above:
Marcel Duchamp
The Bush, December
1910–January 1911, oil
on canvas.
Philadelphia Museum of
Art, Philadelphia.
The Louise and Walter
Arensberg Collection.

Traversed by light, the bodies appear to merge with one another, resulting in the creation of a dynamic device made of limbs and faces. A circular movement is given by the curved tree trunk in the middle ground and the breasts and shoulders of the three figures, the latter being merged by the design and "cut" a little like propellers. Picasso's works show a recurrent interest in visual devices and machines, and the notion of a work having an existence of its own is a constant theme. His compositions with bathers are the immediate result of his renewed familiarity with the oeuvre of Cézanne. We know that he was struck by the large retrospective of the recently deceased Cézanne at the 1907 Salon d'Automne. Picasso accentuated the contrapuntal movements of his figures and molded them into a sort of war dance. They seem to be influenced by Cézanne's late *Bathers*, with particular reference to the *Battle of Love* painted in the late 1870s, and Picasso is clearly attracted by the theme of conflict between the sexes. *Three Figures under a Tree* demonstrates his ability to assimilate the techniques and processes of others—in this case, *passage*—and adapt them to follow unexpected yet congenial, and, for the most part, visionary directions. Bordering on betrayal, Picasso's tributes to masters of the past almost seem caustic: it was not the delicate atmospheric or chromatic treatments in Cézanne's painting that attracted Picasso but the metamorphic magic of forms in constant conflict and transformation.

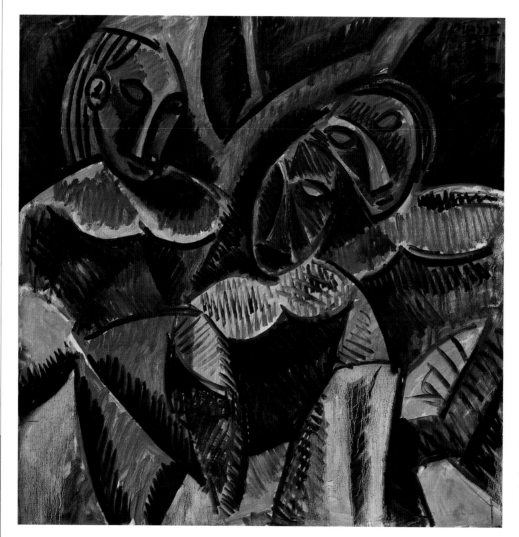

Paul Cézanne
Five Bathers
1885–87, oil on canvas.
Kunstmuseum,
Öffentliche
Kunstsammlung, Basel.

Pablo Picasso
Three Figures under a Tree
fall 1907, oil on canvas.
Musée Picasso, Paris.

Themes, Styles, and Movements *of the Historic Avant-Gardes*

Images and Words: Matisse, Braque, Picasso

Introduced by Braque into his compositions in the summer of 1909, even if very sporadically, the letters of the alphabet were given varied and organic use in the summer of 1911 when Picasso also took an interest. The two artists were spending the summer together at Céret, a village in French Catalonia, both working intensely. "Almost every evening," Picasso remembered, "Braque and I would visit the other's studio. Each had to see what the other had done during the day. We criticized each other's work. A canvas could not be considered finished until both of us had decided that it was."

At first painted by hand, to Braque letters seemed useful in a similar way to the painted nail in *Violin and Jug* of 1910: they provided another feature to involve the observer, they gave energy to static areas of the composition, and they also adapted well to the type of anti-naturalistic space that Braque was exploring. They are "forms that lie outside space," he claimed, "not subject to [perspectival] distortion, rhymes that echo other forms…rhythmic motifs that help to balance the composition and give it movement."

Later, traced onto the canvas with a stencil, the letters took on an independent poetical existence in both Braque's and Picasso's works, aiding in the definition of the research being undertaken and even providing comments on or

Above:
Pablo Picasso
Au bon Marché
1913, oil and pasted
paper on cardboard.
Ludwig Collection,
Aachen.

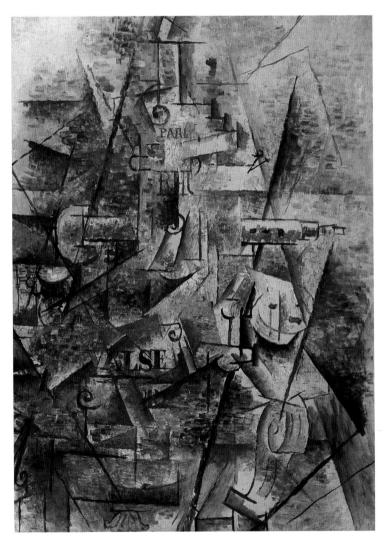

Georges Braque
*Clarinet and Bottle of
Rum on a Mantelpiece*
fall 1911, oil on canvas.
Tate Modern, London.

criticism of it. Whereas Braque included inscriptions that allude to the musical and nonreferential nature of the artist's works—such as "waltzes" or "J. S. Bach"—Picasso preferred to interpret his compositions as pages of a diary that hid private references: the image of a probable lover in *Ma Jolie* (first version), or travel notes in *Souvenir of Le Havre*. When their fragments did not refer to aspects of an immediately pictorial nature, Braque and especially Picasso made use of them as narrative "keys": full understanding of fragments of text in their paintings would only be possible for those—their friends and confidants—who understood the "keys" to the compositions, a code that was frequently erotic. In an attempt to shed light on cunningly encrypted

allusions and references, interpreters and art historians have often investigated the biographies of the two artists to search out significant events and relationships. And over the last few decades, a lively debate has ensued between those who argue the validity of the biography method and those who believe that the significance of a works lies purely within itself.

Perhaps it is possible to mediate between these two positions and assume a standpoint that takes both into account. There is no doubt that understanding a painting like *Ma Jolie* is enhanced by knowledge of some of the circumstances of Picasso's private life around winter 1911. At this time the artist was launching into a new sentimental

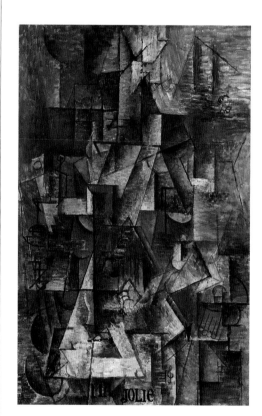

Pablo Picasso
Ma Jolie
(Woman with a Guitar)
winter 1911–12,
oil on canvas.
The Museum of Modern
Art, New York.
Acquired through the
Lillie P. Bliss Bequest.

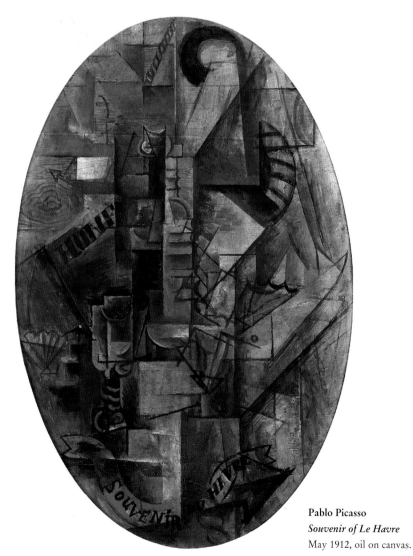

Pablo Picasso
Souvenir of Le Havre
May 1912, oil on canvas.

relationship that his partner of the time, Fernande, paradoxically helped to spark: when Fernande was attracted by a young Italian artist, Ubaldo Oppi, she made use of Marcelle Humbert to set up romantic trysts between Oppi and herself, but, when the young Marcelle was herself attracted to Picasso, she so ably played the role of Fernande's confidante that she managed to win the artist away from her friend. Without this background information, the insatiable curiosity shown by Gertrude Stein on leaving Picasso's studio would remain our own as well, as we would never have known that Marcelle was *Ma Jolie* ("My pretty one"). We would also have remained ignorant of the subtle psychological strains (irony, narcissism, lewdness) of the

elusive serenade Picasso was playing to his lover, and of his irresistible gaiety (Stein did not see the painting we know today by this name but by another painted around the same time that also included the words "Ma Jolie": *The Architect's Table*). It is also true that the inclusion of obscure techniques may suggest the use of correctives by artists who, like Braque and Picasso, do not wish to abandon the traditional narrative nature of a painting: newspaper headings, labels from liquor bottles, advertisements and private inscriptions such as "Ma Jolie" lend themselves wonderfully well to representing objects or figures, amplifying distant "echoes," as Braque admitted, and giving out "information." The inclusion of bits of text in Cubist compositions could also

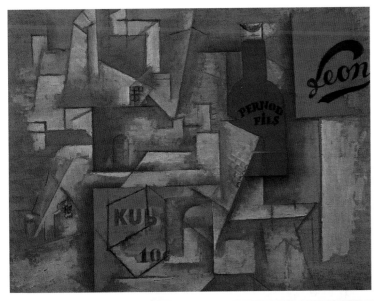

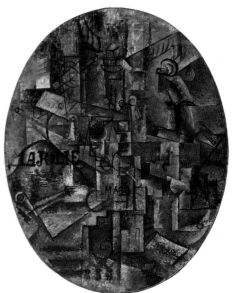

Above:
Pablo Picasso
Landscape with Posters
July 1912, oil on canvas.
National Museum of Art,
Osaka.

Left:
Pablo Picasso
Pipe and Musical Score
1914, oil and charcoal.
The Museum of Fine
Arts, Houston.
Gift of Mr. and Mrs.
McAshan.

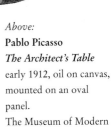

Above:
Pablo Picasso
The Architect's Table
early 1912, oil on canvas,
mounted on an oval
panel.
The Museum of Modern
Art, New York.
Gift of William S. Paley.

be explained on a purely formal basis, in which they make no reference to the everyday lives of the artists but instead have the purpose of rendering the practice of representation more complex (perhaps reflecting on the press or advertising). For instance, the insertion of a name or word can suggest a person or object that is not represented in the picture.

If we examine *Ma Jolie* closely, we might think that Picasso chose to invert the relationship that traditionally exists between a title and its image: he placed the title inside the frame and gave it paradoxical "figurative" functions. A curious exchange of gifts between Picasso and Matisse in the fall of 1907 (we take a quick step back in time here) allows an image to be considered from another point of view. In exchange for *Jug, Cup, and Lemon* of 1907, which Matisse wanted for his private collection, Picasso chose *Portrait of Marguerite*, a painting with, in addition to bright colors and rapid, spontaneous design, the name Marguerite written in the top left corner in large, uncertain letters. At the time Matisse made this portrait of his daughter, he was particularly interested in children's art (he collected the drawings made by his sons, Jean and Pierre) and reflected on the complex relationship between drawing, writing, and figurative arts. "I have to learn," he told an interviewer much later, "or perhaps relearn the way to make writing possible through lines and outlines; in the future, probably after us, a specific form of [figurative] litera-

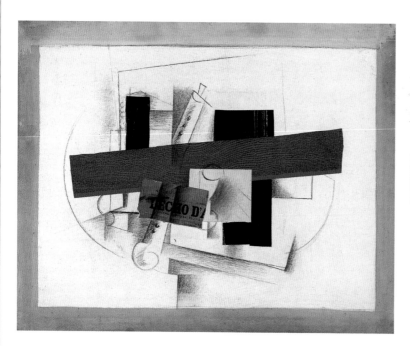

Georges Braque
Still Life with Tenora
(formerly known as The Clarinet)
summer 1913, pasted paper, oil, charcoal, chalk, and pencil on canvas.
The Museum of Modern Art, New York.
Nelson A. Rockefeller Bequest.

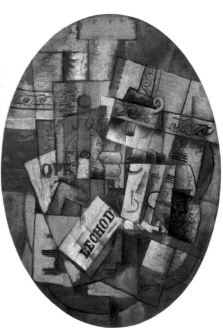

Georges Braque
Pedestal Table
fall 1913, oil on canvas.
Heinz Berggruen Collection, Geneva.

ture will come into being." The undifferentiated use of letters of the alphabet and figurative elements—a technique the master conceived from the example given him by children's art—exemplifies his attitude towards "expression" and emotional spontaneity linked with drawing.

Picasso became very fond of *Portrait of Marguerite:* a late photograph shows him looking for the right place to hang it on the walls of the Chateau Vauvenargues, by which time Matisse had been dead for four years. It is difficult to say what the painting might have meant to Picasso in the fall of 1907, during the months that followed the exhaustion and bitterness aroused in him by the painting and reception of the

Demoiselles d'Avignon: certainly the image of Marguerite—with the clear luminosity of the Sienese or Byzantine gold ground and the detached elegance of the model—offers an unusual contrast with the "monstrous" adolescents of Picasso. It is also possible that the written name immediately attracted the artist's attention though it brought no immediate consequences: to find an echo of it in *Ma Jolie*, five years were to pass. The two textual inclusions—included rather like cartouches in Picasso's paintings to evoke the emotional dimension of his private Eden—seem related. *Ma Jolie* might well be an erotic and slightly blasphemous parody of *Marguerite*, Matisse's chaste declaration of paternal love.

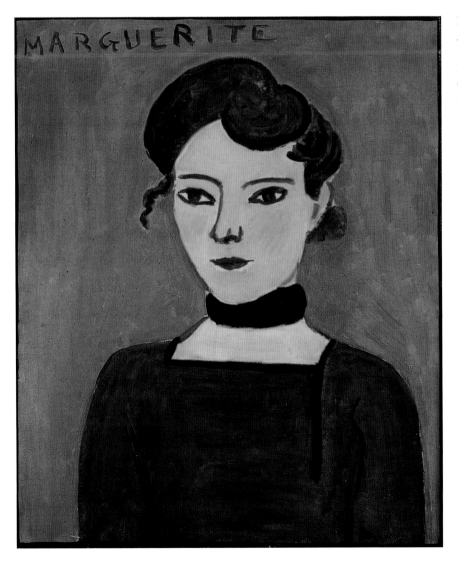

Henri Matisse
Portrait of Marguerite
1907, oil on canvas.
Musée Picasso, Paris
© Succession H.
Matisse/SIAE 2005.

A New "Hieroglyph": Der Blaue Reiter

Perhaps the most distinctive aspect of Der Blaue Reiter was the close connection its members established between the image and the word. As was the case with Marc and Klee, Kandinsky images—often intimately linked with literary, esoteric, or prophetic texts—were used to illustrate "spiritual" themes. It was Kandinsky who initiated this path, even though he was not to follow it as far as it could go. Beginning in 1911–12 his compositions often seemed to oscillate between pure painting and avant-garde communication.

"Perhaps," he wrote in *Concerning the Spiritual in Art*, "at the end of this newly born epoch, a new decoration will be come into being, not composed purely of geometric forms"; and went on, "a new decoration [will return to consider] natural forms and colors not as external data, but as symbols, almost hieroglyphs….But today," he concluded cautiously, "to attempt to create it would be like wishing to open a flower bud with one's fingers." Kandinsky completed his short treatise in 1909, and between 1911 and 1914 he decided to speed up the time until the "flower bud" opened and be more daring. He painted a series of large format compositions in which schematic and hypersimplified forms—"symbols, almost hieroglyphs"—were used to narrate episodes of resurrection, salvation from the waters, the killing of the dragon, and the Annunciation, as in ancient religious texts.

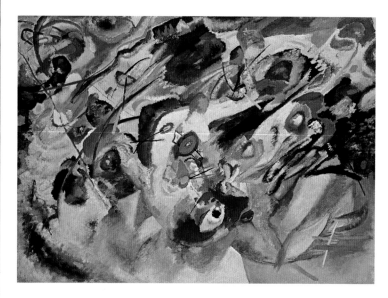

Wassily Kandinsky
Study for "Composition VII" (second version)
1913, oil on canvas.
Städtische Galerie im Lenbachhaus, Munich.

Wassily Kandinsky
Impression III (Concerto)
1911, oil on canvas.
Städtische Galerie im Lenbachhaus, Munich.

The passage to the "new decoration" referred to by Kandinsky seems to strike a chord with his archaeological and esoteric interests: it takes its cue from a remarkable comment made by Matisse that was adapted (and perhaps molded) to fit highly symbolic requirements: "The paintings of the Impressionists," he stated in 1909, "teem with contrasting sensations.... We want something else. We are aiming for serenity through the simplification of ideas and form." In giving his point of view on "linear writing," Matisse was relating with the "synthesist" experiences of Gauguin and Maurice Denis, but he believed that it was necessary either to subject these experiences to calmly considered revision, or to move beyond them. Denis's "theory of equivalences," or his theory of moods transposed into three-dimensional form, was valid from an ornamental standpoint, but the needs of Matisse, the painter of *Dance*, went beyond simple research into formal harmony to investigate "movement" and "expression." In Kandinsky's thinking, "linear writing" evolved in completely new idealist directions.

In 1913 Marc had the idea of inviting several artists close to him to illustrate the Bible. At his instigation Klee, Kubin, Kokoschka, and Kandinsky each chose a book to illustrate. The project, which never reached fruition, was also promotional in nature: accused of allowing eclectic and excessively cosmopolitan developments in its midst, the Blaue Reiter wished to show itself as the heir to the great German tradition of sacred illustration. But the project also had a deeper sense

Franz Marc
Pacification monogrammed work
1912, wood engraving.
Städtische Galerie im Lenbachhaus, Munich.

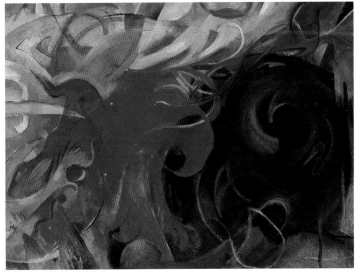

Franz Marc
War of Forms monogrammed work
1914, oil on canvas.
Staatsgalerie Moderner Kunst, Bayerische Staatsgemäldesammlungen, Munich.

connected with the difficulties of a form of writing through images: Marc referred to "a figurative dogmatism of the states of the spirit," by which he meant a repertoire of line and pure colors able to express moods and "spiritual" values without recourse to the representation of forms. His question was: In drawing and painting, is it possible to use a highly sophisticated and arbitrary system of notation similar to the one used in writing music? His last paintings—which were pretty much entirely abstract and full of symbolic references—and, even more so, his graphic works seem directed at giving a concrete answer to this question.

"I choose a point of origin from which to create formulas for man, animal, plant, stone and earth, fire, water, air and all the cosmic forces," wrote Klee in 1916, reflecting on the differences between himself and the "more human and passionate" Marc (the news of Marc's death on the battle-field had just reached him). Ever since the first post-Impressionist research, the alterations wrought by light on our perception of natural forms had attracted his interest, as a result of which he concluded that he should reduce figures and landscapes to "hieroglyphs." In his compositions on a journey in Tunisia he introduced a sort of private notation that alluded to experiences and memories that could not be translated into "figures" or communicated. It was only later, however, that he made use of letters of the alphabet and ideograms in their own right, almost developing the "figurative literature" of which Matisse spoke.

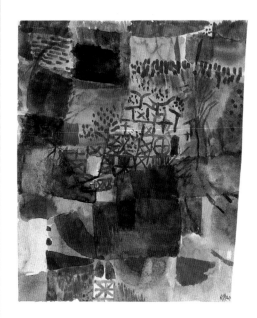

Paul Klee
Memory of a Garden
1914, watercolor on linen paper, mounted on cardboard.
Kunstsammlung Nordrhein-Westfalen, Düsseldorf.

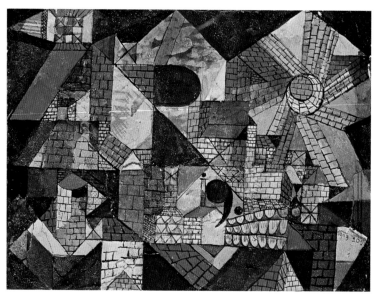

Paul Klee
City R
1919, watercolor on chalk, mounted on cardboard.
Städtische Galerie im Lenbachhaus, Munich.

Once Emerged from the Gray of the Night is a watercolor with words in place of figures, to be read like an ancient illuminated plate: the short poetic text describes the history of a star that waxes and wanes. Divided into triangles and squares that call to mind the compositions of Schiele (aerial views of cities on the Danube) and Delaunay, the colors suggest the cycle of warm light (at the center of the image) and cold light (at the bottom and top) of a normal day.

The "cosmic" theme of the composition was well suited to the notion of interior distance Klee developed during the war years. As a simple soldier he reacted with unease to the landscape of death and desolation. Macke died during the early months of the war, and the outbreak of hostilities quickly dispersed the community of artists, writers, and musicians who had come together as a result of the Blaue Reiter. Around 1916 the different tendencies that had merged in the Expressionist movement seemed obsolete. Klee wrote in 1916, "Unfortunately, I have to protest about the title [of the magazine *Der Sturm*] which is now outdated. On a cultural level, today world peace exists and our credo only seems a storm to the elderly."

The old world of patriarchal authority and privilege seemed to have crumbled, and with it also the chance for the artists to go back to their prewar roles of heroes or prophets of the "spiritual." The younger generation was soon to adopt irony, portray the horrors of the war crudely, and devote itself to political and social satire.

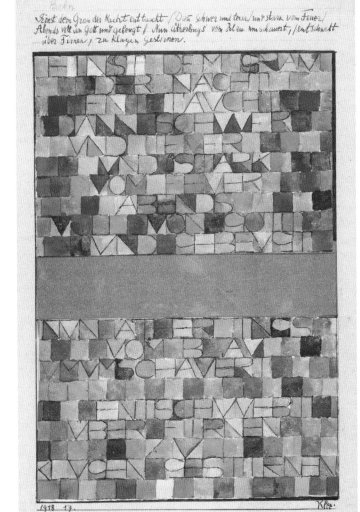

Above:
Christian Schad
Abstraction I
1918, wood engraving.

Left:
Hans Arp
Untitled
c. 1916, ink and pencil
on cardboard.

Left:
Paul Klee
*Once Emerged from
the Gray of the Night*
1918, watercolor on paper,
mounted on cardboard.
Kunstmuseum,
Paul Klee-Stiftung, Berne.

Themes, Styles, and Movements *of the Historic Avant-Gardes*

Between the Two Wars

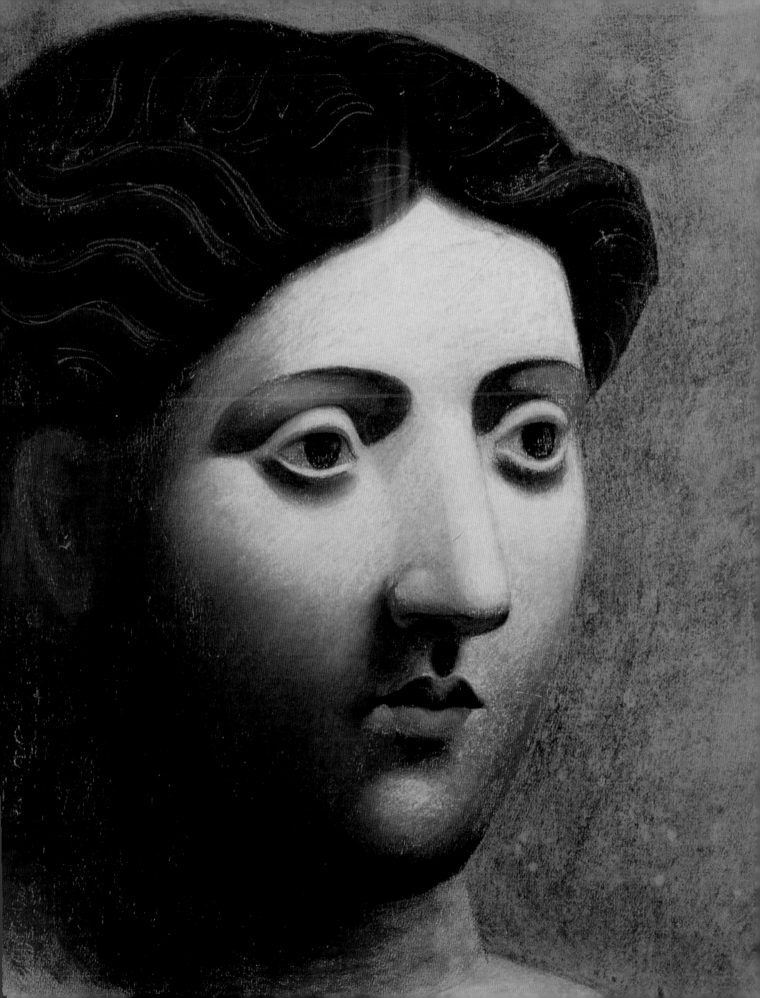

Philippe Soupault
Portrait of an Imbecile
1921, framed mirror,
exhibited at the Salon
Dada, June 1921.
Unknown location.

Far right:
Hugo Ball in the Role
of the Magic Bishop
at the Cabaret Voltaire
in Zurich
photograph taken June
23, 1916. Fondation Arp,
Clamart.

Bottom:
Aleksandr Rodchenko
Layout of the book
Conclusion *by Sergei*
Tretiakov, 1923.

Preceding page:
Pablo Picasso
Study of a Head for the
"Three Women at the
Fountain"
1921, pastel on
cardboard.
Fondation Beyeler, Basel.

Images, Industry, Politics, Revolutions

Set against the background of the cultural mockery of the Dadaists in the early Twenties (and also late Teens), as far as painting and sculpture were concerned the new decade quickly developed into one of cultural professionalism and reinforcement: artistic schools and trends were taken up by the market, and critical and historiographical assessment; meanwhile, cultural institutions, collectors, and art galleries strengthened their influences in both Europe and the United States.

There was significant continuity between the prewar experimentalism and the directions that achieved greatest international success in the period between the wars. Many of the technical innovations and new trends dated from 1914 at the latest, such as fragmentation of the object, abstraction, collage, installations, assemblages, and ready-mades. Postwar experimentalism shifted from the liberal to applied and industrial arts, and real innovation was seen in advertising and publishing graphics, art movies, photography, architecture, and monumental decoration. The

Above:

Anton Lavinskij
Battleship Potemkin
1926, movie poster.

Left:

Aleksandr Rodchenko
Books!
1925, reconstruction by
Varvara Rodchenko.

Between the Two Wars

Above:
George Grosz and
John Heartfield in front
of *Quartermaster
Heartfield Gone Wild*,
an "electromechanical"
sculpture by Vladimir
Tatlin, from the *Dada
Almanac*, Berlin 1920.
The caption reads, "Art is
dead. Long live the new
Tatlinian machine art."

Right:
Raoul Hausmann
The Art Critic
1919–20, collage.
Tate Modern, London.

Below:
Kurt Schwitters
*(With the Coffee
Grinder)*
1919, design for
postage stamp.
Marlborough
International Fine Art.

rejection of aesthetics and the ferociously parodistic use of museums—particularly through satirical pastiche—arose more decisively in revolutionary contexts: in Russia around and after 1917 and in Germany immediately after World War I. The desire of the Constructivists (with Dada elements) in Germany and Russia to play an active role in the tumultuous social changes taking place prompted even more moderate artists to aim their work at broader and different audiences, to reject the use of the easel and instead attempt themes and techniques typical of public art, such as frescoes and large decorative work: in other words, to "destroy idolatrous images" in the name of "authentic proletarian art." This was the uncompromising challenge thrown down by the radical painter Franz Seiwert.

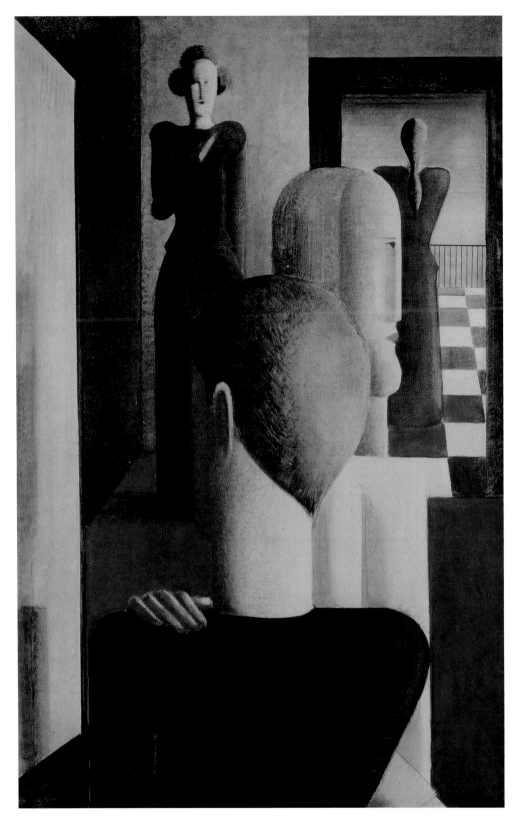

Above:
Franz Seiwert
The Workers
1920, oil on canvas.
Kunstmuseum,
Düsseldorf.

Left:
Oskar Schlemmer
Five Figures in Space
1925, tempera and oil on
canvas.
Öffentliche
Kunstsammlung, Basel.

Below:
Georg Scholz
Industrial Farmers
1920, oil and collage
on canvas.
Von der Heydt-Museum,
Wuppertal.

Between the Two Wars

Above:
Pablo Picasso
Woman with a Veil
1924, pencil on paper.
Rosengart Collection.

National Contexts: Mediterranean Myths, Nordic Realities

In ways that were quite independent of his actual thinking, the shift in the painting of Picasso—who in 1914 had already inventively explored Classical figuration—towards the painting of Ingres was generally welcomed in Paris, Rome, and Milan shortly before the outbreak of World War I. It happily complemented the proud proclamation of a "superior" Latin civilization, the reaffirmation of a Classical heritage founded on equanimity and harmony, and the myth of the "constructors" of a new social order. In the highly competitive art world of Paris, the marketing of nationalities was an important element throughout the second decade of the century, and the community of artists tended to revolve around

Above:
Amedeo Modigliani
Caryatid
c. 1911–12, oil on canvas.
Die Kunstsammlung
Nordrhein-Westfalen,
Düsseldorf.

Left:
Georges Braque
Female Nud
1925, pencil on paper.
Dessau Trust.

Facing page, top right:
Mario Sironi
The Pupi
1923–24, oil on canvas.

Facing page, bottom right:
Pablo Picasso
The Rape
1920, tempera on wood.
The Museum of Modern
Art, New York.
The Philip L. Goodwin
Collection.

Below:
Gino Severini
Still Life with Mandolin
c. 1920, tempera on paper.
Formerly Léonce
Rosenberg Collection.

national identities. Modigliani "the Italian" played the role of martyr for the Italiens de Paris, supported by the art critic Waldemar George. Catalans like Salvador Dalí and Joan Miró always played up their roots in the years before they made the move to Paris, and sometimes also afterwards, during their membership in the markedly internationalist Surrealist movement, situating their images in historical, social, and geographic settings through the use of stylistic archaisms, motifs, and painted texts. And among the Jewish artists of Paris who had a European or Eastern background, for example Marc Chagall, a tendency arose towards

Above:
Corrado Cagli
*The Little Girl
(Infancy of Giovanna)*
1934, encaustic tempera
on wood.

Far right:
Salvador Dalí
*Young Girl Seen
from Behind*
1925, oil on canvas.
Museo Nacional Centro
de Arte Reina Sofía,
Madrid.

Right:
Joan Miró
The Farm
1921–22, oil on canvas.
The National Gallery of
Art, Washington, D.C.

diasporic interpretation of avant-garde figurative research, with the inclusion of images, themes, and motifs that described cultural and geographic "homelands." The appeal for "order," requested by many, and the demand for a national cultural principle—whetted if possible by the passions aroused by the war—linked the second decade of the twentieth century with the debate in the early 1900s over neo-traditionalism in those countries sharing a Latin language and cultural background. In the early 1920s arguments that originated with the theoretician Maurice Denis achieved their greatest success in Milan among the artists of the Novecento, in Rome in the circle of the magazine *Valori Plastici* (close to the German-Roman painter Christian Schad), and even among the neo-Quattrocento painters of the Roman school who were ready to create fresco works (at the urging of the critic Roberto

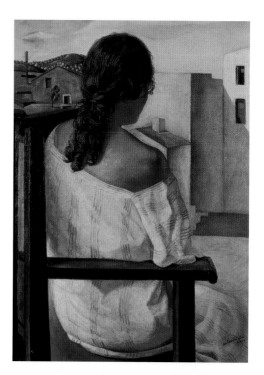

Above:
Marc Chagall
Feast Day (Rabbi with Lemon)
1914, oil on cardboard on canvas.
Die Kunstsammlung Nordrhein-Westfalen, Düsseldorf.

Left:
Franz Radziwill
The Fatal Fall of Karl Buchstätter
1928, oil on cardboard.
Museum Folkwang, Essen.

Longhi) typical of the Umbrian and Tuscan tradition, and *plein air* modern paintings. In Germany, where the economic and social consequences of the catastrophic war dramatically affected a large proportion of the population, the search for a northern tradition that had not been implicated in the destructive policies of the Prussian Reich induced Otto Dix to explore the German art of the period of the Reformation. Close to Dix in the 1920s, but from an increasingly distant ideological position, Franz Radziwill (an outstanding exponent of the Neue Sachlichkeit) investigated neo-Romantic stylism.

In the dense background of schools, movements and orthodoxies, such eccentrics as Chaïm Soutine, Jules Pascin, Filippo de Pisis and, partly, Gino Scipione stood out, set halfway

between the avant-garde and tradition, disinterested in programmatic and demanding theoretic formulations, but ready to adapt the naturalistic, Expressionistic, or neo-Baroque traditions of "touch painting" (and, in the case of the young Olga Carolrama from Turin, also watercolors) to the representation of private expression and the exploration of vulnerabilities and desires.

Franz Radziwill
Wehde Church in Frisia
1930, oil on wood.
Klaus Hüppe Collection, Oldenburg.

Above:
Carolrama
Appassionata
1940, watercolor
on cardboard.

Right:
Rudolf Schlichter
Fetishists and Flagellants
c. 1921, watercolor.

Below:
Otto Dix
Scene II, Murde
1922, watercolor.
Otto Dix Foundation,
Vaduz.

Facing page:
Julius Pascin
The Blue Shirt
signed 1929,
oil on canvas.
Musée du Petit Palais,
Geneva.

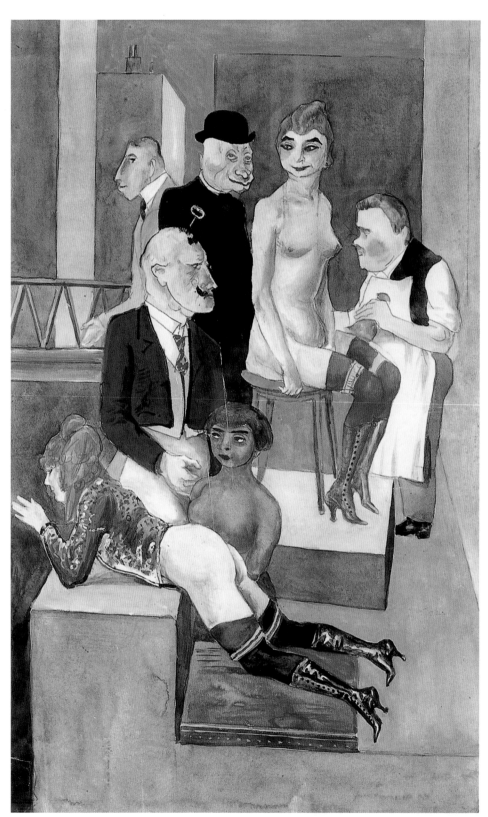

à Claire Goll
Pascin

Above:
Ivan Kliun
Red Light
(Spherical Composition)
c. 1923, oil on canvas.
The George Costakis
Collection (property
of Art Co. Ltd).

Right:
Georgia O'Keefe
Abstraction
1917, watercolor
on paper.
Mr. and Mrs. Gerald P.
Peters Collection.

Below:
Theo van Doesburg
Cosmic Sun
1915, pastel on cardboard.
J.P. Smid, Art Gallery
Monet, Amsterdam.

Art, Architecture, Communities: "Abstraction," Symbols, and Myths

The rapid international success of abstraction dated to the war and immediate postwar periods, when much of the generation involved in the conflict rejected cultural boldness. Considerations on the relations between art, architecture, and society characterized the debate on abstract art and granted a more lively presence to the growing theoretic and didactic formalization of the "spiritual." The most radical research by Kandinsky, Mondrian, Malevich, and Ivan Kliun took place between 1910 and 1915 and involved specific symbolic motifs from which architecture was initially unconnected. The notion of the cultural transformation of humanity, reflections on the modern city, and beliefs about the symbolic significance of buildings and even large decorative works, were variously present in the prewar works of the above artists, and all underlay a strong shift in disciplinary hierarchies

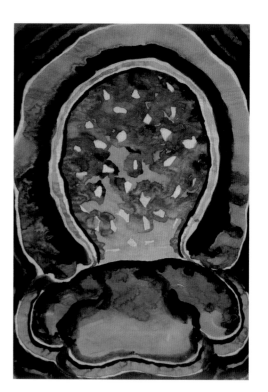

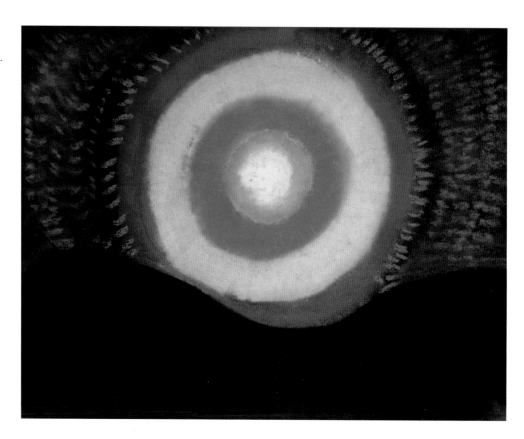

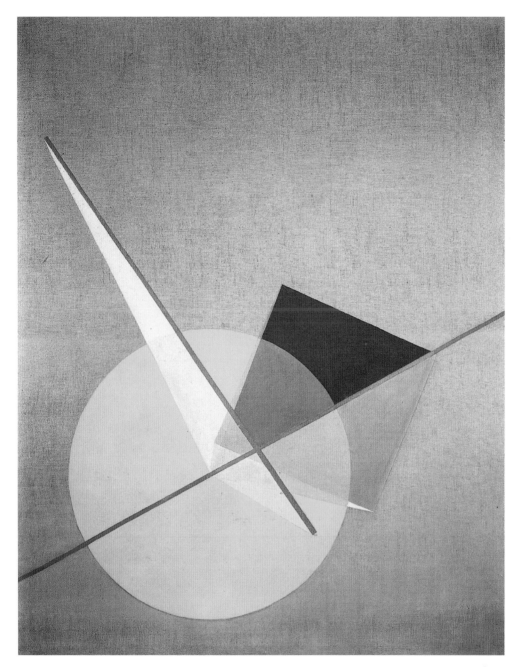

Above:
El Lissitzky
Proun R.V.N.2
1923, oil on canvas.
Sprengel Museum,
Hanover.

Left:
Laszlo Moholy-Nagy
Yellow Circle
1923, oil on canvas.
MacCrory Collection,
New York.

and interests. Metaphysical reflections on light became present in nonfigurative artistic research and architectural design in glass and crystal from around 1910, and the working collaboration between architects and city planners was made possible in the 1920s by joint morphological research and at least partly shared social and cultural objectives. For example, nonfigurative compositions and theories of form developed in painting and sculpture contributed importantly to the development of a rationalistic aesthetic of the project.

With regard to more narrative works, the passage from Dadaism to Surrealism was made possible primarily by a renewed openness to symbols and individual or collective myths. The

Hannah Höch
High Finance
1923, photomontage
with collage.
Galerie Berinson, Berlin.

aim of early Surrealism, outlined by the young André Breton and summarized by the proposal to combine Marx and Rimbaud, was a rare, clearly stated document of radical cultural arguments that were neither simply iconoclastic nor populist. Members of the avant-garde circles of Paris were undoubtedly annoyed by the aristocratic visits of the "Mediterranean" Picasso and the completely new favor that contemporary art received among high society, but the desire to turn the page was in the air around 1922. "Dada is old," wrote Francis Picabia in 1922, who had until then been considered the leader of the movement in the French capital, and, for somewhat atypical Dadaists like Hans Arp and Max Ernst, there existed playful, reflexive, and ritual dimensions of art that could not be sacrificed to political satire.

New Objectivity

Furthermore, a responsibility of which artists and writers are very much aware is that of giving complete representations of their time, creating narratives that amplify and explain, and becoming "primitives of a new sensibility." This sort of nonideological, artistic militancy arises from the aim of conferring cognitive utility on art, and involving it directly in the documentation of contemporary historic and social changes. In Germany the prewar legacy of Futurism, which was launched in Berlin by a famous exhibition in the Der Sturm gallery and considered in terms of the "painting of reality," contributed—together with the success of de Chirico in Dada circles and broad awareness of the paintings of Rousseau, Derain, and Chagall—to research whose aim was innovation in the documentary and narrative aspects of the artist's work, and not in technique or style. These, on the other hand—from choice and in ways often provocatively eclectic, retro, or "post-historic"—remained within deceivingly traditional dimensions.

Whereas for artists, critics, and theoreticians of the Neue Sachlichkeit the figurative arts were called upon occasionally to compete with the

practical sciences, the naturalist novel, and reportage at the level of attention paid to historic and psychological reality, photography made a decisive contribution to the classification of human "types," and the examination of the contemporary social landscape. In the most memorable cases, the images seemed to offer

both documentary impassibility and "bewildered contemplation of detail," to quote Walter Benjamin. The resulting narration was both factual and hyperbolic, distancing and visionary. For the Expressionist Kandinsky, the "great realism" exemplified by Douanier Rousseau was a means to attain the "spiritual."

In territories contiguous to Neue Sachlichkeit, which rapidly also became established outside the area represented by Germanic culture and language, artists were active as they oscillated between magic realism and figurative surrealism, for example in Belgium and Holland and countries with a Spanish linguistic and cultural background. Their preferred themes were human drives, nightmares, and premonitions. In the United States, particularly with the work of Charles Sheeler, a purist version took root based around objects typical of the 1920s. Their images typically featured clear northern light and meticulously detailed celebrations of American technology, industry, and society.

Rudolf Dischinger
Gramophone, detail
1930, oil on plywood.
Museum für Neue Kunst,
Städtische Museen
Freiburg, Freiburg.

Charles Sheeler
Classical Landscape
1931, oil on canvas.
Collection of the Mr. and
Mrs. Barney A. Ebsworth
Foundation, Saint Louis.

Masquerades and Archetypes

The Dada evenings in costumes and "primitive" masks were in part artistic performances and in part cabaret turns or charades. Tristan Tzara seemed to attribute too much to their original meaning when he wrote, decades later, "the art of 'primitive' peoples was an integral part of social and religious functions: it was a key manifestation of the life of a community. Dada wanted to create a form of art and poetry that came very close to the life of traditional cultural activities, manifestations of intellect and will." Awareness and understanding of Oceanic, African, pre-Columbian and Inuit art became more widespread only gradually during the 1920s: around the end of the decade avant-garde art incorporated texts of depth psychology (Freud), ethnographic art catalogues, and treatises on ethnography and anthropology (Mauss, Frazer, and Lévy-Bruhl). The clear awareness of an uncrossable social, historical, and cultural gap—"We have nothing in common with regard to art, metaphysics, ways of living," Masson claimed retrospectively in 1950—was pervasive, as was familiarity with collections of ethnographic art that suggested new directions, such as social and biological references to psychology- and gender-based viewpoints, using recent techniques such as assemblages, ready-mades, and installations. Picasso made a decisive contribution to the creation of the myth of the artist's studio as a magical and primitivistic place with the sacrifice of the model in his atelier, serving himself her nudity and in some way feeding on her in his production of ironic or macabre contemporary "fetishes." "Painting is not an aesthetic process," he stated when remembering his famous visit as a young man to the Trocadéro. "It is a sort of magic placed between the hostile universe and ourselves, a means to acquire power over our fears and desires." (The conviction that long underlay studies of the history of contemporary art and in part even artistic research, i.e., the belief that, from the 1920s to the 1950s, the line of separation ran between "figurative" and "nonfigurative," seemed to fall short of the original historical definition: for the most part there were no "abstractions" but distinct narrations, hidden images, and metaphors. "I always try to detach my gaze from reality," Picasso declared. "What I aim for is affinity—a deep affinity, more real than reality.")

Marcel Janco
Invitation to a
Dada Soirée
1916, charcoal.
Kunsthaus, Graphische
Sammlung, Zurich.

Below left:
Marcel Janco
Mask
1919, paper, cardboard,
mixed media, gouache,
and pastel. Centre
Georges Pompidou,
Musée National d'Art
Moderne, Paris.

Below right:
Meret Oppenheim
My Nurse
1936, mixed media.
Moderna Museet,
Stockholm.

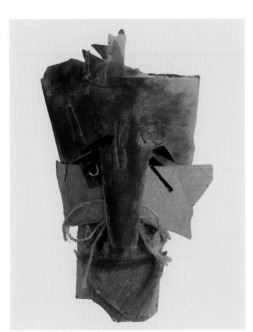

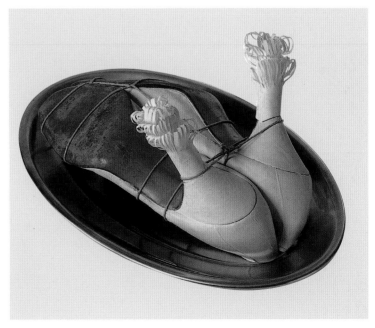

Frida Kahlo
*Self-Portrait
with Monkey*
1938, oil on canvas.
Albright-Knox Art
Gallery, Buffalo.

Joseph Cornell
*A Dressing Room
for Gilles*
1939, mixed media.
Richard L. Feigen,
New York.

Salvador Dalí,
*The Enigma of
William Tell*
1933, oil on canvas.
Moderna Museet,
Stockholm.

The exploration of "disturbing" psychological and psychiatric realms, such as the connections between eroticism and violence, the obscure depths of organic processes, and the atavisms or processes of scission of the ego, could not be closely connected to understanding of "primitive" art—it also drew its impulse from artists who showed no interest in it. However, the existence and accessibility of non-Western aesthetics turned out to be surprisingly valuable on the plane of history painting when, during the late 1930s, at the height of the power of the European dictatorships, and at the time of greatest persecution by police and the law, bloody civil wars and illegitimate territorial annexation, many artists involved in various ways with the Surrealist movement (and, shortly after, Picasso with his *Guernica*, begun on May 1, 1937, following the German bombing of the Spanish village on April 26) evoked the horror of totalitarianism by attributing to it forms of ethnographic idols.

Left:
Hans Bellmer
The Doll
1938, mixed media.

Below:
Pablo Picasso
Reclining Nude
1938, oil on canvas.
Marina Picasso
Collection, Galerie Jan
Krugier-Ditesheim,
Geneva.

Facing page:
Pablo Picasso
*Silhouette of Picasso and
Young Girl Crying*
1928–29, oil on canvas.
Musée Picasso, Paris.

Page 71:
Oscar Domínguez
Electrosexual Machine
1934, oil on canvas.

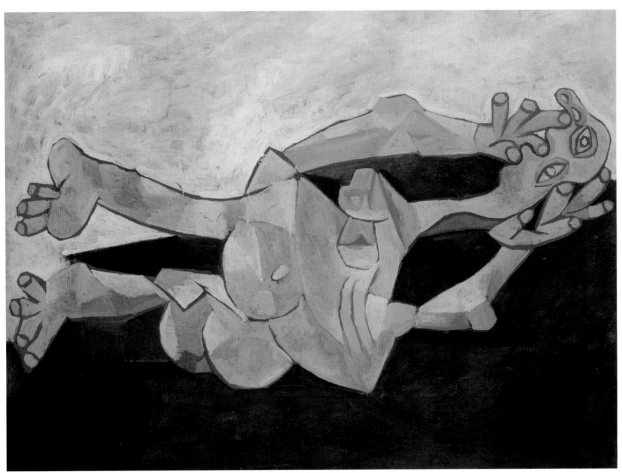

Piet Mondrian, 1907.

Piet Mondrian
(Amersfoot 1872–1944 New York)

Mondrian studied at the Academy of Fine Arts in Amsterdam. In 1901 he visited Spain and painted regional landscapes. From 1905 he was in Amsterdam where he experimented with post-Impressionist techniques and styles. He was close to Jan Toorop. He exhibited at the Stedelijk Museum. In 1911 he moved to Paris and frequented Cubist and Orphic circles. Beginning around 1912–14 he exhibited at the Salon des Indépendants. When war broke out he returned to Holland. He began working with Theo van Doesburg and Bart van der Leck in 1915. In 1917 he was a founding member of the De Stijl group and wrote for their magazine until 1924. He returned to Paris in 1919 and a year later Léonce Rosenberg published his essay "Neoplasticism." In 1924 he exhibited at the De Stijl show put on by Rosenberg. "Neoplasticism" was translated into German and published in the Bauhaus series of books. Mondrian was a member of Cercle et Carré and Abstraction-Création but left Paris for London in 1938. He moved to New York in 1940.

Piet Mondrian
Church in Domburg
1910–11, oil on canvas.
Gemeentemuseum,
The Hague.

In a letter to Jan Toorop written in the fall of 1910, Mondrian set out his "spiritual" orientation and the "theosophic" notion of the combination of art and initiation. With its severe verticality, the ancient Romanesque bell tower was a symbol that the artist imbued with the significance of his artistic activities: he alluded to the breaking of illusion, and the manifestation of the "most delicate regions" of experience. He wrote that only "the most receptive," those who evolve through discipline and "introspection," achieve perception.

Piet Mondrian
Evolution
1910–11, part of a triptych, oil on canvas.
Gemeentemuseum, The Hague.

Piet Mondrian
Composition 3
1917, oil on canvas.
Museum Boymans-van
Beuningen, Rotterdam.

The arrangement of the
colored squares on the
surface of the painting
seems an overture to their
gradual thinning out and
fading away. A white
space has been created at
the center to suggest
effects of movement. The
individual elements of
the composition, and the
composition itself, are
"form" and symbol: the
kaleidoscopic world of
tangible reality and color
elusively fades, benefiting
the diaphanous luminos-
ity of vision.

Piet Mondrian
Composition 1
1925, oil on canvas.
Kunsthaus, Zurich.

During the 1920s Mondrian set further strictures on his compositions, whose ritual
nature was already clear in the indifference the artist showed to obvious innovations
and modifications: in his view, variation is a subtle art that connects rather than sep-
arates. Alterations assist in changing our ways of perceiving the painting; Mondrian
experimented with new formats (for example, upended squares). Each composition is
an individual moment or episode in an interior process of meditation and self-collection.
The only compositional elements that he permits are vertical and horizontal lines, three
primary colors (red, blue, yellow), and three non-colors (white, black, gray). The
fragmentary character of *Composition 1* is signaled by slight irregularities and asymme-
tries: the right angle on the left is cut off at its juncture, the thickness of the black vertical
lines is not uniform, a small yellow quadrilateral in the bottom left just announces its
presence in the field of vision. The interior experience that inspired the painting, which
in some way demands both the painting's existence and nature, cannot be translated
into forms and colors: it remains extraneous to the painting, precedes it but also goes
beyond it. At most it coincides with life, is uncontainable and continuous—it is pure
time, flow, "duration." The frame or outer edge of the painting is a conventional
delimitation, in some ways inappropriate.

Constantin Brancusi
Photographic Self-Portrait in the Study, detail, Paris 1933–34, photo Brancusi 717.

Constantin Brancusi
(Pestisani Gorj, Romania 1876–1957 Paris)

Brancusi went to Bucharest in 1898 to study sculpture, then to Munich, Zurich, and Basel before arriving in Paris in 1904. He exhibited at the Salon de Société Nationale des Beaux-Arts in 1907 and attracted the attention of Auguste Rodin. In 1909 he met Modigliani and often visited Rousseau. In 1912 he took part in the Cubist exhibition at the Salon des Indépendants, then at the Armory Show in New York in 1913. He was a friend of Marcel Duchamp, Pierre Roche, and Erik Satie. At the Salon des Indépendants of 1920, he was accused of exhibiting pornography. Katharine Dreier and Duchamp invited him to New York, and Ezra Pound wrote about him. Brancusi visited the U.S. in 1925 and 1928, and India in 1933 at the invitation of the Maharajah of Indore to build a meditation temple. In 1936 he provided six works at MoMA for the exhibition Cubism and Abstract Art. His solo exhibition at the New York Guggenheim in 1956 consecrated him among the "classics of the modern age."

Constantin Brancusi
Sleeping Muse
1910, bronze.
The Metropolitan Museum of Art, New York, Alfred Stieglitz Collection.

This work, of which ten versions exist, has several sources: ancient Romanian and Eastern sculpture, and an engraving of a decapitation by Redon. His interest in "the essence of things" prompted Brancusi to simplify and reduce. At the origin of his *Sleeping Muse* is a bust dedicated to Baroness Renée Franchon, one of his favorite models. The ambivalent relationship between the young sculptor and Parisian aristocrat does not seem to have existed outside the prolonged work of compositional sublimation: references to feminine sensuality are progressively eliminated and the drowsy figure exudes vulnerability.

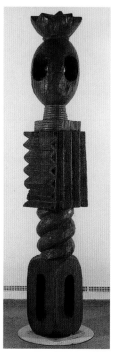

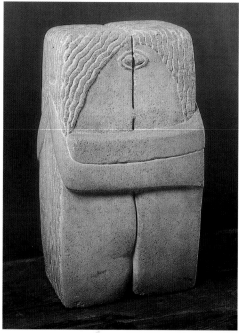

Left:
Constantin Brancusi
King of Kings
late 1930s, wood.
Salomon R. Guggenheim Museum, New York.

Top right:
Constantin Brancusi
The Kiss
1916, limestone.
Philadelphia Museum of Art, Philadelphia.
Louise and Walter Arensberg Collection.

With *The Kiss* (first version made in 1908) Brancusi produced a vigorous but essential sculpture, one elementary and, so to speak, illiterate, to be considered necessarily from frontal and lateral viewpoints. It rejects the self-assured, neo-manneristic elegance of Salon sculpture, which is conceived in terms of "movement," preferring to invite the observer to move around it. It is also free of the dominating influences of Michelangelo and Rodin, who were so admired at the time: it remains untouched by the "magniloquence" and sensuality of their works.

Kazimir Malevich
(Kiev 1878–1935 Saint Petersburg)

Kazimir Malevich at Kursk,
c. 1900.

In 1904 and 1905 Malevich painted *en plein air*. In 1908 he took part in the Symbolist exhibition of the Blue Rose group. In contact with Mikhail Larionov, in 1910 he exhibited at the Jack of Diamonds show. In 1912 he participated in the second Blaue Reiter exhibition. In 1913 he participated in the congress of Futurist poets in Uusikirkko, Finland. He designed the sets for *Victory Over the Sun*, an opera with music by Mikhail Matyushin. In 1915 he published "From Cubism to Suprematism." In 1917–18 he worked for the People's Education Committee, then moved to Saint Petersburg in 1918 but returned to Moscow a year later. He split from Vladimir Tatlina and the Constructivists. From 1919 to 1922 he taught in Vitebsk at the Popular Art School run by Chagall. Malevich then returned to Saint Petersburg and taught at the State Institute of Artistic Culture. In 1927 he visited Warsaw and Berlin. In 1930 he was arrested, accused of producing counter-revolutionary works.

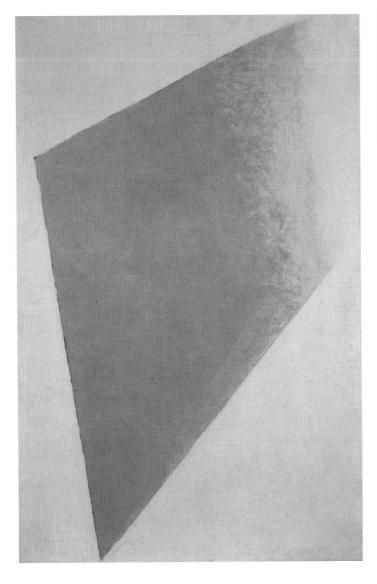

Kazimir Malevich
Red Square
1914, oil on canvas.
State Russian Museum,
Saint Petersburg.

Kazimir Malevich
Suprematist Composition
1917–18, oil on canvas.
Stedelijk Museum, Amsterdam.

Malevich's first reflections on the "fourth dimension" (an extrasensory reality that only art, music, and poetry could touch on) date to the two years of his most intense avant-garde experimentation: 1912–13. However, the "fourth dimension" was discussed not only in Moscow and Saint Petersburg: "Orphists" and "spirituals" in Paris and Munich conducted research related to going beyond the visible. Malevich's ideas of "supreme" forms were often associated with brief descriptions of a simplified and transfigured reality. Thus his *Red Square* (from the second phase of Suprematism) was presented in Saint Petersburg in 1915 at the Last Futurist Exhibition 0.10 as "pictorial realism of a two-dimensional peasant." For Malevich Suprematist compositions retained a symbolic and narrative dimension even when they were presented in the most radically nonfigurative terms.

Francis Picabia
(Paris 1879–1953)

Picabia studied at the École des Arts Décoratifs and during 1902–03 created Impressionist paintings. From 1903 he exhibited at the Salons des Indépendants and d'Automne, and he had his first solo show in 1905 at the Galerie Haussmann. He began experimenting with avant-garde techniques and styles in 1908. In 1911 he met Apollinaire and Duchamp. In 1913 he exhibited at the Armory Show in New York and had a solo exhibition in Alfred Stieglitz's gallery. From 1915 he produced mechanical drawings with grotesque backgrounds. In 1917 Picabia published his first book of poetry and launched the magazine *391*. Close to the Dadaists in Paris and Zurich, he distanced himself from the movement in 1921, shortly before returning to a figurative style. In 1922 he left Paris for Tremblay-sur-Mauldre and two years later broke with André Breton. In 1935 he exhibited in Chicago but without success; the catalogue contains a poem by his friend Gertrude Stein. He returned to Paris at the end of World War II.

Francis Picabia, *La Veuve Joyeuse*, detail with photograph of the artist, 1921, oil, photograph, and paper glued on canvas.

Francis Picabia
Parade Amoureuse
1918 (inscribed "1917"),
oil on cardboard.
The Morton G. Neumann
Family Collection.

The sources of the image above were contemporary reproductions of mechanical and electric devices. Picabia made fun of the "eternal" values associated with love and family by reducing the attraction between the sexes to an obtuse, compulsive process.

Francis Picabia
Animal Tamer
1923 (inscribed "1937"),
enamel on canvas.
Centre Georges
Pompidou, Musée
National d'Art Moderne,
Paris.

In 1922–23 Picabia painted surprising and ambiguous images. Here he used a type of industrial paint and three- or four-color techniques to create a poster-like image. The painting seems like an industrial, mechanical, mass-produced image, but at the same time it comments ironically on the linear qualities and elegance of "French design" that returned to fashion following Picasso's shift in the direction of Ingres. However, Picabia was not simply satirizing museum art and "good taste"—on the contrary, his works marked a move away from the radical aspects of Dadaism.

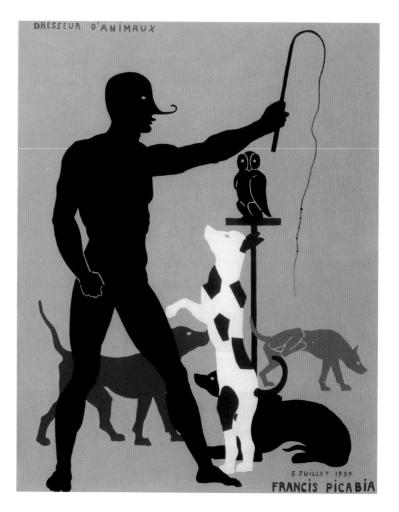

Felice Casorati
(Novara 1886–1963 Turin)

Felice Casorati in his studio,
1950s.

As early as the 1907 Venice Biennial the young Casorati showed a fondness for Mitteleuropean figurative tendencies, Austrian in particular, with extreme attention to detail, well-defined, cutting design, a modest propensity for enigma, two-dimensional simplification, and a refined, though garish, use of color. Having moved to Turin at the end of the war, he frequented the progressive and liberal circles of the city. In 1923 Piero Gobetti wrote a monograph on the artist. His art developed along metaphysical lines, and, like de Chirico, he wished to be a "painter of ideas" rather than motifs. Later he moved towards moderately archaizing classicism, with soft, broad blocks of color, posed and solemn forms, and a partiality for flesh tones and insertions of pure color.

Felice Casorati
The Puppets
signed and dated 1914
oil on canvas.

Four string puppets stand out against a dark background in a puppet theater. Painted rather like silhouettes, without any interest in depth, their only defining characteristics are their costumes and heavily made-up faces. The puppet theater is awaiting someone to come and bring the puppets to life; it awaits the director of the show, the puppet-master, a young child. Here Casorati established a subtle set of analogies and comparisons between painting and puppetry.

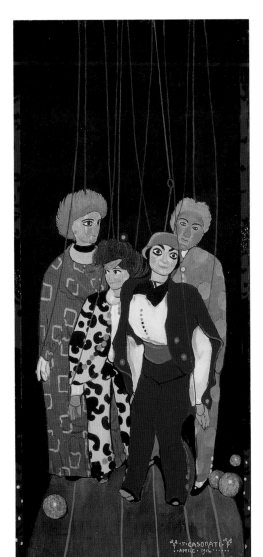

Felice Casorati
Daphne at Pavarolo
1934, oil on plywood.

The model is set against the backdrop of the countryside of Piedmont in a complex composition that modifies the actual landscape into a simulation of surfaces, endowing a two-dimensional quality to the surround: left, right, and behind. The model is portrayed as a statue in aesthetically pure forms, with an elongated cylindrical neck, her arms closed to form a mandorla (an ancient symbol with two overlapping circles), and her figure placed in a simple solid, whether cubic or parallelogram.

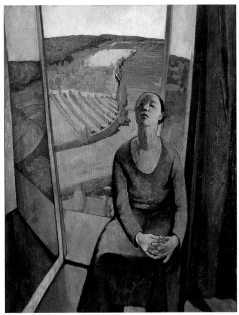

Chaim Soutine, 1916.

Chaim Soutine
(Smilovich 1893–1943 Paris)

The tenth of eleven children in a Lithuanian family of Jewish descent, Soutine studied at the Academy of Fine Arts in Vilnius from 1910 to 1913. He then moved to Paris to attend the École des Beaux-Arts and the studio of Fernand Cormon. He was in contact with Chagall and Modigliani; the latter painted his portrait. At the Louvre he admired Rembrandt, Chardin, and Courbet. In 1920 the American collector Albert Barnes bought a large number of his paintings. Soutine painted still lifes, landscapes, and portraits, mostly of the young living on the edges of society: altar boys, errand boys, waiters, etc. Forced to leave Paris by the German invasion, he lived in poverty, uncertainty, and mental instability. He returned to Paris in 1943 for surgery and died a few weeks before the Liberation.

Chaim Soutine
The Pastrycook's Boy
c. 1922, oil on canvas.
Albert C. Barnes
Foundation, Merion.

Chaim Soutine
Gladioli
1918–19, oil on canvas.
Musée de l'Orangerie, Paris.

The vase is made smaller and moved towards the bottom right corner so that the flowers can fill the center of the composition. The stems and flowers are aligned rhythmically like a series of flagpoles being raised. Inspired by the work of Courbet, Van Gogh, and the Fauvists, and particularly the early paintings of Cézanne, Soutine discovered a naturalism, both lyrical and grotesque, often humorously vernacular in his narration. He made

use of thick, dull-colored backgrounds that contrasted with the brilliant red-oranges and off-whites of his motif. His paintings are idiosyncratic and inventively "irregular." During Impressionism's period of greatest success—which was "discovered" and turned into a national school of art—Soutine returned to the origins of the modern French tradition, to a time when the elegant conventions of *plein air* were not binding. He used luminous, brilliant colors, blue shadows, and delicate, closely packed brushstrokes. In *Gladioli* the strokes are irregular, rapid, and heavily loaded with color. They remain visible on the canvas like the elements of a frenetic and excited cursive script.

Max Beckmann
(Leipzig 1884–1950 New York)

Max Beckmann, *Self-Portrait in Tuxedo*, detail, 1927, oil on canvas. The Busch-Reisinger Museum, Harvard University Art Museums, Association Fund.

Beckmann studied at Weimar Art School and in 1903–04 made trips to Paris. He then moved to Berlin and in 1905 became part of the Secession. He stayed at Villa Romana in Florence in 1906. His first solo exhibition was mounted by Paul Cassirer in 1913. The next year he volunteered for the army and entered the health service; he drew and made watercolors. Following a mental breakdown as a result of what he saw in the hospital, he was discharged in 1915. His painting became more engaging and dramatic, though never animated. Having turned down a teaching post at Weimar, from 1925 he taught at the School of Applied Arts in Frankfurt. He had a large retrospective in 1928 in Mannheim, another in Basel in 1930, and a third in Paris in 1931. He exhibited at the Venice Biennial in 1932. The Nazi administration, who considered his art degenerate, fired Beckmann from his post by in 1933. He moved to Paris and Amsterdam. In 1948 he went to the U.S., where he was feted until his death two years later.

Max Beckmann
Rugby Players
1929, oil on canvas.
Wilhelm Lehmbruck
Museum, Duisburg.

Right:
Max Beckmann
Man and Woman
1932, oil on canvas.
Private collection, Zurich.

In 1932 Beckmann was at the height of his career. Retrospective exhibitions, museum purchases, and participation at the Venice Biennial were the flattering rewards for his work. *Man and Woman*, which the artist also referred to as *Adam and Eve*, was greeted as the start of a "new classicism." The two nudes are placed in a timeless landscape, devoid of architectural or sartorial clues. Their forms are severe and monumental, with the man's body reminiscent of archaic Greek *kouroi*, and the woman's of Romanesque art. Their postures and the vegetation are suggestive of sexuality: the woman lies on the ground, the man turns his back on her as he walks away. A reader of psychoanalytical texts, Beckmann with this work began a series of works related to myth. This choice seems to reflect his need to distance himself from the outside world, in part because of the threats made against him by the Nazi press.

Mario Sironi, 1950s.

Mario Sironi
(Sassari 1885–1961 Milan)

After graduating in engineering at Rome University, Sironi studied at the Academy and was a frequent visitor, with Boccioni and Severini, at the studio of Giacomo Balla. He undertook a Divisionist and Futurist apprenticeship, displaying a cutting, caustic talent that allowed him to earn a living as an illustrator during and after the war. With the Novecento movement, Sironi became a protagonist of traditional and severely constructive plasticism to the point where he refused to incorporate narrative dimensions or visually pleasing elements in his paintings. His compositions were of refined solemnity and took on didactic-allegorical tones, even to the point of exhortation. Although he later relaxed his manner, his work continued along the same lines as de Chirico's *Piazze d'Italia*, that is to say, his paintings were comments on Italy's historical and social condition, within which the artist performed his activity.

Mario Sironi
Solitude
1926, oil on canvas.
Galleria Nazionale d'Arte
Moderna, Rome.

Sironi's production between the two wars fell broadly into three categories: female nudes, compositions on the theme of work, and urban landscapes. The female nudes, like this painting, *Solitude*, should not be considered erotic. Rather, they are exercises in one of painting's leading genres, in which the nude figure is conceived less as the revelation of a body than as a figurative discourse on the purpose of aesthetic activities: in Sironi's opinion, this purpose was beauty united with morality, or "demure beauty."

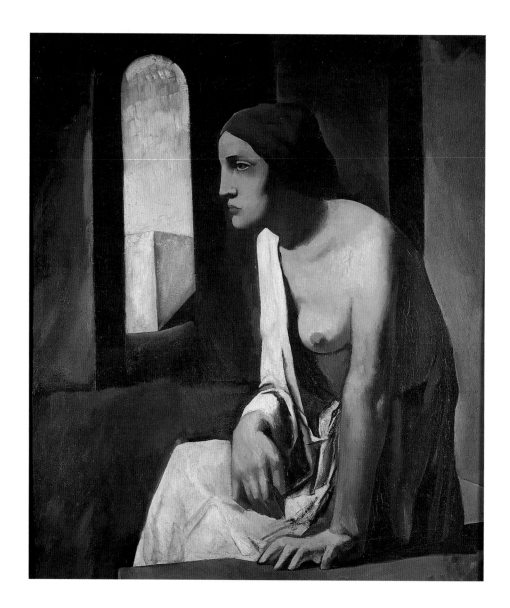

Hans Arp
(Strasburg 1886–1966 Basel)

Hans Arp in Strasburg, c. 1905.

A pupil at the School of Applied Arts in Strasburg and Weimar, Arp visited Paris in 1908. In 1911 he was a member of the Moderner Bund ("Modern League") group in Zurich, and in 1912 participated in the second Blaue Reiter show. He met Delaunay. In 1913 he contributed to the *Der Sturm* magazine and took part in the first German Autumn Salon. Arp went to Zurich in 1915 and soon became a leading spirit at Cabaret Voltaire's Dada soirées. He worked with artists, poets, and critics to set up a transnational Dadaist movement. He visited Cologne in 1919 and 1920, then Paris and Hanover. Among his friends were Max Ernst, Tristan Tzara, Paul Eluard, and Kurt Schwitters. He exhibited in the first Surrealist show in Paris in 1925. In 1930 he joined Cercle et Carré and in 1932 Abstraction-Creation. During World War II he stayed in southern France and Switzerland. In 1954 he won the international sculpture prize at the 27th Venice Biennial.

Hans Arp
Nosecheeks
1925–26, cardboard.
Museum of the Beyeler
Foundation, Basel.

In the 1920s he returns to the human figure on several occasions in his paintings, engravings and reliefs. He reduces appearances to "ciphers" and ideograms, and creates ornamental patterns. His view of the world is ironic and paradoxical but never biting. He seems to enjoy himself when bringing caricature and the art of the "spiritual" together.

Hans Arp
First Dada Relief
1916, painted wood.
Öffentliche Kunstsammlung, Basel.

In 1916–17 Arp produced a series of wood engravings similar in style, cosmic-natural themes, and nonfigurative approach to the black-and-white works of the Expressionist Wassily Kandinsky. In Paris in 1914–15, he met Picasso, who may have turned the young artist's attention to assemblages and experimental painted sculpture. At the end of 1916 Arp produced his first wooden reliefs: these were simple organic forms that he called "terrestrial forms." They suggest flowers, trees, birds, and landscapes. He never emphasized the individual figure but the general rhythm of a composition, and the interrupted or swirling movement that unites different elements and refers to unseen, internal life. Color was added to his assemblages for its qualities of attraction and was selected to pay tribute to artistic and artisanal decorative practices.

El Lissitsky
*Portrait of Arp with
Dada Monocle*
1923.

Marcel Duchamp
(Blainville 1887–1968 Neuilly-sur-Seine)

The brother of Raymond Duchamp-Villon and Gaston Duchamp (the latter known as Jacques Villon), Marcel studied painting at the Académie Julian. He painted post-Impressionist landscapes and figures. In 1911 he became interested in the new Cubist developments, and the artistic gatherings he organized with his brothers resulted in their being nicknamed the Puteaux group (after the location of their house). Other group members were Roger de la Fresnaye, Fernand Léger, Albert Gleizes, and Francis Picabia. With *Nude Descending a Staircase* (1912) Duchamp moved away from Cubist research and approached Futurist themes: representation of the body in movement, "simultaneous" image, and monumental scale. In New York during World War I, he struck up a close partnership with Picabia and Man Ray. In contact with the Zurich Dadaists from 1919, he championed Dada in Paris and the U.S. In the 1920s he became interested in experimental photography and cinema.

Marcel Duchamp with Katharine Dreier's Cockatoo, unknown date.

Marcel Duchamp
Bicycle Wheel
1913/51, ready-made.
The Museum of Modern Art, New York.

Following an ironic but also biting reflection on the recent developments in the art of Picasso and Braque, in 1913 Duchamp decided to give up painting. His *Bicycle Wheel* was his first ready-made. The wheel and stool were assembled and employed outside of their normal context; they were transformed into parts of a device with the purpose of creating associations. We, as observers, are an integral part of the work: not limited to interpreting its sense, we create its sense through a projective, though subjective and fully valid, process of which we are often unaware. The original *Bicycle Wheel* no longer exists, as Duchamp left it in Paris before departing for the United States in 1915, but there are eleven replicas.

In 1915–23, in the famous work *The Large Glass* (p. 85), "the bride stripped bare by her bachelors" is an erotic metaphor that alludes to the dual process of meaning.

Marcel Duchamp
Chocolate Grinder 2
dated 1914, oil on canvas.
Philadelphia Museum of Art, Philadelphia. The Louise and Walter Arensberg Collection.

The "chocolate grinders" that Duchamp painted (in several versions) in 1913–14 are allegories of an artwork: in the absence of an "amorous" interaction with the observer, the work of art is demoted, loses all its "artistry," and becomes nothing but an inert machine.

Marcel Duchamp
The Large Glass or The Bride Stripped Bare by Her Bachelors, Even
1915–23, oil and lead wire on glass.
Philadelphia Museum of Art, Philadelphia.
The Katharine S. Dreier Bequest.

Marcel Duchamp
Given: 1. The Waterfall, 2. The Illuminating Gas
1946–66, mixed media.
Philadelphia Museum of Art, Philadelphia.
The Cassandra Foundation.

Inside a box, the nude body of a woman lies open to our gaze on the ground. In her hand she holds a gas lamp. The background is a landscape of water and trees. Here the artist returns, in his own way, to the interwoven themes of cruelty and desire, manipulation and dependence, that link the gaze of the aesthete, art critic, and connoisseur to the work of art. Macabre and savage, the image is a figurative example of black humor. The only manmade object in what appears to be the scene of a crime, the gas lamp comments caustically on the "instant" of voyeuristic excitation expected, searched for, and found in a museum.

Marcel Duchamp
Wanted
1922.

In the early 1920s Duchamp created a series of characters or "appearances." Duchamp the "artist" is no longer where he should be or where we might expect to find him: in his studio, at the museum, in the gallery. He is always somewhere else, performing paradoxical, "anti-artistic" roles. We see him from behind on the sofa, sucking on his pipe, unaware and uncaring, with a tonsure in the form of a comet on his neck. We also find him as a wanted criminal, as his bizarre female alter ego "Rrose" Sélavy or as the Belle "Haleine," on the labels of perfume bottles, on roulette chips from the casino in Monte Carlo, his head covered with shampoo, his hair like wings in a parody of the Athena Nike. The satire is invigorating: it overturns the pompous seriousness of the works, artists, collectors, and connoisseurs of the early 1920s, who are caught up in a nascent system of art that revolves around a return to classicism. The jibe lies in the fact that, if a "work" has nothing artistic about it, then not even its artist can exist, and who in this case practices other (uncertain) occupations.

Giorgio de Chirico
(Vólos 1888–1978 Rome)

Born in Greece to Italian parents, with his brother Alberto Savinio, Giorgio de Chirico was an exception in the art and culture of Italy before the 1950s. A cosmopolitan and polyglot, he studied in Munich in 1906 and lived in Paris on several occasions. He was also a passionate lover of music, literature, and theater. Due to the complexity of his training and multiple interests, he gave himself up to the cliché of the painter who devotes himself purely to his art. His "metaphysical" compositions were conceived as an ironic response to the experimental research undertaken by Picasso and Braque. Between 1917 and 1920 he worked closely with Carlo Carrà. Immediately after World War I, he moved to Rome and argued for a national art able to dialogue with the country's great artistic tradition. Considered more than effective, his classicism nonetheless also had irreverent aspects: elements of parody and kitsch were included to belie his art's complete faithfulness to the canon.

Giorgio de Chirico,
Self-Portrait with Bust of Euripedes, detail, 1923, tempera on canvas.

Giorgio de Chirico
The Gentle Afternoon
1916, oil on canvas.
Peggy Guggenheim
Foundation, Venice.

In 1916 Giorgio de Chirico was in the army in Ferrara. He still sent his works to Paul Guillaume, his dealer in Paris, as he remained fairly unknown in Italy, yet he nonetheless thought of Italy as his homeland and Italian culture as his working sphere. He painted compositions with mannequins and "metaphysical architecture," and others featuring biscuits, loaves of bread, boxes of matches, reels of thread, gloves, rulers, and set squares. He considered his images letters and messages, instances of coded correspondence, locked images destined for select recipients. The everyday objects he painted were loaded with allegorical meanings and gave visible form to premonitions. Suggestions for action were mixed with obscure comments on Italy and nostalgic memories of family "interiors" in which he spent his childhood.

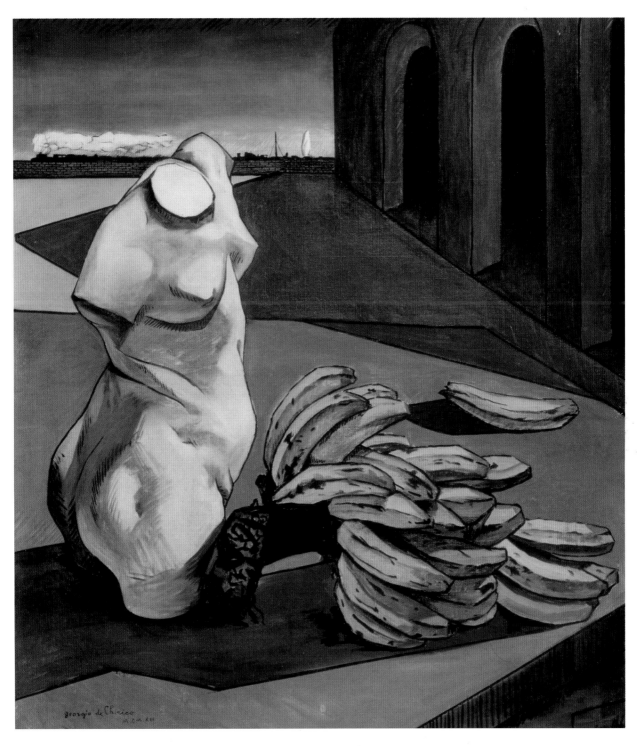

Giorgio de Chirico
The Uncertainty
of the Poet
1913, oil on canvas.
Tate Modern, London.

Man Ray, *Self-Portrait with and without Beard*, 1943, original photographic print.

Man Ray
(Philadelphia 1890–1976 Paris)

Emmanuel Radnitzsky (Man Ray) studied painting in New York. In 1913 he met Stieglitz and visited the Armory Show. He painted and took photographs. He struck up a friendship with Duchamp in 1915, despite the two speaking different languages. Financed by Katherine Dreier, they set up an organization in New York named the Société Anonyme dedicated to contemporary art. In 1921 Ray moved to Paris where Duchamp introduced him to Dada circles. He met Erik Satie, and portrayed Proust on his deathbed. From 1922 he produced "rayographs" by placing objects directly on film and exposing them to light, without the need for a camera or lens. He opened a studio in Montparnasse and made portraits. Close to Surrealist circles, he experimented with photographic techniques and made films. He worked for *Vogue*. Shortly after the German invasion of Paris, he moved to Hollywood, returning to Paris in 1951. Large retrospectives of his work were held in Stockholm, Los Angeles, and New York.

Man Ray
Tears
c. 1930.

His movie-making experience inspired Ray to work in his studio as though he were on a set, emphasizing elements of artifice, such as recitation, direction, furnishings, makeup, and lighting. As an early exponent of developments in photography that only flourished fully from the late 1970s, Ray inventively interwove elements of set and fashion photography with avant-garde ideas.

Above:
Man Ray
Black and White
1926.

Man Ray
Breeding Dust
1920–47, gelatin-silver print from original negative.
Jedermann Collection, New York.

This photograph was published in 1922 as an aerial view in the Parisian magazine *Littérature*

edited by André Breton and Philippe Soupault. It is a detailed image of the back of Duchamp's *Large Glass* (see page 85) that Ray photographed in the painter's studio in New York in 1920. As such, it plays with the credulity of the public and is aimed at creating an aura around a work of art not yet seen.

Giorgio Morandi
(Bologna 1890–1964)

Although he began his career as a Futurist, Morandi's work is exemplary for its reserve and apparent detachment from contemporary culture and current affairs. He made no attempt to organize or promote the avant-garde, and spent his time in isolation, unwilling to suffer the artists of either his or the younger generation who attempted to introduce more historical or social viewpoints into art at the expense of technique. His studied preference for seclusion was reasoned and even strategic: his oeuvre betrays his desire to enter the celebrated artistic heritage of French modern masters of still lifes and landscape painting. After a short metaphysical period, Morandi concerned himself increasingly with problems of light, the magic of form, and the pictorial rendition of surfaces that together harked back to Cézanne and Chardin.

Giorgio Morandi, 1950s.

Giorgio Morandi
Bottles and Fruit Bowl
1916, oil on canvas.

Three glass household objects are arranged against a brown and bluish ground organized in horizontal bands rather like a Mozarabic miniature. The dark brown band at the bottom of the composition represents the thickness of the table the objects stand on; the light brown band is the table top; and the ash-blue band is the wall behind. The slight asymmetry of the two objects that give most character to the still life (the bottle on the left and fruit bowl on the right), coupled with the vivid rotational movement of the bowl, energize the forms with an interior, secret existence, and mysteriously suggest ancient battles.

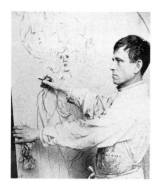

Otto Dix at work.

Otto Dix
(Gera 1891–1969 Singen)

Between 1909 and 1914 Dix attended the Dresden School of Applied Arts. He adopted a late-Impressionist style and gradually became aware of the avant-garde movements. During the war he fought as a volunteer in France and Russia. In 1919 he founded the Dresden Secession group with Conrad Felixmüller. He distanced himself from Expressionism, preferring art connected with reality. Dix visited Düsseldorf in 1922, and in 1924 published 50 engravings titled *War*. In Mannheim in 1925 he participated in the Neue Sachlichkeit exhibition. He was in Berlin 1925–27, then moved to Dresden where he taught at the Academy. He painted two triptychs titled *War* and *Metropolis* in the period 1927–32. He was fired by the Nazis in 1933. His works were withdrawn from museums in Germany and shown as part of the Degenerate Art exhibition. Suspected of an attempt on Hitler's life, Dix was imprisoned in 1939 but later released. During World War II, he was conscripted, captured, and made a prisoner of war.

Otto Dix
Portrait of Doctor Koch
1921, oil on canvas.
Museum Ludwig,
Cologne.

Prostitutes, outcasts, and unscrupulous businessmen are recurring subjects in Dix's naturalistic story-telling, strongly tinged by imagination. Dr. Hans Koch is portrayed among the tools of his trade, his gaze fixed and proud, and is a typical example of Dix's preferred subjects of mutants and wretched people. Dix was a victim of war and a morphine devotee; we can imagine him destroyed profession-ally and personally by his addiction.

Otto Dix
Saint Christopher IV
1939, oil on wood.
Kunstsammlung, Gera.

During his career, Dix's relationship with the German art of the Reformation grew in importance. In compositions by Grünewald and the painters of the Danube school, he found his own technical and formal refinement, scrupulously painted details, allegory, and theological and moral consistency with the time.

According to Dix in 1927, "The new painting is nothing but the intensification of forms that already existed in the works of the Old Masters. To my eyes, the theme remains of primary importance, followed by form."

Alberto Savinio
(Athens 1891–1952 Rome)

Alberto Savinio,
Self-Portrait, detail, 1936.
Galleria Civica d'Arte
Moderna, Turin.

Alberto Savinio (real name Andrea de Chirico, brother of Giorgio de Chirico) was a musician and writer by training. Having completed classical studies in Greece, Savinio first moved to Munich, then to Paris in 1910, where he joined artistic, literary, and musical avant-garde circles. He displayed a bizarre and irreverent talent in his unusual musical performances. In 1916 in Ferrara with his brother, he attempted to weave together historical, biographical, and cultural references around metaphysical compositions. Immediately after the war he was a critic for *Valori Plastici*, the most important art magazine of the period. (De Chirico, Carrà, and Savinio were its most respected contributors.) His first solo exhibition was held in Paris in 1927. It instantly aroused general attention, and Savinio was contested on the one hand by the classicist painters of "Mediterranean" themes, and, on the other, by the Surrealists.

Alberto Savinio
Sodom
1929, oil on canvas.

The Bible tells the story of the ancient city of Sodom and its legendary fornicators, and of the divine wrath visited upon it, and how Lot, an honorable man, is the only one to be saved from the city's destruction. An archetypal term of all future invective against contemporary forms of decadence, Sodom returned frequently in the art and literature of the 1920s. Even Carrà made reference to it indirectly in a composition called *The Daughters of Lot*. Savinio shows the city enveloped by flames, while in the sky a bizarre object—seemingly a series of toys mixed with an ideographic stela and a black banner—flies like an exterminating divinity or Horseman of the Apocalypse. Will the new art—whether the "ideographic" art produced by emulators of Picasso, or that of Savinio's brother de Chirico—protect the West from decline? Savinio seems both to pose the question and parody it at the same time.

Max Ernst
(Brühl 1891–1976 Paris)

Max Ernst, detail, 1942,
photograph by Arnold Newman.

Ernst studied philosophy at Bonn University. In 1910 he met Macke and came into contact with contemporary art. In 1913 he participated in the First German Autumn Salon held in the Der Sturm gallery. He met Delaunay and Apollinaire, then, in 1914, Arp. Drafted for the war, he fought in France. He had a solo exhibition in 1916 at Der Sturm. In Berlin he met Grosz and in 1919 visited Klee in his studio and became a founding member of the Dada group in Cologne. In 1920 he exhibited his collages in Paris at the invitation of André Breton. He moved to Paris in 1922 and was a founding member of the Surrealists. He wrote for the magazine *La Révolution Surréaliste* and in 1925 took part in the first Surrealist exhibition held at the Galerie Pierre. Between 1926 and 1930 he published collections of frottages and collages, and experimented with stylistic techniques and anachronisms. In 1941 he moved to New York and was in Sedona from 1946. He returned to Paris for good in 1953.

Max Ernst
Two Children Threatened by a Nightingale
1924, oil on wood, elements in wood.
The Museum of Modern Art, New York.

A woman follows a nightingale clutching a large knife. Another figure, in classical drapery, lies dead on the ground. A man carrying a child flees over a roof from an unspecified danger; his hand reaches out towards the knob almost as though to open a door and find an escape (from the picture?). In the background there is a dome and monumental gate. In the foreground stands an enigmatic house without either an entrance or windows. A note of parody is added to the overall discordance in its very format: overlarge compared to painted panels, ordinary but not without a degree of pretentiousness, and all in all pedantic, the work seems to have been made for the walls of conservative, sentimental collectors who prefer fatuous idyllic landscapes and scenes from classical mythology. The themes of the work are anxiety, irony, and intolerance: dreamlike, imaginative elements combine with cutting criticism of the painter's trade, the public, and museum art. Ernst seems to enjoy offering unfinished and absurd narratives: the title, taken from a verse written by Ernst himself, adds another layer of mystery and contrast.

Max Ernst
Landscape with Wheatgerm
1935, oil on cardboard.

The springtime landscape features an interpretation of geology and natural cycles. Iconographic conventions taken from scientific illustrations—the layers of the Earth's crust—are depicted in a poetical and fantastic manner. Ernst interprets natural processes in a sexualized, Dionysian way: the serpent-phallus extends sinuously from the depths of the Earth to emerge into the light.

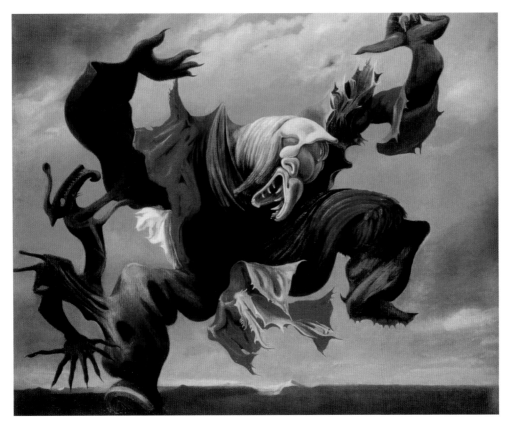

Max Ernst
The Angel of Hearth and Home
1937, oil on canvas.

In one of the tensest and darkest periods of Europe's twentieth-century history, characterized by ideological violence and totalitarian military states, Ernst's mocking of the conformism of the lower-middle and middle classes is developed here as a renewal of a figurative *grande genre* and history painting. The deformity of the figure overshadows the lesser aspects of caricature to create an extraordinary contemporary representation of Evil.

George Grosz, *Self-Portrait*, 1916, pen and ink on paper.

George Grosz
(Berlin 1893–1959)

Grosz studied at the Fine Arts Academy in Dresden. In 1913 he visited Paris, and in the fall of the same year, he went to Berlin where he discovered the Expressionists and Italian Futurists at the First German Autumn Salon. A volunteer in the war, he was discharged in 1915. A pacifist, he visited Ludwig Meidner, Elsa Lasker-Schuler, and Theodor Daubler. Grosz was recalled to the army in 1917, and had a nervous breakdown shortly afterward. From 1918 to 1922 he had an exclusive contract with the Goltz gallery in Munich. Among the founders of Dada in Berlin, he joined the German Communist Party (he resigned in 1923) and the radical art association Novembergruppe. Accused of producing pornography in 1924, he was sued and fined. He signed a contract with Alfred Flechtheim and worked as a set designer with Brecht and Piscator in 1928. He was accused of blasphemy. In 1933, like many other German artists, he moved to New York. In 1938 he became an American citizen. He returned to Berlin in 1959.

George Grosz
Careful Observation
1917, pen and ink on paper.

A crude satire of culture and customs, this drawing pours scorn on the elevated "spiritual" claims of the prewar avant-garde. The collector shown— his eyes wide open, a magnifying glass in his hand—is examining a female nude (possibly Cubist?). Grosz was an assiduous collector of pornographic photographs and drawings: he used them as ideas for his images of seduction and prostitution, almost as though to provide allegorical portrayals of the dark, contemptible, greedy side of society. He later wrote in his *Autobiography*, "All I learned before the war can be summed up as follows: nothing else exists in life apart from the drive to gratify the needs for food and sex."

Right:
George Grosz
Circe
1927, watercolor.
The Museum of Modern Art, New York.

"The labyrinths of mirrors," he wrote ironically in 1917, "the enchanting street gardens! The places where Circe turns men into pigs…and the red Port that destroys the liver.…Oh, the delights of large cities!"

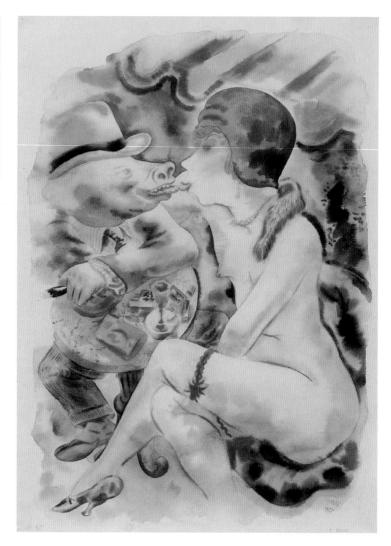

Joan Miró
(Barcelona 1893–1983 Palma de Majorca)

Joan Miró, *Self-Portrait,* winter–spring 1918, oil on canvas. Musée Picasso, Paris.

Miró studied painting in Barcelona. In Paris for the first time in 1920, he met Picasso and attended a Dada soirée. He returned to Paris in 1921 and had his first solo exhibition at the Galerie La Licorne. He journeyed back and forth between Paris and Montroig. Close to the Surrealists, in 1925 Miró had a solo show at the Galerie Pierre and then participated in the Surrealist exhibition held there. In Holland in 1928, he was influenced by the art of the Old Masters. He produced collages and *papiers collés*. From 1929 to 1933 he experimented with printing, lithography, and engraving. He created assemblages using "found objects" and stones or painted wood. In 1936 he left Spain, and in 1937 decorated the Spanish Pavilion at the international exhibition in Paris. He designed a stamp in support of the Spanish Republican resistance. Miró was at the MoMA exhibition Cubism and Abstract Art in New York. Starting in 1941 he produced ceramics. In 1958 he painted murals for the UNESCO building in Paris.

Joan Miró
48
January–February, 1927, oil and watercolor on canvas.

Miró's compositions with words play figuratively with the untranslatable qualities of experiences, emotions, and desires: certain numbers (a non-narrative and recurrent motif) and the bare canvas remind the observer of the limitations and impossibility of painting, which turns to poetry for assistance.

Joan Miró
Still Life with Old Shoe
February 24–May 29, 1937, oil on canvas.
The Museum of Modern Art, New York.
James Thrall Soby Bequest.

Miró began to paint this work in winter 1937, when he was unable to return to Spain and continue the unfinished work there. "I intend to push the painting to the limit," he wrote, "because I want it to be comparable to a good Velázquez." He returned to the style he used in the early 1920s in a series of still lifes and Catalan landscapes that celebrated the poverty of the Spanish peasant and the dignity of his endurance.

Christian Schad, 1935.

Christian Schad
(Miesbach 1894–1982 Stuttgart)

Schad studied at the Fine Arts Academy in Munich. He made Expressionist wood engravings and experimented with avant-garde styles. In 1915 he went to Zurich to avoid military service. In Geneva from 1918, Schad produced "schadographs," images on film made without a camera or lens. He visited Rome, Naples, and Vienna between 1920 and 1925, during the period of his greatest success. He painted artists, intellectuals, and aristocrats in Vienna and Berlin, cities where he lived between 1928 and 1933. Following the Nazi rise to power, he retired from public life and painted only portraits privately. He exhibited in New York at the MoMA exhibition Fantastic, Dada, and Surrealist Art in 1936. His Berlin studio was destroyed in Allied bombing in 1942–43, and he moved to Aschaffenburg in 1943. Large retrospectives in the 1970s brought him international fame.

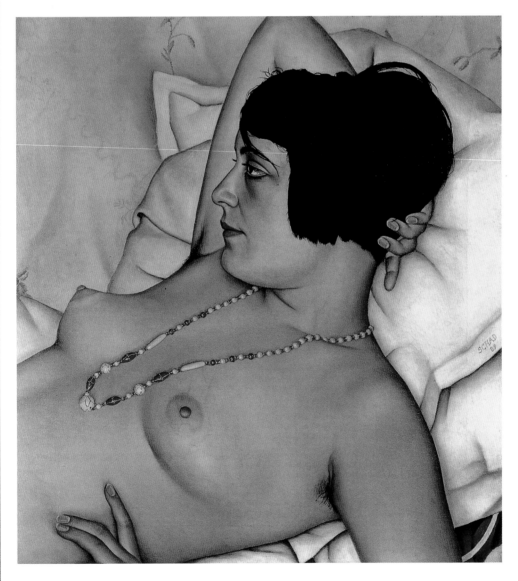

Christian Schad
Half-Length Nude
1929, oil on canvas.
Von der Heydt-Museum,
Wuppertal.

Schad's drawings and paintings demonstrate a deliberate use of pornography: he made use of sexually explicit images to show bodies but also to reflect on the relationship between the painting itself and (the eye of) the collector or connoisseur. This nude is explicit and attractive, stimulating in us the senses of smell and touch: we see the veins in her breasts, her reclining posture, her face alight as though from a recently consummated act of love. The red and white bead necklace adds a note of seduction to her nudity, evoking sexual availability and conjuring up images of odalisques. The woman seems warmly welcoming, fully uninhibited, and sympathetic.

Christian Schad
The Operation
1929, oil on canvas.
Städtische Galerie im Lenbachhaus, Munich.

This painting pays tribute to the Dutch masters of the seventeenth century (also to the late-nineteenth-century French naturalists) for their strong interest in contemporary reality. Schad made use of people known to him as his models: his partner Maika is the nurse holding the patient's head, and his good friend Felix Bryk—an entomologist and journalist—is the suffering patient.

Christian Schad
Agosta, the Man-Bird, and Rasha, the Black Dove
1929, oil on canvas.

An aesthete and dandy, Schad portrayed the most elegant and sophisticated circles of society, establishing a perverse complicity with his models. He depicted their solitude, physical deformities, and humiliating dependencies. The series of portraits he executed in the 1920s is like an initiation novel written by means of images and figures. The author adopts the role of an insider: he has special access to the secret, wicked, nocturnal heart of the "great city" and leads us by the hand to explore its darker corners. Agosta and Rasha are two circus workers whom Schad met in Berlin in 1929 and immediately invited to pose for him in his studio. Their daily relationship is simple: they are professional colleagues. Agosta is an acrobat, Rasha (originally from Madagascar) has an act that includes a snake. However, Schad offers an erotic-romantic interpretation and creates a fascinating image of sexual ambiguity. We know that during one sitting Agosta confided to the artist that he was frequently approached by women in search of unusual erotic experiences. Schad, who regularly transcribed the stories of his models, was thus encouraged to give a sexual dimension to the image of the man with the deformed ribs.

Carlo Levi, *Portrait of de Pisis with a Parrot*, detail c. 1933, Fondazione Carlo Levi, Rome.

Filippo de Pisis
Still Life with Sculpture
1927, oil on canvas.
Galleria Nazionale d'Arte Moderna, Rome.

Filippo de Pisis
(Ferrara 1869–1956 Milan)

De Pisis (real name Filippo Tibertelli) was in many ways an eccentric in Italian art between the wars: cultivated, cosmopolitan, and versatile, he displayed neither unrealistic extremism nor the bitter, haughty reserve of many of his contemporaries. He was a painter, poet, and narrator who avoided having to take official or serious stances. Shrewd and ironic, he observed with gentle, languid sentimentality, and was unusually self-assured and unprejudiced. His love life was busy, urgent, and unorthodox. De Pisis's first compositions were like painted collages and metaphysical puzzles. He met de Chirico and Savinio in Ferrara in 1916. In the late 1920s he was part of the general return to a painting of touch and color typical of the Paris art scene, where he moved in 1925. Some of his apparently naturalistic paintings contain fragments of his private existence.

The composition revolves around a brilliant but concealed comparison between painting and literature. The scene is a private space in a domestic interior; on the wall is a painting or print of a classical kneeling faun, a curious scarlet bookplate with what seems like a child's scrawl, and the view of an ancient monument, probably an amphitheater (perhaps the Colosseum?). Like the faun, the last is a souvenir of Italy. (The painting was executed while de Pisis was in Paris.) The three elements of the composition are not figures, but figures of figures. They are different in scale, context, and type, and placed beside one another, but are narratively autonomous like elements of a collage, connecting like the phases of a story that has a nude adolescent male as its hero. This same story is not immediately apparent; the task of reconstructing the plot, recognizing allusions, making connections, and guessing is left to us, the observers.

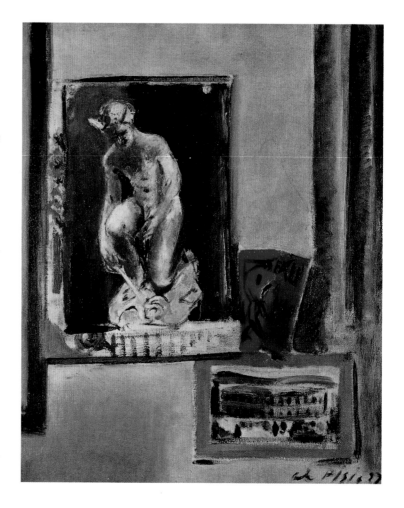

André Masson
(Balagny 1896–1987 Paris)

André Masson, 1970s.

Masson studied art in Brussels, then moved to Paris in 1920 where he continued his studies. In 1922 he met Kahnweiler, who became his art dealer. In 1924 he had his first solo exhibition. He met Breton and became a member of the Surrealist circle. (He left in 1928.) He wrote for *La Révolution Surréaliste* and participated in the Surrealist exhibition at Galerie Pierre in 1925. He got to know Georges Bataille in 1928; he illustrated *L'Oeil* and *Acéphale* and contributed to "Documents." In 1933 he designed the sets and costumes for the Ballets Russes, and he was in Spain from 1934 to 1936. Back in Paris, Masson reunited with the Surrealists. He left France in 1941 for Connecticut, where he remained in close contact with the émigré European artists who revolved around New York. He exhibited at Peggy Guggenheim's gallery and held conferences on modern art. He returned to Paris in 1945, and published *Plaisir de Peindre*, his complete writings in 1950. The MoMA held a large retrospective of his work in 1976.

André Masson
The Earth
1939, oil on sand.
Centre Georges
Pompidou,
Musée National d'Art
Moderne, Paris.

Masson began to produce "automatic" drawings and used sand in his paintings when he first joined the Surrealists. The purpose of the sand is to spread the oil colors, reduce their brilliance, and deny the painted canvas all its powers of attraction. At the same time, this technique is suited to compositions that are more designed than painted: it creates a delicate superficial modulation and in some way substitutes color. In the 1930s Masson's experimentation with techniques and materials became less urgent, giving way to references to archetypes and myths, cultural consideration of violence and eroticism, and archaeological and ethnographic research of models that he reinterpreted in a more personal manner. In this painting, the obscure fecundity of natural processes is evoked by the self-inflicted wound, the generosity of the offering, the sprinkling of blood, and the unlimited receptivity of the body.

René Magritte
(Lessines 1898–1967 Brussels)

René Magritte in front of his painting *The Barbarian*, later destroyed in a bombing raid on London during World War II.

Magritte studied at the Académie des Beaux-Arts in Brussels. In 1922 he discovered de Chirico. In 1924–27 he was one of the founders of the Société de Mystère. From 1927, the year he moved to Perreux-sur-Marne, he gravitated toward the circle of André Breton. In 1928 he participated in the Surrealist exhibition at the Galerie Goeman in Paris. In the summer of 1929 he was in Cadaques as Dalí's guest. In 1936 Magritte exhibited for the first time in New York, and two years later had a solo show in London. He regularly altered his themes and styles, often in parody: notably the "Renoir period" in 1943, the "cow period" in 1948. In 1954 he presented compositions based on images and words at the Sidney Janis Gallery in New York. Between 1960 and 1967, retrospectives were held in museums such as the MoMA in New York, the Palais des Beaux-Arts in Brussels, the Museum Boymans-van-Beuningen in Rotterdam, and the Moderna Museet in Stockholm.

René Magritte
Young Girl Eating a Bird (Pleasure)
1926, oil on canvas.
Kunstsammlung Nordrhein-Westfalen, Düsseldorf.

At the foot of a tree filled with richly plumed birds, a young girl in smart clothes bites into the stomach of a bird, without showing any signs of hunger, anger, or madness. The girl's face displays no particular emotion: on the contrary, all occurs as though it were completely normal. The paradisiacal narration of the background, with the view of the Tree of Life, is abruptly contradicted by what is taking place in the foreground. Savagery and cruelty are ingrained in the human species; idyll and pastoral pleasure, so dear to painting, do not take into account our history and end up seeming puerile.

René Magritte
The Empty Mask
1928–29, oil on canvas.
Kunstsammlung Nordrhein-Westfalen, Düsseldorf.

The words in the painting betray the fictitious nature of the painted image. Words—that is to say, conventions loaded with meaning—are used to replace the representation of natural forms. There is nothing "surreal" in this; it is more an attempt to educate us, the observers, to consider a painting as we would a text, not as a simple simulacrum, and to encourage us to reflect on painting as a conscious activity, or a refined, difficult, reflex form of communication.

Scipione
(Macerata 1904–1933 Arco, Trento)

A surprising element in the painting of Scipione (real name Gino Bonichi) is the unusual conjunction of local and cosmopolitan elements: Rome not only forms the background to many of his paintings, it is also an archetypal and deliberately Baroque place, just as he wanted his painting to be. There is nothing artistically Roman or contemporary—except for the occasional magical-realist aspect—in his compositions, which favor a narrow range of yellows and oranges, and forms that border on decay: the forms are in the process of falling apart, and his compositions reveal awareness of the Expressionist tradition in Europe. (Ensor, Kokoschka, Pascin, and Soutine were some of Scipione's favorite artists, though he only knew of them through reproductions.) He formed a partnership with Mafai and Antonietta Raphael, which Roberto Longhi called the "school of Via Cavour" (the work of the three young artists was thus also connected topographically to the city where they lived).

Scipione, *Self-Portrait*, detail 1928, Giuliano Gori Collection, Prato.

Scipione
Roman Courtesan
1930, oil on canvas.

Scipione's painting accommodates a veritable catalogue of his own character types—the Catholic prince, Catholic deacon, and Roman cortesan—exist outside of time and history, set immutably against the background of a Rome that is both clerical and pagan, given over entirely to mystery and magic.

Alberto Giacometti
(Borgonovo, Switzerland 1901–1966)

The son of the painter Giovanni, Alberto Giacometti grew up in a stimulating and innovative artistic milieu. While a student at the École des Beaux-Arts in Geneva, he visited Italy for the first time in 1920. He loved the art of ancient Egypt and the Italian "primitives." He returned to Italy in 1921, visiting Florence, Assisi, Rome, Pompeii, and Paestum. In 1922 he moved to Paris, where he visited the studio of Antoine Bourdelle. Between 1925 and 1927 he produced and exhibited his first primitivist sculptures, which bore affinities to the works of Laurens, Lipschitz, and Brancusi. Giacometti studied African, Oceanic, pre-Columbian, and Cycladic art at the Musée de l'Homme. Through Masson he gravitated to Surrealist circles in 1928–29. He exhibited at the Galerie Bernheim-Jeune at the instigation of Teriade; at the Galerie Zak with the Italiens de Paris; and kept company with Sartre, Simone de Beauvoir, and Picasso. From 1941 Giacometti was in Geneva. He returned to Paris in 1945 and quickly achieved international fame.

Alberto Giacometti, 1922,
photograph on his identity card.

Alberto Giacometti
The Peasant
1921, oil on canvas.
Private collection, Switzerland.

This composition dates from fall 1921, shortly after Giacometti's second stay in Italy, which lasted nine months. In Italy he studied the old masters with a modern sensibility and reflected on the relationships between painting and sculpture, color and form, the finished and unfinished. On his return to Switzerland he experienced his first difficulties in "finishing" a bust from life (of his cousin Bianca), as "life" seemed unwilling to allow itself to be shut up in a form. The precedents laid down by Hodler and Cézanne (at the time considered linked by art historians and critics, much more than today) were well known to Giacometti. The color in this work is wide-ranging, and subtle compositional distortions, such as concealed shifts of the plane, accentuate the irregularity of the dimensions and "verticality" of the model, portrayed in a similar manner to ancient images of majesty. The way the shoulders emerge from the bust, or the head arises from the shoulders, seems "mountainous," like alpine peaks set against the background of the sky, and the large beard suggests a snowy expanse.

The painting is imbued with a constant, restrained emotion, and the dynamic, rapid touch emphasizes the "spiritual" aspects of the portrait, both humble and (in the manner of Segantini?) epic at the same time. Giacometti celebrates the integrity and simplicity of the old, silent mountain-dweller.

Right:
Alberto Giacometti
Suspended Ball
1930–31, variant executed in 1965 in chalk and metal.

Giacometti counted *Suspended Ball* among his "mute, mobile objects." The sculpture was particularly appreciated by the Surrealists: ambiguously erotic, susceptible to infinite interpretations, but finally without any unequivocal meaning, it is a perfect example of an "object with a symbolic function" the artists in Breton's circle were so keen to find.

Top:
Alberto Giacometti
Head
1925, chalk.
Centre Georges Pompidou, Musée National d'Art Moderne, Paris.

The clear, geometric forms of the small idol have a simplicity of construction that render it attractive and "reasonable" (in Picasso's words). And such is the minimalism of its presentation—being devoid of narrative, historic, psychological, or ritual elements—that what we find all the more striking is its refusal to translate into words, art critique, style debate, or literary paraphrasing. The small, almost portable idol seems succinct, complete, to the point. Its "significance" lies in the playful and ritual process that generated it, not in any thematic interpretation.

Above:
Alberto Giacometti
Alberto Giacometti, Life Goes On
1932, chalk.
Centre Georges Pompidou, Musée National d'Art Moderne, Paris.

The artist described this sculpture as "a sort of landscape-cum-armored head," generated by the "attempt to find a solution to the conflict between calm, full things and sharp, violent things." Among the models for *Life Goes On* may have been an ancient African game rather like checkers. Evident in its low, horizontal presentation is the desire to open the sculpture to time and duration, to offer toy-forms that are not purely for the gaze of collectors, connoisseurs, or aesthetes, but which become to all intents and purposes presences in our everyday life.

Alberto Giacometti
Woman Standing
1948–50, bronze.

Leading Figures | Alberto Giacometti

The Modern Movement in Architecture

The fresh technological and intellectual contributions to architecture between the two world wars were equally matched by new economic, political, and social opportunities, leading, for example, to the demand for new living styles by the emerging middle class, an emphasis on municipal housing, developments in technology and construction, and the growing importance of good design. However, there was significant continuity between prewar rationalism, particularly in Mitteleuropa, and the Modern Movement that began to take root between the wars. The consideration of form as function, the importance placed on luminosity and the salubriousness of the working and domestic environment, the emphasis on the flexibility and reliability of new materials, and the research into design solutions to achieve maximum benefit from industrial developments were all characteristics of the Deutscher Werkbund (German Work Federation), an association of German architects and intellectuals formed in 1907 that soon became a point of reference through-out Europe.

Architecture and Lifestyle: The "Machine for Living"

As a painter, architect, city planner, and cultural organizer, Le Corbusier made a decisive contribution to the development of the Modern Movement, first focusing on the requirements for comfort, mobility, and understated, functional elegance in the private residences of the well-to-do. Lifestyles and the notion of "luxury" were undergoing change. The new clients no longer wished for buildings made of wood or stone evoking regional architecture or Gothic castles; roof gardens, wide open interiors,

and large windows and glass doors best represented the expectations of a society typified by a desire for health, and whose rhythms had been accelerated by mass production. In the period between the wars, physical well-being, sports, and physical capability were more fashionable than ever among the well-off. The Futurist and purist aesthetic of machinery, which Le Corbusier incorporated into his designs from 1917, governed his theory of design: the home, he wrote, was a "machine for living," a flexible and responsive device designed to respond to the needs of the owner. The Villa Savoye best exemplifies the directions the Swiss architect was taking. The villa does not have a traditional façade: it has no face designed to impress the approaching visitor, nor were special angles engineered from which it should be viewed. Its forms are geometric and simple, the walls white. Surrounded by vegetation and lying some way from the road, the building makes no attempt to blend in with its natural context, or to hide its man-made and technological nature. The living floor is raised on eight slender columns called *pilotis*, which confer a sense of lightness on the construction, while also allowing the humidity rising from the ground to disperse. On the second floor a large, glass-walled salon opens onto a vast terrace-cum-solarium, which is partly also a roof garden. Even nature is ordered rationally inside the architectural design, like furniture, offering the inhabitants of the house additional well-being. In addition to the pilotis and roof garden, the long, horizontal ribbon windows were the third radical innovation: the window runs uninterruptedly along the walls, contributing to the extreme luminosity of the building and in some way disparaging the closed, defensive appearance of the traditional, middle- or upper-middle-class home of the nineteenth century.

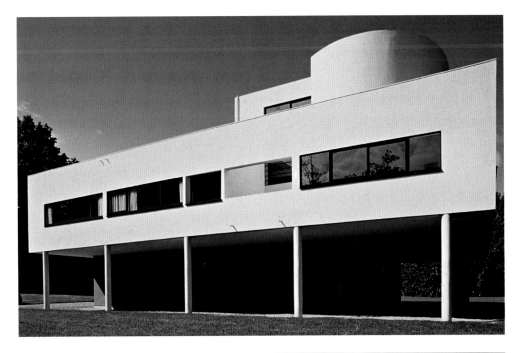

Le Corbusier
Ville Savoye
1928–30.
Poissy (France).

Left:
Mies van der Rohe
(with Lily Reich)
German pavilion at
the 1929 Barcelona
International Expo
(1986 reconstruction).

Le Corbusier
*Still Life with
White Pitcher*
1920, oil on canvas.
Basilea, Öffentliche
Kunstsammlung.

Le Corbusier the City Planner

Underlying Le Corbusier's thinking on city planning was the determination to correct certain historically or economically caused imbalances in Western cities and, if possible, to contribute to the planning of new settlements where innovative design solutions could be tested. As he wrote in 1933, it was above all necessary to contain the "violence of private interests" and the "thrust of economic forces," and to place the practices of architects and city planners under administrative control. And also: "The majority of cities … present a picture of chaos: these cities in no way fulfill their destiny, which is to satisfy the primordial biological and psychological needs of their inhabitants."

In the early 1920s Le Corbusier had already drawn up plans for a futuristic "city for three million inhabitants." Every living space was conceived as a modular element that could be added to an apartment block or series of blocks ad infinitum. He wanted to industrialize construction, and turn the building site into no more than a place to assemble prefabricated components. The plates he created to illustrate his project are drawn purely in outline using an elegant, linear technique. The characteristics of his approach—clarity and recognizability of style—would become increasingly established internationally, extending to France, Switzerland, the Soviet Union, Brazil, and India.

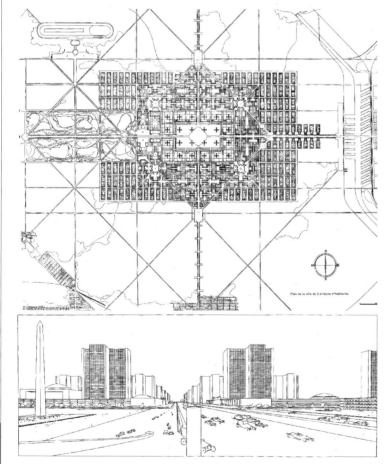

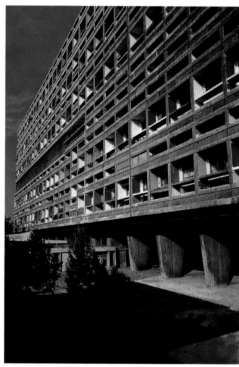

Le Corbusier
Plan of a City for Three Million Inhabitants, and Drawing of a City of Three Million Inhabitants
exhibited for the first time at the Salon d'Automne, Paris, November 1922.

Le Corbusier
Unité d'Habitation
1946–52, Marseilles.

With his Unité d'Habitation (Housing Unit) in Marseilles, which he conceived as a city in itself, Le Corbusier took his city planning philosophy to the limits, to the point where he overrode evident requirements of the residents in terms of habitability: with shared, overcrowded spaces, inward-looking like a concentration camp, this project forced the architects and theoreticians of the Modern Movement to reflect on the limitations and failings of merely functional Rationalism.

From Utopia to Industrial Design: The Bauhaus

Immediately after the Great War in Germany, radical cultural protest led to the overthrow of the soberly rational principles of the Deutscher Werkbund and the refusal to accept "utopian" architecture. The challenge to the status quo was accompanied by examples of architectural Expressionism (with contributions from Peter Behren, design consultant to the German company AEG) and Romanesque Gothic revival, though the latter soon turned to kitsch.

Rationality and design clarity became important factors in the early 1920s, a period when the arts congregated around and contributed to architectural design, and notions of unitary stylistic renewal became more strongly stressed.

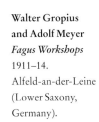

**Walter Gropius
and Adolf Meyer**
Fagus Workshops
1911–14.
Alfeld-an-der-Leine
(Lower Saxony,
Germany).

Walter Gropius
*Axonometric Drawing of
the Bauhaus in Dessau*
1923–25.

From the standpoints of interdisciplinary collaboration, the exchange of ideas, and the connections between art and design, the experiences of the Bauhaus were unmatched during this period.

At the time he was appointed to run the Weimar Institute (still known as the "School of Applied Arts" that had previously been directed by Henry van de Velde), Walter Gropius (1883–1969) was a young architect just ending his association with the Novembergruppe of Berlin, a Dadaist-Expressionist movement that had produced successful prewar projects characterized by a functional sobriety of design and an interest in new materials and technologies.

Although they were conventionally referred to as Expressionist, the first years of the Bauhaus ("House of Architecture," which Gropius named) were also adventurous.

The institute was underfunded and the tendencies of the teaching staff and students were decidedly "spiritualistic," more suited to a creative work-shop than a school of architecture.

The Mass-Produced Object

The turning point occurred around 1923, when the young Hungarian Constructivist Laszlo Moholy-Nagy took over direction of the basic course at the Bauhaus and initiated the first collaborative work with industry. An urgent need for money obliged Gropius to create partnerships with private companies and the school's experimentation with new industrial materials and mass production brought the Bauhaus international notoriety just before it moved to Dessau, the new site designed by Gropius. In the 1920s it became possible to model steel tubes inexpensively, a

Carl Jakob Jucker
Wilhelm Wagenfeld
MT 10 Table Lamp
1923–24, glass, milk glass, brass, and nickel-plated steel. Vitra Design Museum, Weil am Rhein.

Karl Hubbuch
Hilde with a Bauhaus Lamp
1928–29, watercolor on paper. Rolf Deyhle Collection, Stuttgart.

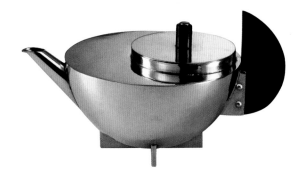

Marianne Brandt
Teapot and Ashtray
1924, (teapot) brass, silver-plated interior, ebony; (ashtray) partially nickel-plated brass.

component that had until then been used exclusively in the aeronautics industry. This technological innovation became an integral feature of chairs that met with great success in the marketplace. They were designed by the Hungarian Marcel Breuer and promoted by Bauhaus advertisers as indispensable and innovative items of furniture in the "modern," luminous, functional, and slightly futuristic home. The B3 is a six-piece, modular armchair, well designed to suit the seated body. Its geometric, see-through, and linearly fluid design make it seem like a three-dimensional Constructivist composition, but its expressiveness is reminiscent of Dada automata. The advertising leaflets featured a photograph of a young woman wearing a silver mask and Bauhaus clothing sitting in the seat. Like the gentle alien relaxing in it, the B3 came from distant galaxies and a science-fiction future.

Top right:
Erich Consemüller
Ise Gropius
(or Lis Beyer?) with
a Silver-Plated Mask
by Schlemmer, on a
Seat designed by
Marcel Breuer
1926, original print.

Right:
Karl Hubbuch
Hilde with a Hair-Drier,
Bicycle, and Seat by
Marcel Breuer
1928–29, lithograph and
watercolor on cardboard.
Sammlung Huber,
Offenbach.

Marcel Breuer
B3 ("Wassily") Seat
1925.

Frank Lloyd Wright: The Modern Movement and Regional Architecture

Trained in Chicago at the well-known firm of Louis Sullivan, Wright made an outstanding contribution to the new architecture at an international level, though he only partly upheld the proposals and tendencies of the Modern Movement, from which he distanced himself on certain aspects.

Unlike the European architects considered above, Wright was interested in the traditional Anglo-Saxon, single-family home. He considered the use of local materials and architectural traditions indispensable, and he took as his starting point the open vastness of the natural world rather than the inhabited, shared urban space. This last point is evident even in his urban projects, which he endowed liberally with green areas. The architect of both elegant and functional solutions, and willing to work with new materials, Wright preferred to keep his distance from programmatic solutions.

Designed for businessmen and wealthy professionals, his prairie houses are examples of the quality housing made possible by the liberal, prosperous society of the early twentieth century: large, comfortable, and welcoming, they are not excessively official in nature, and relate harmoniously with their surrounding environments without overshadowing them. They feature large, horizontal spaces, sloping roofs, and open galleries. "Organic architecture more or less means organic society," he said, and went on, "An architecture inspired by this ideal cannot acknowledge the laws imposed by aestheticism or mere taste, just as an organic society should reject any external imposition on life that

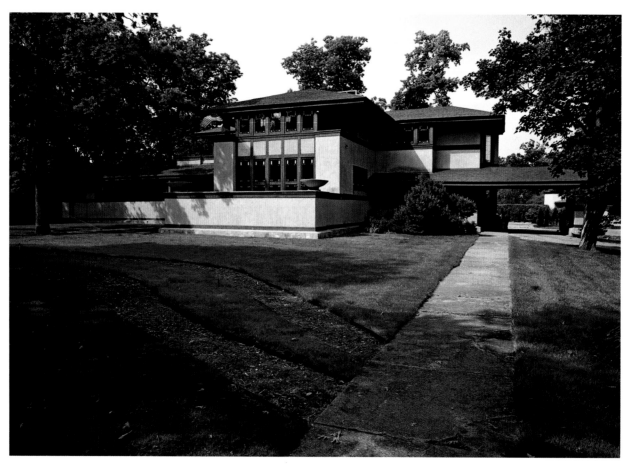

Frank Lloyd Wright
The Willits House
1902.
Highland Park, IL.

contrasts with nature and the character of the man who has found his work."

Built at Ohiopyle (Bear Run, Pennsylvania) in 1936, the famous Fallingwater house is the most appropriate example of how, according to Wright, a design neither comes before nor dominates its surrounding environment, but is more an architectural interpretation of certain environmental, climatic, and geologic conditions. The care with which the American architect studied the plan of the building was such that no trees had to be cut down on the site.

The cladding of the pillars was made from local stone, and the shape of the house (commissioned by Edgar J. Kaufman), with horizontal stories that project outwards into empty space, was suggested by the layers of rock beneath. The house and spaces are open plan: the walls are not load-bearing and are reduced to the minimum.

Fallingwater was Wright's first project to experiment with the properties of elasticity and firmness of reinforced concrete; however, the building's style reflects a deep knowledge of traditional architecture in Japan (where the architect had worked between 1916 and 1922), and the use of new construction techniques respected the site as much as possible in order to integrate the natural environment and the building harmoniously.

Photography as Science and Art

Between the two wars photography consolidated its status as an art form and dialogued in multiple forms with painting, sculpture, architecture, installations, cinema, advertising, and poetry. It explored nonfigurative dimensions, competed

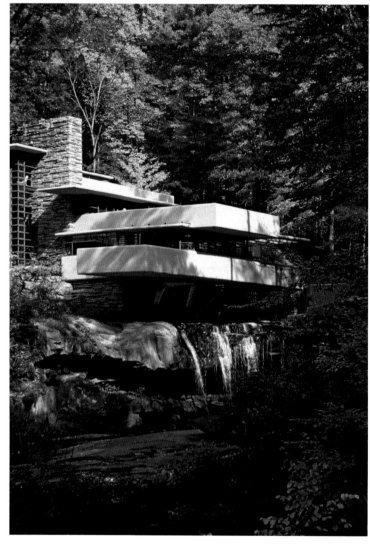

Frank Lloyd Wright
Views of Broadacre City
1934–58.
The Frank Lloyd Wright
Foundation.

Right:
Frank Lloyd Wright
Fallingwater
1936.
Ohiopyle (Bear Run, PA).

with novels discussing society and customs, helped introduce the positive sciences to the "objective" processes of cataloguing and documentation, and contributed decisively to the revitalization of advertising graphics and political propaganda, eventually in close relationship with film— the Soviet Union was a prime example of how art and revolutionary ideology could be combined. Free of programs and theories, photography was used in experimental and "improper" procedures (like the camera-less prints made by Christian Schad and Man Ray) and contributed to the popularization of the most anti-ideological figurative genre, the nude.

The Photographic Book

There was great diversity in how photography was used. The photographic collages of Lazlo Moholy-Nagy concentrated on creating visual poetry: the images of Albert Renger-Patzsch exemplified the dissociating formalist principle of Neue Sachlichkeit, and were hardly aware of the political and social transformations being experienced in Germany at the time; and Hans Bellmer, partly following the examples provided by Picasso, Duchamp, and Man Ray, planned his sculptural and installation works (whether in the studio or outdoors) starting from the photographs he would be able to take of them, and thus for which he built a photographic set. At the opposite end of the Modernist photography spectrum were a broad assortment of narrative cycles, whether diaristic, fantastic, epic, novelistic, or (war) journalistic. With regard to the last,

From the top:
Aleksandr Rodchenko
Young Pioneer
1930, original print.
Rodchenko and
Stepanova Archive,
Moscow.

Laszlo Moholy-Nagy
*Between Sky and
Earth II*
1926.

Leni Riefenstahl
*Festival of Beauty at
the Olympiastadion*
1936, frame from the
film *Olympia.*

the most memorable were the reportages by Robert Capa and Gerda Taro on the Spanish Civil War in *Death in the Making*, published by André Kertész in 1938 (the book's cover showed Capa's famous image of the shooting of a militiaman). Photographic books were very popular during the 1920s and '30s and their wide circulation increased the influence of photography and photographers in avant-garde circles.

Social Anthologies

August Sander's "social anthology" of the "people of the twentieth century" was one of the broadest and most ambitious in the Neue Sachlichkeit sphere. The project had its origin in the early-twentieth-century debates on art, evolution, and biology. The prewar photographs took the farmer as their "archetype" and portrayed human "types," temperaments,

Above:
Albert Renger-Patzsch
Cover of "Die Welt Ist Schön" ("The World Is Beautiful")
100 b/w photographs, Kurt Wolff Verlag, Munich 1928.

Above:
Karl Blossfeldt
Cynara Cardunculus scolymus
1928, b/w photograph, from the book *Primordial Forms of Art*.

Top:
Robert Capa
Death of Loyalist Militiaman Federico Barell García
Cerro Muriano, 1936.

Cover and frontispiece of Death in the Making, 148 b/w photographs by Robert Capa and Gerda Taro, Covici Fried Inc., New York, 1938.

Dorothea Lange
Cover of "An American Exodus. A Record of Human Erosion"
112 b/w photographs by Dorothea Lange, text by Paul S. Taylor, Reynal & Hitchcock, New York 1939.

Between the Two Wars

Themes, Styles, and Movements

and characters. The viewpoint lay outside of historical events, and the photographer seemed to be investigating the obscure depths of organic processes, and the ways in which "culture" and "native soil" interact in order to discover causal nexuses, "degenerations," and atavisms. Unlike painting, "photography makes it possible to portray the world as much in magnificent beauty as horrendous reality." As Sander said in 1927, initially he wished less "to give as faithful an image as possible of our time" as to create an evolutionary map of humanity on the model of the biological and ethnographic sciences. The entire series of photographs was characterized by the romantic theme of the double.

The photographer's eye is not attracted by the superficial but moves directly to an origin, an "essence" of a certain place or mood.

"I chose the farmer as an archetype," Sander remembered in 1954. "The models in the anthology were born in the small area called the Westerwald. Men I had known since my youth seemed to me to represent my idea of a social anthology due to their relationship with nature."

Paris by Night

The series of photographs Brassaï (Gyula Halász) took of Paris introduces us to the city's hidden life. His narration is never official: led by the author's hand through the thick winter fogs and deep shadows, we are also present at the noisy celebrations and hard toil of the workers at Les Halles and of the rail track cleaners, the nighttime activities of tramps and clandestines, the ambivalent cheerfulness of prostitutes, the secret meetings of homosexuals,

August Sander
Farmers' Sons
1913.
Die Photographische
Sammlung/SK Stiftung
Kultur—August Sander
Archiv, Cologne;
SIAE, Rome, 2005.

the daily ritual of breadmaking, and the challenges posed one another by the police and thieves. The emphasis is placed on history and narrative, though this is no more than suggested. It never falls on form alone, even if the photographs are not instantaneous and assume, in addition to careful lighting, the agreement if not the pose of the model. "The artist is distinguished by two gifts," wrote Brassaï, "on one hand, a particular awareness of life, and, on the other, the ability to capture it. It is never a question exclusively of form." In Brassaï's case it is clear that the artist had a strong feeling for the "underbelly" of the metropolis: nor did he miss the many stories of the migrants and exiles who arrived in Paris from all corners of the earth.

In the face of the young black meat porter, snow-covered Vespasian statues, African dancers, and nightworkers, a slight melancholy is discernible: solitude and hardship mingle with the engaging spectacle of the multitudes spurred on by the twin drives: the need for money and personal desire.

Modernism and Documentary Photography in the United States: Edward Weston, Paul Strand

Magnificent, sensual, technically perfect, the photographs of Edward Weston provide perfect examples of the direction Modernism took in the United States, in particular at the end of about two decades of pictorialist aesthetics.

Attracted by the opportunities the country's post-revolutionary government seemed to offer artists, Weston went to Mexico in 1923 with Tina Modotti, and there developed the taste for control, strong definition, and

Brassaï
Morris Column
1933, Avenue de
l'Observatoire, Paris.
© Estate Brassaï—R.M.N.

Brassaï
*Négus (Meat Porter
at Les Halles)*
1935, Paris.
© Estate Brassaï—R.M.N.

compositional elementariness that would characterize his work for the rest of his career. European and American precedents existed for this approach: Weston recognized the importance of Paul Strand's photography to his own later stylistic development, and direct knowledge of Cubist compositional "devices" (as well as perhaps a curiously formalized interpretation of Duchamp's urinal) fostered in New York at the time—in Strand no less than in Charles Sheeler—an interest in the efficiency of an electromechanical lathe and the polished perfection of an industrial standard.

Weston's Mexican photographs deliberately refrain from including disturbing, emotional, or obscure narrative. They seem conceived to place the emphasis on the photographer's ability, and to attest to the perfect appropriation of a theme or motif.

Weston's eye captured pure plastic forms, moving contrasts of black and white, and nude bodies carved by light. Faces, landscapes, and objects push their way out of the edges of the frame, and monumentality, compactness, and internal closure are morphological characteristics seen again and again in narrations that are often heroic, centered on the wilderness of the south, the victorious people, and the boundless euphoric beauty revealed by his new photographic language.

Paul Strand
Lathe, Akeley Shop
New York
1923.
© 1971 Aperture
Foundation Inc.,
Paul Strand Archive.

Facing page:
Edward Weston
Hand of Amado Galván
Tonalá, Mexico 1925–26.
Collection Center for
Creative Photography
© Center for Creative
Photography,
Arizona Board of Regents.

Tina Modotti
Illustration for a
Mexican Popular Song
1927.

Tina Modotti
Child Sucking Milk
1926.

Participative Niewpoints: Tina Modotti

Having arrived in Mexico with a different background, Tina Modotti—of Italian origin—acquired her perfect technique progressively as a result of her relationship with Weston. The celebration of form, however, was never for her an end in itself. Her gaze was more composite and participative, more desirous of capturing details, actions, and human or social events: the mother suckling her baby, the young revolutionary with her flag over one shoulder, an old woman carrying an earthenware pot on her curved back, and workers protesting in the street.

Her interest focused on the political and "personal" together, almost foreshadowing the sensibilities and positions of the minority movements of the 1970s. The point of view she insistently searched out was that of the simple human being hard at work performing obscure but valuable labor.

Modotti dedicated an entire series of photographs to the hands of people who carry out humble work—for example, farmers, washerwomen, etc.—and in the studio created "revolutionary" still lifes, emblems of expectations, hopes, and the historic processes in progress in Mexico in the 1920s and 1930s.

The Informal
Decade

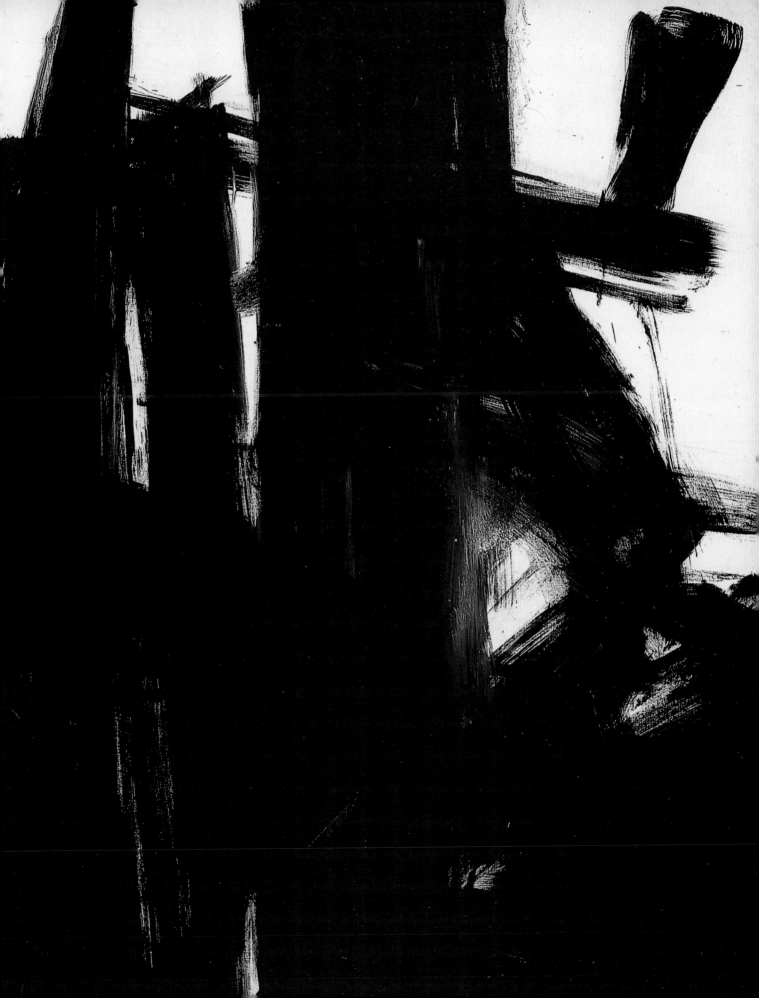

Jean Dubuffet
The Cellarman
May 1946, oil and mixed techniques on canvas.

Right:
Jean Fautrier,
Hostage's Head No. 16,
monogrammed
"d.b.d.:F.45"
1944, pastel and oil
on canvas paper.

Below right:
Henri Moore
*Reclining Figure
and Red Rocks*
1942, ink and
chalk on paper.
The Trustees of the
British Museum, London.

Below:
Antoni Tàpies
Newspaper Cross
1946–47.

Preceding page:
Franz Kline
Black Iris, detail
work illustrated on
page 125.

Informel, Art Brut:
Explorations and Restlessness

In some ways the first decade after World War II seemed to be a continuation of the period *entre-deux-guerres*, harking back to late Surrealism and concrete abstraction, as well as to the painting of sign, field, and color, and experimentation with varied or "improper" techniques, such as collages, assemblages, and ready-mades. The abstract tendencies seemed characterized by a greater opening up to emotion and narration, and were renewed by their relations with organic forms and, in particular, calligraphy and hermetic writing. There was a hybrid flowering of schools and new directions, and the period was typified by a greater mobility of techniques, styles, cultural suppositions, and the crossing of geographic and linguistic boundaries.

Informel and *Art Brut* radiated internationally from Paris: exponents of these tendencies started out painting together and shared nonstandard routes that cannot easily be traced to such simple interests, like those of Wols and Dubuffet, in children's art, psychiatry, and caricature. New

research into the matter used to create art led to new, forceful areas of expression and encouraged art to go beyond itself, to enter the fields of irreverence and impudent nonconventionality, to explore such territories as the "low," the "obscure," the "repugnant," the "failed," and excrement. And, on the other hand, to celebrate desire.

In Europe artworks were mostly small-format, biting, licentious or pensive series of works approachable like moments of private reflection, almost diaristic notations on the relationship between power and violence, the vulnerability of the living, and the destructiveness of history. Or, once the first, most tragic postwar years were past, inventive repertoires of signs animated by freedom of thought and emotion.

Paris / New York

Following the war, the intellectual diaspora from Europe, and the inevitable transfer of culture and skills, international cultural sociology and geography were profoundly altered. Around 1950 it became clear that Paris was no longer the capital of art and that New York was rapidly staking a claim due to the liveliness of its cultural scene, the multiplicity of its offerings and references, and the generous availability of wealthy collectors. A new generation of artists uninhibitedly moved beyond Europe's most recent traditions, experimented with completely new formats, and practiced intuitive, anti-ideological and highly emotional abstraction.

Viewed in hindsight, and completely unknown to the individual artists, contemporary art was entering the game of politics: the dizzying rapidity with which "Abstract Expressionism" or action painting became established was contributed to by the American administration and government agencies during the Cold War as part of their remote jousting with the Marxist enemy: in the eyes of politicians, diplomats, and strategists in international relations, artists are a dazzling advertisement for a society, a form of politics, and an economic-industrial system, and as such are assets to be protected and exported. In the United States in the late 1940s and, above all, with Jackson Pollock (see pages 134–135), a new social status was emerging for the artist, who until this time had felt at ease only among the restricted circles of collectors and intellectuals; with a talent for promoting himself, Pollock had himself filmed, photographed, and interviewed. His fame grew enormously in his late period, and the popularization of his work on a simplified and spectacular level, rather like an illustrated magazine, enticed a larger public than normal to approach contemporary art.

121

Above:
Jean Dubuffet
Figure in Butterfly's Wings
Aug.–Oct. 1953, butterfly wings. Private collection, Switzerland.

Left:
Wols
Butterfly Wing
1946–47, oil, grattage, pieces of quill on canvas. Centre Georges Pompidou, Musée National d'Art Moderne, Paris.

Below:
Jules Bissier
28. XI. 56 (Hagnau)
1956, tempera and oil on linen.

Louise Bourgeois
*The Blind Leading
the Blind*
c. 1947, painted wood.
Robert Miller Gallery,
New York.

Roberto Matta
Interior Landscape
1939, oil on canvas.
Gordon Onslow-Ford
Collection, on loan to the
San Francisco Museum of
Modern Art.

The Development of an American Idiom

One of the reasons the cultural center shifted from Paris to New York so quickly was that, even in the 1930s, expatriate Europeans like Hans Hoffmann transferred the Expressionist and "spiritual" legacy to the United States, demonstrating a different use for the abstract research carried out in Europe in the early twentieth century, one that was neither repetitive nor predictable like late Cubism. During wartime the influence of the many Surrealist exiles gradually became more apparent, from Ernst to Masson and Breton, and from Dalí to Matta and the young Louise Bourgeois. The art circles of New York, partly composed of European emigrants like Arshile Gorky and Willem de Kooning, experienced a phase of fervid acculturation. "In the first half of the 1930s," remembered Clement Greenberg, an art critic and traveling companion of artists such as Pollock, Clyfford Still, Mark Rothko, and Barnett Newman, "it was as if the answer or solution had to depend on a more complete assimilation of Paris."

Rothko's compositions of the New York subway system at the end of the 1930s established an implicit comparison between painting and photography. (The artist addressed a public that he knew well in the years immediately before the same subway system became the theme of famous essays by photographers like Paul Strand and Aaron Siskind.) Whereas photography captures the most fleeting historical and social reality in unrepeatable detail and fixes it on film, painting (in Rothko's view) deals with more perplexing and elusive dimensions, such as nuances, emotions, and sensorial thresholds. Like the stairway down to the subway, it leads into a different, dark, and subterranean world. Rothko ignored all concrete circumstance: the forms are stripped of interest,

Mark Rothko
Entrance to the Subway
1938, oil on canvas.
Kate Rothko Prizel
Collection.

Arshile Gorky
Creating the Calendar
1947, oil on canvas.
Museum of Art,
Munson-Williams-
Proctor Institute,
Utica, NY.

The Informal Decade

Clyfford Still
Untitled
1955–56, oil on canvas.
The Menil Collection,
Houston.

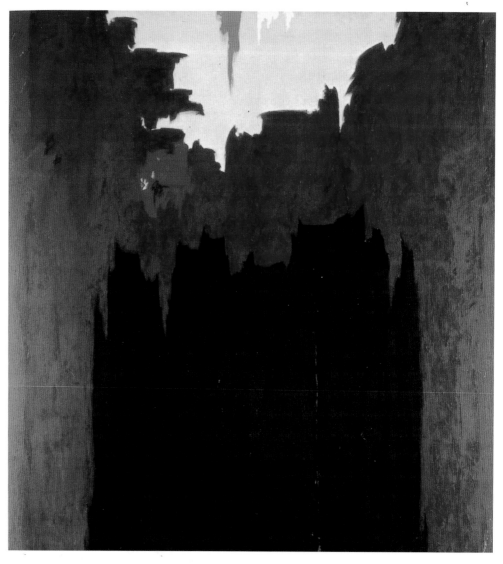

and remain undifferentiated and formulaic—nothing but outlines or schema. In terms of ideograms, the exercise in abstraction restores perceptible appearances in decidedly post- or neo-Impressionist, almost Nabi, ways.

The cultural institutions of New York, such as the MoMA, encouraged Modernism but, being closely attached to the tradition of naturalistic art, did not endorse the more recent trends. Further, the prestige that surrounded Picasso was so great that it did not encourage innovation. In just a few years, however, all models and references were to change. Towards the end of the decade Klee,

Miró, and the early works of Kandinsky became known and appreciated in New York almost as much as in Paris. (Superb Expressionist canvases by Kandinsky were acquired by the Museum of Non-Objective Painting, today the Guggenheim.) The premises were therefore laid for compositions in which such concepts as construction and grid were of much lesser importance. Works could be built using the more freely expressive dimensions of design and color, in large formats, and created a genuinely American idiom able to break with the School of Paris, leaving behind the light obsession with "taste," *bonne peinture*, and easel painting.

An American Art

The conviction that American art, or more particularly Abstract Expressionism, could compete equally with European art, or even forge ahead, emerged in the early 1940s, though it only fully developed a decade on (and was not to take on markedly nationalistic-cultural characteristics until even later). It was certainly not a movement, nor even a trend, and the artists involved differed greatly among themselves, not sharing the same aims as a school would require. The advances took their cues from multiple premises eclectically and surprisingly composed, most of which were derived from the European Modernist tradition (but not all: the cases of Mark Tobey, Ad Reinhardt, and to a certain extent Franz Kline are significant for their inclusion of Middle and Far Eastern calligraphic traditions). For example, late-nineteenth-century models—who cannot recognize the art of Edouard Vuillard and Pierre Bonnard behind Clyfford Still's fringed colored outlines—were combined with analytical Cubist and late Cubist techniques and styles, amplified treatments of automatic drawing, the Surrealist interest in archetypes and myths, and the preferences accorded to hard, impetuous design, and crumbled color applied to an opaque, absorbent, and rough surface, typical of Mexican mural painting. There was also some agreement on the dimensions of the works, their emotional attitudes, and narrations: the breadth of the canvases is overwhelming and changes our method of perception and ambience, as, when we stand before the painting, we are unable to take in the edges or the frame; if we do, it occurs only accidentally and on the periphery of our sight. Our historical and cultural references dissolve and appear to be replaced directly and immediately by dimensions of expression and emotion. The works are frequently without a title, given a simple number— *No. 58*—or tautology, for example *Painting* or *Abstract Painting*, which adds nothing to the work in itself. The value of transcriptions or literary paraphrases relating to images that hover on the boundary between formulability and nonformulability is reduced, like that between silence and absence of language. When an evocative title is given, the emphasis often falls on a specifically sensual dimension of the painting, which is to be understood both as a painted canvas and as a "performance" by the painter.

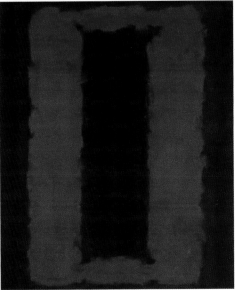

Above:
Franz Kline,
Black Iris
1961, oil on canvas.
The Panza Collection,
The Museum of
Contemporary Art,
Los Angeles.

Top left:
Barnett Newman
Eva
1950, oil on canvas.
Tate Modern, London.

Left:
Mark Rothko
Untitled (Seagram Mural)
1959, oil and acrylic on canvas.
The National Gallery of Art, Washington, D.C.
A gift from the Mark Rothko Foundation.

Below:
Ad Reinhardt
Abstract Painting, Black
1954, oil on canvas.
Marlborough
International Fine Art.

The Informal Decade

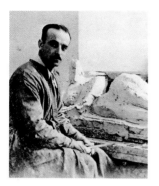

Lucio Fontana in his studio.

Lucio Fontana
(Rosario di Santa Fé, 1899–1968, Comabbio, Varese)

A pupil of Adofo Wildt at the Accademia di Brera, in the eyes of his master Fontana immediately proved an artist of great talent, dynamically experimental and richly inventive. He was interested in what was happening in art circles in France, curious about prehistoric art—his first terra-cotta works display knowledge of the graffiti at Altamira—and the possibility of collaboration between the figurative arts and architecture. After World War II, with Alberto Burri he became the most authoritative point of reference for young Italian artists: he wrote the "Manifiesto Blanco" (1946) and "Technical Manifesto of Spatialism" (1951), the latter for the movement he named. He created the famous series of *Ambienti*, installations featuring lights, colors, and shapes in three-dimensional spaces. The series of *Spatial Concepts*—monochrome canvases featuring one or more slashes with a knife—was started in 1951. Underlying many of the post-Informel tendencies of the late 1950s, Fontana also heralded the conceptual trends that followed immediately after.

Lucio Fontana
Spatial Concept, Waiting
1960, oil on canvas.
Civico Museo d'Arte
Contemporanea, Milan.

His series of *Concepts* clearly express irritation and annoyance: they show what Fontana defined as a "transformation," or better, "the end of the painting" in the sense of a beautifully executed decorative object created using the skills of a craftsman or artist. Faced by the futile and ingenuously decorative dimension of art, Fontana created monochrome canvases violated by a knife: what interested him lay beyond the canvas, beyond the representative fiction, in the direction of artistic experience, of the "nothing…: and man reduced to nothing does not mean that he is destroying himself: he will become as simple as a plant, as a flower, and when he becomes so pure, he will be perfect."

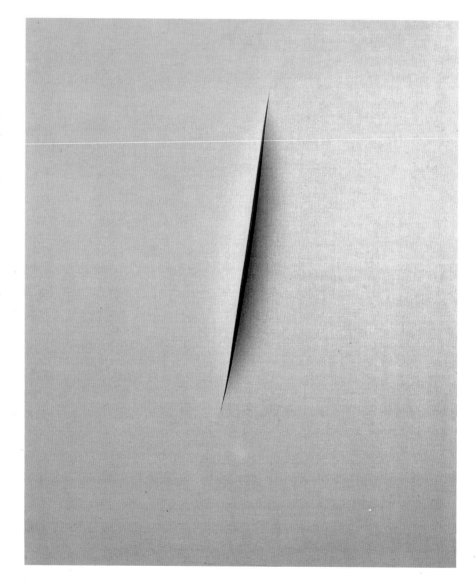

Willem de Kooning
(Rotterdam 1904–1997 New York)

De Kooning studied at the Academy of Rotterdam, and in 1926 embarked as an illegal immigrant to the United States. In Manhattan he came into contact with the circle of avant-garde writers and artists frequented by Gorky and Harold Rosenberg. He worked as a window dresser and house painter. He painted murals for the 1939 New York World's Fair and the same year took up painting full-time. His first solo exhibition was held in 1948. He showed abstract compositions executed in oils and enamels, in black and white. He returned to figurative painting immediately after, concentrating on the female figure. Exhibited at the Sidney Janis Gallery in 1953, his *Women* caused a sensation and brought him fame as the most gestural painter of his generation. From 1960 his compositions took on breadth and luminosity, and his figures and landscapes dissolved in the clear Atlantic light.

Willem de Kooning, 1950s.

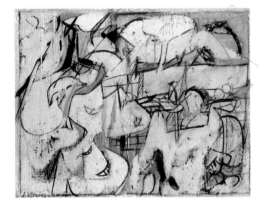

Willem de Kooning
Letter Box
1948, oil, enamel, and charcoal on paper
mounted on cardboard.
Private collection, Fort Worth.

The inclusion of scattered biomorphic elements endows a mostly abstract image with energy and a narrative quality. We see sneering mouths, a banana. The composition seems to have been conceived as a "letter box": the artist promulgates "news" and "messages" of the world of appearances as he playfully alters and erases areas of the composition, staging a sort of hermetic narrative.

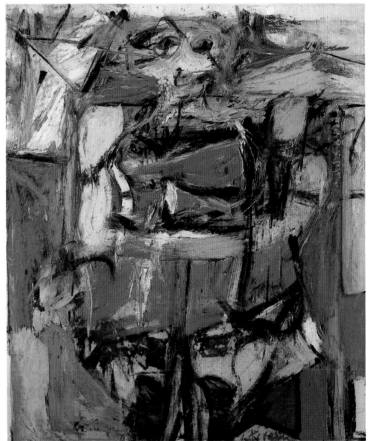

Willem de Kooning
Woman VI
1953, oil on canvas.
The Carnegie Museum of Art,
Pittsburgh. Gift of G. David Thompson.

The disjointed female body suggests play on two and three dimensions and emphasizes pictorial performance. The model appears humorously brutalized as the canvas is covered with fluid, sensual brushstrokes.

Mark Rothko in his Studio, 1964, photograph by Hans Namuth.

Mark Rothko
Untitled
1953, oil on canvas.
The National Gallery of Art, Washington, D.C. Gift of the Mark Rothko Foundation.

Described by Rothko as the "simple expression of a complex thought," the canvases of his last two decades focus on color and its subtle processes of irradiation. He applied many, modulated layers of paint. Slight interference between the colors where they meet creates the impression of movement and expansion, a dimension of emotionality and a capacity for transformation. Rothko often worked around basic contrasts, a dramaturgy of light and darkness, of severity and intimate delicacy. The total exclusion of a narrative dimension ensures that the images exist purely in terms of time and duration.

Mark Rothko
(*Mark Rothkowitz*, Dvinsk, Russia 1903–1970 New York)

Having emigrated to the United States in 1913, Rothko enrolled at Yale University and, in 1924, at the Art Students League of New York. With Adolf Gottlieb, he formed the Group of Ten. He exhibited at the Galerie Bonaparte in Paris in 1936. Rothko experimented with techniques and styles of the French School, with metaphysical and Surrealist painting, and researched archetypes and fragments of mythology—he called them "tragic, timeless themes" in the *New York Times* in 1943. He painted scenes of the subway system. He became an American citizen in 1938, and exhibited at Peggy Guggenheim's Art of This Century Gallery. He taught in San Francisco, New York, and New Orleans. Rothko's first large compositions with rectangular fields of color date to 1949–50. A retrospective at the MoMA in New York and important mural commissions (Seagram Building, Harvard University) confirmed his international success.

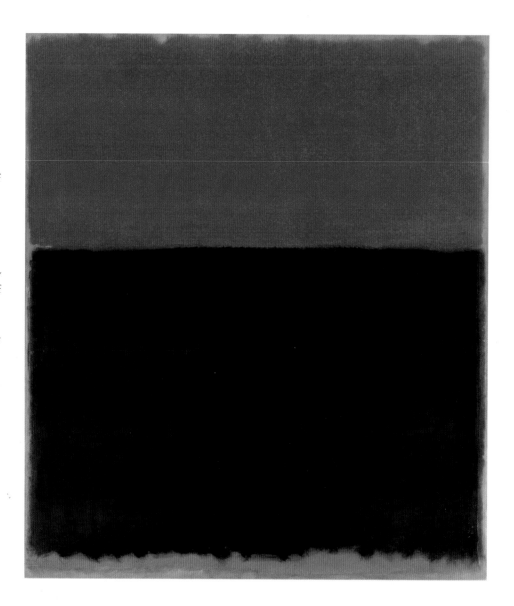

Mark Rothko
No. 10
1958, oil on
canvas.

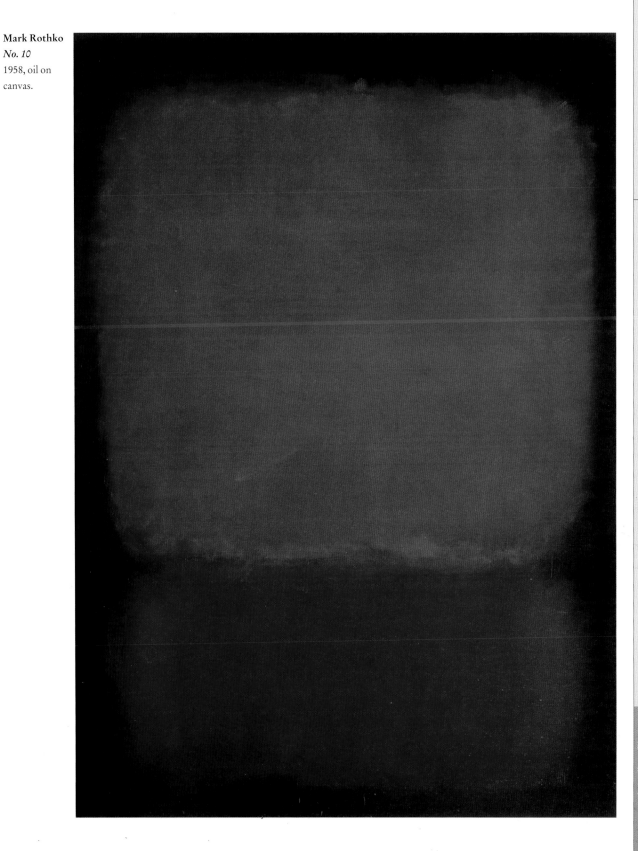

Francis Bacon
(Dublin 1909–1992 Madrid)

Francis Bacon, photograph by Irving Penn.

Self-taught, Bacon visited London in 1925, and Berlin and Paris in 1926. He remained in Paris for two years, working as an interior designer, then began to produce drawings and watercolors. He discovered the metaphysical work of Picasso in Paul Rosenberg's gallery and decided to take up painting. Residing in London from 1929, he exhibited in private spaces. He first achieved notice in the 1930s. Close to Victor Pasmore, Graham Sutherland, and later to Lucian Freud, in 1943 he executed *Three Studies for Figures at the Base of a Crucifixion*, which engendered both admiration and scandal. Bacon destroyed many of his pre-*Studies* works. In 1949–50 he painted deformed heads and portraits of popes. In 1954 he exhibited at the Venice Biennial. He visited Tangiers often in the years 1956–59. His work was exhibited widely at international level.

Francis Bacon
Study for a Nude
1951, oil on canvas.

Recurring features of Bacon's work are the human figure and the nude transposed onto a monumental scale. The artist reinterpreted traditional iconographic sources and compositional solutions typical of museum art in deliberately dark and atrocious images. In this work, a male model poses like a monkey in the dark space of a studio, in a posture that is regressive, prehistoric, and in some way hostile. He looks at the painter as though to challenge him, but at the same time his gaze seems aimed at us, the observers. A struggle is taking place, one that might be called a contest of love. A strand of eroticism is entwined with the violence. Behind the model a sort of small, cubic theater is the precursor of the boxes in which Bacon would later place many of his figures. On the ground is a ruler.

It seems almost as if the artist has illustrated the operations of the painter himself as he measures and fits the living body to the two-dimensional surface of the canvas: life, biology, and desire do not easily allow themselves to be arranged by the hand of man in accordance with formal standards.

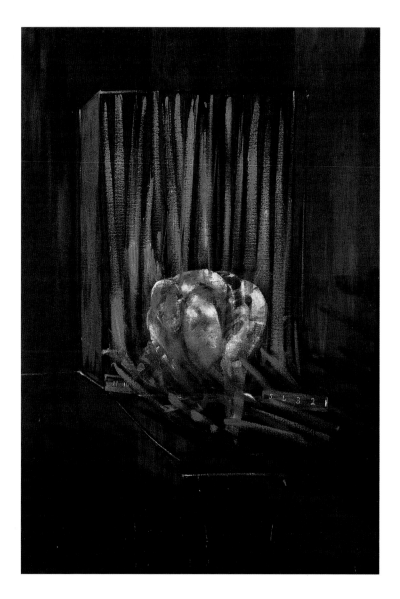

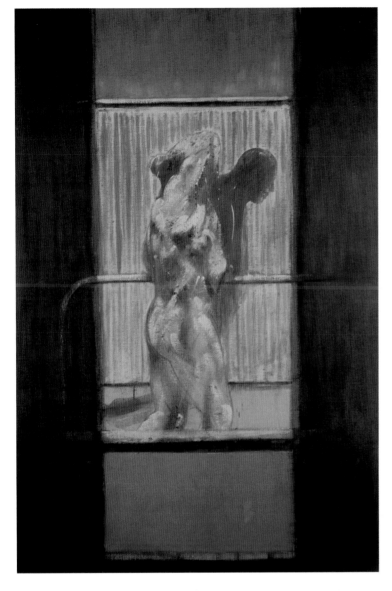

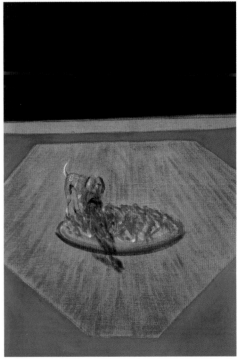

Below:

Francis Bacon
Dog
1952, oil on canvas.

The animal is the metaphor of the bloodthirsty nature of human society, the species. Bacon characterizes the image in a historical and anthropological sense through a quite specific reference: the shape of the singular lawn, where the tray of meat rests, derives in part from the sets installed during the 1937 Nazi conference in Nurnberg.

Francis Bacon
Painting
1950, oil on canvas.
Leeds City Art Galleries.

The construction of the painting betrays strong awareness of the modern tradition of the nude, from Degas to Picasso to Beckmann in the 1930s. The model poses against a backdrop of a curtain in the studio. The artist deliberately and ironically moves between two and three dimensions, decomposing and recomposing the body. Oil colors are used to deny the image brilliance and create the tonalities of a fresco. The colored, central section of the composition unrolls from the top downwards like the hanging of a Renaissance painted throne. The nude is vigorously sculpted, while the black lateral bands emphasize the surface of the canvas, thereby dissolving the spatial illusion. The red band at the bottom, rather like the outside of a bath, seems to perform a similar function: it "cuts off" the model's legs at the calves and emphasizes the two-dimensionality of the work. The shadow thrown is a *coup-de-théatre* that gives life and drama to what is otherwise an academic exercise. What is taking place in the artist's studio refers to life outside of the painting: it touches on magic, and reveals forces and powers.

Arshile Gorky, early 1940s.

Arshile Gorky
(Vosdanik Adoian, Khorkom, Armenia 1904–1948 Sherman, Connecticut)

Deciding to emigrate because of the genocidal persecution of Armenians by the Turks during and after World War I, the self-taught Gorky left Armenia for the United States in 1920. He taught at the New School of Design in Boston from 1920–22. In 1926 he taught at the Grand Central School in New York, and made contact with Stuart Davis and Willem de Kooning. In 1934 he had his first solo exhibition at the Mellon Galleries in Philadelphia, and in 1937 painted murals on the theme of aviation at Newark Airport. Gorky profoundly altered the techniques and style of each artist that he took as a reference: Cézanne, Picasso, Miró. After he was introduced to Surrealism by André Breton and Roberto Matta, his work moved in that direction. Following a series of serious personal misfortunes, he commited suicide in his studio in Sherman in 1948.

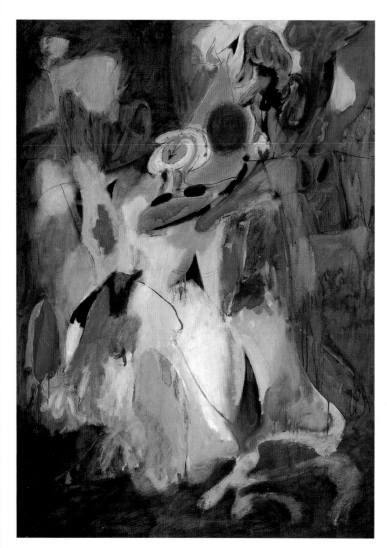

Arshile Gorky
Waterfall
1943, oil on canvas. Tate Modern, London.

A graphical element, a dart, introduces movement and organizes the observer's perception from the enigmatic red triangle at the top center of the composition. The central section is colored in yellow-orange tonalities, and ochre and flesh tones that suggest the delicate processes of organic life: turgor, tumescence, flux. The sides of the composition are rendered in mossy, dark green tones. Biomorphic elements with an elusive sexual connotation are seen inside and at the edges of the colored areas. The surface pulsates, becomes tangible, able to correspond emotionally and participate with the development of the painting.

Below:
Arshile Gorky
Orchard with Apple Tree
1943–46, oil on canvas.

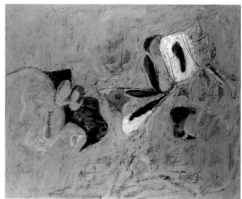

Alberto Burri
(Città di Castello 1915–1995 Nice)

Alberto Burri, 1980s.

A military doctor, Burri was captured by the Americans during World War II. He began to paint in a prison camp in Texas using whatever materials were available. Back in Italy, he moved to Rome. He gave up medicine for painting. From 1952 he executed compositions in sacking, sewing his pieces of burlap together like a surgeon. His work achieved international acclaim. He later worked with wood, burnt plastic, and iron, then began his "cracked" cycle of works. There is no shortage of figurative allusions in his compositions: it seems that Burri enjoyed evoking pictorial images even as he refused to paint them. It is perhaps more beneficial to consider the artist's work in light of its constructive nature than to search for elements of traditional or museum art.

Right:
Alberto Burri
Large Sack B
1958, burlap on canvas.
Staatsgalerie Moderner Kunst, Munich.

Burri was skillful at preserving elements of narrative and memories from the history of art in non-figurative and, for the most part, antipictorial compositions, for example the "wounds" (holes) inflicted on fabric, letters printed on bits of sacking, and sewn bits of material: these immediately capture our attention. The inclusion of bits of high quality material, like a strip of gold leaf, helps to aestheticize the "humble" materials and techniques typical of Arte Povera (art by impoverished artists). However, almost as though keeping his distance from refined, formalizing considerations of his work and recognizing instead their internal hardness, their contemporary adverse quality, Burri himself warned, "in my work there are neither signs nor symbols.... Certainly, anyone who looks will always find references, but if I wished to include references, I would do it differently."

Left:
Alberto Burri
Large Sack BS
1956, burlap, acrylic on canvas.
Kunstsammlung Nordrhein-
Westfalen, Düsseldorf.

Jackson Pollock
(Cody, Wyoming 1912–1956 Springs, Long Island)

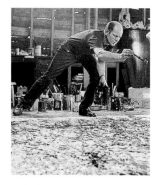

Pollock painting "One: number 31," detail of a photography by Hans Namuth, 1950.

In 1930 Pollock enrolled at the Art Students League in New York and studied under Thomas Hart Benton. In 1936 he was David Alfaro Siqueiros's assistant and took part in Federal projects to support the arts. He started psychoanalysis to weaken his dependence on alcohol. He combined regionalist, Surrealist, muralist tendencies with classical and Native American myths in an eclectic manner. He found constant admirers in Clement Greenberg and Peggy Guggenheim, and his first solo show was held at the Art of This Century Gallery. On Peggy Guggenheim's return to Europe, Pollock formed a partnership with Betty Parsons and Sidney Janis. In 1945 he left New York to live in Springs, Long Island. He experimented with large formats and the dripping technique. His works from this period brought him widespread fame. He died in a car accident in 1956.

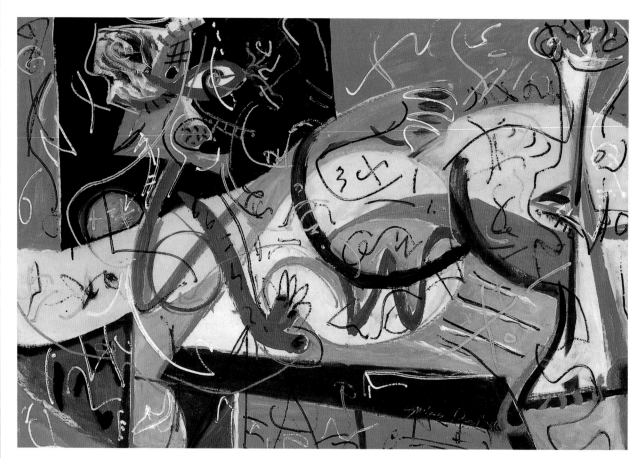

Jackson Pollock
Stenographic Figure
c. 1942, oil on canvas. The Museum of Modern Art, New York.

Early on, Pollock alternated styles and techniques: his models were the metamorphic Picasso of the late 1920s, Miró and Masson in automatic drawing, and Picabia for the use of transparency. This composition appears as though it were painted on two sides of a sheet of glass. The background represents the painter's studio, a place of transformation, where a certain reality, such as a nude, is transformed into an idol and archetype. But the canvas is also covered with signs and script, fragments of ritual experience that goes beyond the limitation of what can be represented, and which finds difficulty in communicating itself even through simple, radical means like figures.

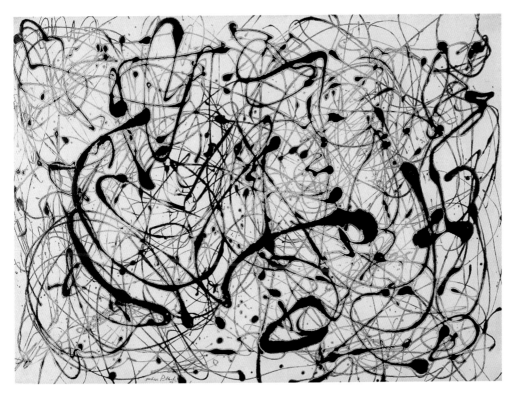

Jackson Pollock
Number 14
1948, enamel on chalk
on paper.
Yale University Art
Gallery, New Haven.
The Katherine Ordway
Collection.

Below:
Jackson Pollock
Lavender Mist No. 1
1950, oil, enamel, and
aluminum on canvas.
The National Gallery of
Art, Washington, D.C.
The Ailsa Mellon Bruce
Bequest.

From 1947 Pollock executed his works by placing the canvas on the floor and walking around it as he poured color onto it. At first it seemed to be a process of cancellation, because he poured colors over figures already partially painted. Later he used drops, filaments, overlays of pigment and vibrant, delicately atmospheric effects in images created in the manner of a performance, and which could vary greatly in size. He moved from small sizes to large and very large formats that called to mind the social and landscape traditions of mural and North American painting. Occasionally he worked on series of works, differentiated by the use of monochrome or polychrome, the preference accorded to metallic colors, the distribution of delicate traces or colored dots, and the inclusion of a figurative element often in a central position. Execution of his works was only partly spontaneous. Whereas, according to the artist, the images "may seem to have a life of their own," without technical or cultural mediation, we know Pollock reflected constantly on whatever work was in progress, that he prepared his movements and at every stage of the process checked to ensure he was avoiding compositional disharmony, opacity, and inertia, as well as the thickening of the color, which could halt the movement of energy in the composition and upset the balance and structure of the entire surface.

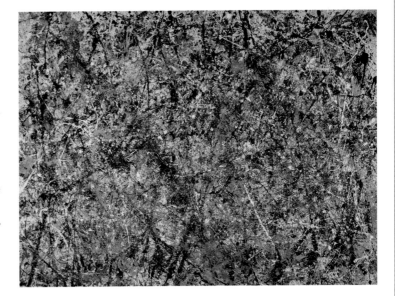

The
Neo-Avant-Gardes

138

Previous page:
Bas Jan Ader
Trap on the Path of
a New Plasticism
photograph of a
performance.
Westkapelle,
Holland, 1971.

From the 1960s to Today

The 1960s wrought a profound change on the techniques, styles, and social perception of art. The decade was marked by extreme differentiation in the artistic directions taken, new geographical areas of importance, and social transformations and divisions. It was in part characterized by the growing politicization of public opinion in the West, and critical historic events like the Vietnam War. Considered purely from a cultural and artistic standpoint, the 1960s represented the start of a series of explorations, reinterpretations and appropriations from the historic avant-garde movements that were to strongly affect the following decades.

Kinetic, Neo-Dada, and Pop Art: Processes, Institutions, and the Street

At the end of the 1950s, in both Europe and the United States, newly established antipictorial trends moved markedly away from Art Brut, Informel, and Abstract Expressionism. Monochrome paintings and ready-mades, as invented by Marcel Duchamp, were produced, irony and detached elegance became fashionable qualities, and great interest arose in works that developed autonomously, through processes that occurred without outside intervention or authorial "psychology."

It was in New York in particular that the change in taste was accompanied by an aggressive stand against the previous generation. The targets of the attack were Clement Greenberg (the critic and theorist), and the most gestural of the Abstract Expressionists, Franz Kline and Willem de Kooning. In the work of Jasper Johns and (even more so) Robert Rauschenberg, the relationship with the European Modernist tradition became less binding: whereas for Greenberg working within a particular technique meant taking that technique, whether painting or sculpture, to the limit of "purity and independence" by means of a constant process of improvement, the compositions of the younger artists were now incorporating images from the media and American popular culture, or personal micro-narrations.

A partial continuity existed in the anti-theoretical approach taken by neo-Dada and Pop: comic strips, cinema stars, and canned food made reference to an untheorizable world of private desires, small everyday fetishisms, routine, and slightly regressive gratification. Moreover, Pop Art—in the specific cases of Claes Oldenburg and Andy Warhol—was characterized by a particularly corrosive anti-aestheticism. From

Yves Klein
Blue Sponge
1960, pigment and
synthetic resin on sponge.
Private collection,
Lugano.

Far right:
Robert Rauschenberg
Erased De Kooning
Drawing
1953, traces of ink
and pencil on paper,
handwritten label,
frame in gold leaf.
Collection of the artist.

1963 Warhol turned his attention increasingly to cinema and rock, tangibly aiming, for both strategic and personal reasons, at a nontraditional public. From the viewpoint of collectors, connoisseurs, and visitors to Modernist museums, the blowing up on canvas of a bottle of Coca-Cola, ketchup, or an advertising caption was unacceptable because it ignored the elementary norms of artistic skill and cultural control: for Duchamp, what's more, the ready-made had already been the equivalent of "the total absence of good or bad taste...of a complete anesthesia."

Above:
Claes Oldenburg
Vanilla Flavored Ice-Cream Cone
1962, plaster and metal, enamel paint.

139

Above:
Andy Warhol
Empire
1964, video still.

Left:
Roy Licthenstein
Little Aloha
1962, acrylic on canvas. Sonnabend Collection, New York.

Minimalism

The innovations introduced to sculpture during the early 1960s were no less decisive. A distinctly modular and geometric approach evolved, based on detachment and impersonality in its presentation of a few basic solid elements placed either on the ground or hung from the walls, i.e., without a pedestal. Preferred materials were industrial, such as iron, steel, Plexiglas, and neon, but also paint, which dried to leave smooth, untreated surfaces. The process of construction and assembly was made transparent, and almost every work was no more than a simple prototype that anyone could repeat ad infinitum, with no hidden tricks included in their execution. Artists tending towards Minimalism were fervently against following the European tradition to which, through Giacometti and Brancusi, they were connected in many aspects, and there was a strong determination to move in a different direction through the adoption of "humanistic" theories and formulas, and to modify the existing relationship between an artwork and its public. In particular, the artist and critic Donald Judd attacked the "structures, values, sentiments" associated with the Modernist canon, above all the sense of completeness, totality, and elegance that, in his opinion, derived from the idealistic aesthetic and was still an attribute of the abstract or abstract-organic sculpture of the 1950s. One of his favorite targets was the work of Anthony Caro.

Taste, ability, and connoisseurship—three requisites of the Greenberg school of art critics—were rendered extraneous if, as Judd wrote in "Specific Objects," a sort of essay-cum-manifesto of 1965, an artwork no longer included many different details to look at or aspects to compare. What was of interest was the object in its entirety, the quality of its entirety. The things of greatest significance were unique and intense, clear and powerful. Sculpture's public was asked to involve

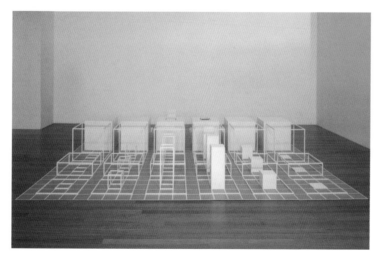

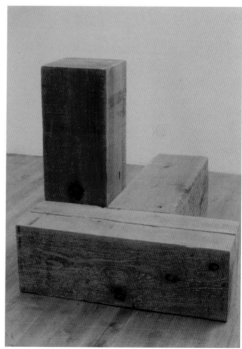

itself in appreciating a work of art, not simply on an aesthetic and contemplative level through their vision, but by experiencing the work directly and corporeally. For example, in scattering large, many-sided, sharp-edged objects on the ground, Robert Morris was creating a microlabyrinth which the observer was asked to enter and experience: it was impossible to consider the work without becoming acutely aware of the difficulties it imposed on movement.

Seriality and Repetition in Photography

The focus on simplicity, seriality, and clarity also governed photography in Europe as well as in the United States. It continued its exclusive use of black-and-white film to distinguish itself as much from amateur photography as from the vivid color saturation of *National Geographic*.

The focus was on documentary and catalogue work, to distance itself as far as possible from the rhetoric of the "lyrical," "heroic," or "ingenious" shot, and the gaze of the photographer aimed to be impersonal. Bernd and Hilla Becher produced a series of photographs of nineteenth-century industrial architecture and archaeology that at the time went completely unnoticed: it included wind and water mills, chimneys, silos, gas cylinders, mining constructions. John Baldessari photographed the backs of trucks that he encountered while driving on the highway from Los Angeles to Santa Barbara. The inclusion in the title of his installation of the day the photographs were taken *(The Back of All Trucks Passed While Driving from Los Angeles to Santa Barbara, California. Sunday 20 January 1963)* meant that the event went beyond the photographic theme itself, and made reference to its existential nature and uniqueness. The performance occurred during a small and arbitrary arc of time, and no less haphazard was the place the event occurred—the highway— with circumstantial conditions that lay beyond the control of the photographer.

Ed Ruscha
Untitled, from *Various Small Fires and Milk*
1964, silver gelatin print.

141

Left:
Dan Graham
Homes for America,
from *Arts Magazine*
Dec. 1966–Jan. 1967.

Bottom:
Bernd and Hilla Becher
Winding Towers
b/w photographs.

Previous page, counterclockwise from top:
Dan Flavin
Monument 1 (to Lenin)
1964, white neon.

Donald Judd
Untitled
1966, steel and Plexiglas.

Sol Lewitt
Serial Project No. 1 (A, B, C, D)
1966, enamel on aluminum.
The Museum of Modern Art, New York.

Carl Andre
The Way North and East (Unsculpted Block)
Vancouver 1975, red cedar.
Paula Cooper, New York.

Above:
Richard Serra
One Ton Prop
(House of Cards)
1969, lead sheeting.

Below:
Walter De Maria
The Lightning Field
1971–77.
Quemado, NM.

Fascinated by Duchamp, whom he discovered at a solo show held in Pasadena in 1963, and also close to Pop Art, Ed Ruscha created collections of pictures that were more or less openly serial. In *Twenty-Six Gasoline Stations* (1963) he showed photographs of gas stations on Route 66 between Los Angeles and Oklahoma City, where he was living at the time. They are cinematic pictures of the United States, whose extremely simple images tell stories of adventure featuring hopes of success, frontier values, and mobility.

In *Various Small Fires and Milk*, a book published in 1964, Ed Ruscha played with visual analogies and surprising passages between images, and a year later created photographic records of condominiums in Los Angeles and all the buildings lining either side of the Sunset Strip.

Dan Graham's reportage *Homes for America* was the first attempt to develop a photographic essay by an artist in a popular magazine. Attracted by the requirements of modularity, elementariness, and repetition, Graham approached the terraced housing typical of American construction after World War II as a minimal ready-made. The artist-sociologist seemed to regard the homes from a formal and soberly typological standpoint, but his interest in the architecture of middle- and lower-middle-class-residences betrayed his desire to employ the new artistic directions outside the contemporary art center or gallery and to mature a historical, political, and social agenda. At the time of publication, Graham's project did not achieve the success he hoped for: the editor of the magazine chose pictures by Walker Evans to illustrate his text. However, exhibited later in slightly different versions, as either a collage or lithograph, *Homes for America* lay the foundation

for the artistic exchange that would later take place between publishing and art galleries.

Anti-form, Earthworks, and Land Art

From the late 1960s art galleries and museums increasingly became the target of criticism by artists. Post-Minimalism began to take root in the United States. (In 1968 Morris offered the definition "anti-form.") The emphasis had moved, not towards compactness and closure, and the repeatability of the industrial standard, but to incompleteness, disharmony, structural weakness, and fracture. Artists associated with the Earthworks movement built piles of rubble, rocks, installations made of earth and grass, and jets of steam, with the purpose of mobilizing the public, creating unstable situations with organic or rejected materials, and denying the prerequisites for the permanence, cohesion, and solidity traditionally associated with a work of art. At first they brought sections of the natural or industrial landscape into the gallery, but later artists like Robert Smithson, Walter De Maria, Denis Oppenheim, and Michael Heizer chose to act directly on the landscape, outside of the institutional spaces of art and culture. They selected natural settings, mostly either in the desert or semi-desert, for projects that were often monumental in scale, and realized with an impressive array of mechanical equipment: artificial hollows, sculpture-temples, fields of energy, asphalt strips, and bands of rocks and rubble laid out in a spiral in the waters of salt lakes. The aim was to create a legend around the artist, to develop narratives of youth, waste, and "energy." These convictions were partly shared by artists in Europe, who focused on installations and performances, for example in Holland Jan Dibbets

and particularly Bas Jan Ader, in Italy Pino Pascali (to a certain extent) and several of the artists involved with the Arte Povera movement. The interventions of British artists associated with Land Art, such as Richard Long and Amish Fulton, were non-invasive and centered on the simple act (both ritual and physical) of walking long distances in search of complete and immediate contact with nature.

Texts, Performances, Collective Projects: The Conceptual Decade

The increasing politicization of the international art scene prompted artists to develop more biting forms of criticism aimed at art institutions at the end of the 1960s and start of the '70s. With regard to conceptual art, the predominant forms were defining, contemplative works by such artists as Joseph Kosuth, Lawrence Weiner, Giulio Paolini, and the British collective Art & Language, analyses of the workings of the art system and museums by Hans Haacke, Carl Andre, Daniel Buren, and Marcel Broodthaers, and performances and civic, social, and environmental actions. From the early 1970s the connections between art and feminism were especially strong and contributed to pointing artistic theory and practice in a more tangible

Top left:
Bas Jan Ader
Fall II
1970, video still from the film *Fall II*, photograph published in the book *Fall* (Amsterdam 1970).

Above, from top:
Pino Pascali
Lianas
1968, steel wool.

Bas Jan Ader
I'm Too Sad to Tell You
1970.

Left:
Jannis Kounellis
Untitled
Rome, 1969.

Previous page, right:
Denis Oppenheim
Vortex (Eye of a Cyclone Created by an Airplane Controlled from the Ground)
El Mirage Dry Lake, CA 1973.

Michael Heizer
Double Negative
aerial view
Virginia River Mesa, NV 1969–70.

145

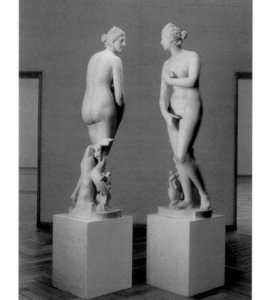

144

Right:
Giulio Paolini
Mimesis
1975, molded plaster.
Brandoli Collection,
Turin.

Far right:
Vito Acconci
Reception Room
1973, cushions, wooden
planks, metal seats,
pillowcase, spotlight,
sound.

Below:
Joseph Kosuth
Frame—One and Three
1965, four parts: collage
on cardboard; wooden
frame, Resopal panels.
Museum Ludwig,
Cologne.

Facing page, large:
Daniel Buren
Peinture-Sculpture
1971, acrylic on canvas.
Work exhibited at the 6th
Guggenheim
International, New York.

direction, in the investigation of the body, sexuality, and material culture. Distrust arose over the "universalistic" meanings usually associated with a work of art and emphasis was placed on "situated" minority points of view, both sexual and racial. Made possible in the early 1960s by movements like Fluxus and Situationist International, and even more originally by Duchamp and Dada,

this was the time of the "dematerialization of art," with emphasis on anti-object, analytical and performance dimensions. The production of images and three-dimensional objects gave way slowly to texts and enunciated theories, documentary photographs and videos, and collective projects. Formed in New York in 1969, the Art Workers Coalition proclaimed a famous "artistic discovery" in 1970: artists met on the steps of the Metropolitan Museum of Art to discuss art, politics, and art collecting. The consequence of the protest was the closure of the museums throughout all of the city of New York for the entire day. An anti-speculation and environmental reclamation project promoted by collectives of resident artists led in 1973 to the designation of SoHo as a historic, artistic district.

This column, from top:
Gordon Matta-Clark,
Splitting, New Jersey
1974, photograph.

Eva Hesse,
Access II
1967, steel and rubber
tubes.

Below:
Art Workers Coalition
Q. And Babies?
A. And Babies
1970, color lithograph.

Mierle Laderman Ukeles
Street Cleaning in
Hartford
1973, photograph.

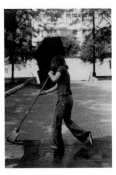

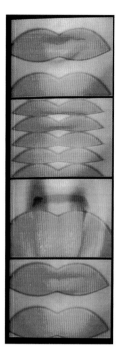

Above:
Gary Hill
Mouth Piece
1978, video still.

Lawrence Weiner
Remains of a Rocket Lit on a Borderline
outskirts of Amsterdam
1968–69.

Cindy Sherman
Untitled No. 96
1981, color photograph.
Saatchi Collection,
London.

Late Conceptualism and New Figuration

The years 1966–72 are usually considered the apogee of Conceptual Art, but the second half of the 1970s represented a gradual increase in interest in the culture of the image that was to lead to a full-blown return in the decade that followed. Installations, videos, and performances became more complex and aesthetically treated, costumes and furnishings took on special importance, and scene photography grew from being simply documentary to becoming an autonomous genre with its own conventions and visual rewards. The schism between artistic photography and photojournalism widened decisively: formats grew larger, poses and lights were used, and fictive situations with the appearance of reality were created. The photography of

architecture won particular attention: at the end of the Conceptual season, by which time a newfound, international, neo-Expressionistic interest was focusing on traditional techniques, drawing, painting, and sculpture, architecture seemed the discipline best able to ask important questions on the relationship between the public and private spheres, and broaden democratic participation. The diffusion of conceptual tendencies was matched in different locations by inventive borrowings, for example in the Soviet Union, or in Latin America where relationships were established between art and activism, figurative activities and ideological criticism by such figures as Hélio Oiticica, Cildo Meireles, and Alfredo Jaar. Between the late 1960s and early '80s, neo-Expressionist tendencies, which were highly fashionable, contributed to a new interest in

Above:
Philip-Lorca diCorcia
Mario
1978, color photograph.

Jeff Wall
Mimica
1982, color photograph.

Enzo Cucchi
Mediterranean Hunt
1979, oil on canvas.
Galerie Bruno
Bischofberger, Zurich.

Francesco Clemente
Map of What Is Effortless
1978, watercolor
on paper.
Anthony D'Offay
Gallery.

Facing page:
Markus Lüpertz
*Babylon
VIII–Dithyrambic*
1975, pigment and glue
on canvas.

Below:
Georg Baselitz
The Painter with a Cloak
1966, oil on canvas.
Kleihues Collection,
Berlin.

the history of art, the culture of the image, the role of museums, and national identity. The term "Transavanguardia" was coined to refer to eclecticism, the free and arbitrary artistic exchange between models, and the amused indifference shown towards the exclusive Modernist principles of stylistic "purity" and "rigor." The use of large formats and bright colors, and the attempt to rekindle magniloquence in painting— which was at times facile and inopportune— prompted succeeding generations to place more emphasis on conceptualism and control. The prominence given by Transavanguardia to art history, museums, and citation encouraged more knowledgeable research into art, and into the roles played by institutions, the public, the client, and the collector.

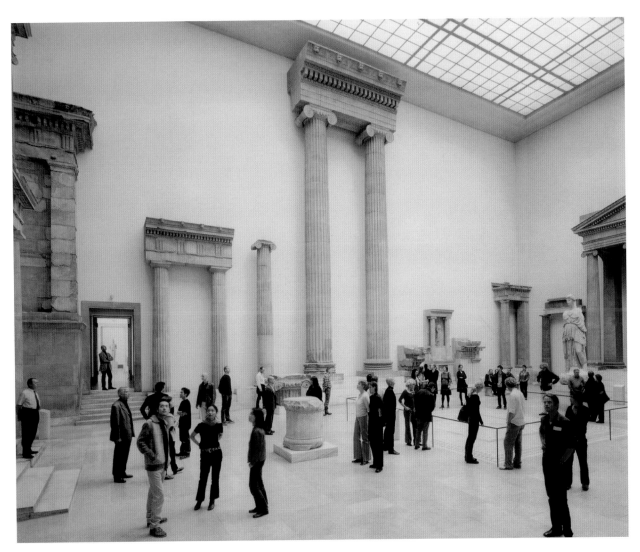

Thomas Struth
Pergamon Museum I
Berlin, 1990.

Andreas Gursky,
Prada I
1996.

Facing page:
Julian Schnabel
Arm
1979, oil, pencil and
photographic repro-
duction with cowskin.
Galerie Bruno
Bischofberger, Zurich.

The Neo-Avant-Gardes

Captions on page 154

A Civic, Environmental, Post-Colonial Agenda: Contemporary Neo-Conceptual Tendencies

Whereas the 1980s, particularly the first half, were characterized by the ludic and ritual interest in traditional techniques, from the end of that same decade, and with increasing frequency in the 1990s, installations, video, photography, and performances once again came to predominate, parallel to a return to the importance of form: this was at times ironic or discreet, at others lavish. Narration occasionally took on a mytho-graphic character and animation became fully accepted as a figurative genre, often combining comics, popular culture, and artistic research. Taking for granted the reductive nature of any generalizing description, it might be said that the neo-Conceptualism of the 1990s was aimed at increasing the participation of the public, not the market. In an attempt to create a broader spectrum of vehicles for social integration, artists

approached such fields as cinema, rock music and fashion, and even the sciences, particularly those relating to man and nature.

On a linguistic level, plurality and eclecticism now predominate: drawing, video, sound, photography, and installations are used promiscuously in

versatile, structured exhibition projects. Less emphasis is placed on a theoretical, considered approach: art is no longer the privileged object of interrogation and definition, but a vehicle for personal processes of mobility, migration, and diaspora. It asks questions about the ways in which cultural initiatives can broaden and deepen forms of social participation, and increase awareness and understanding in multicultural communities. Museums, galleries, and the art system as a whole are under examination with regard to the latest marketing and financial logic governing cultural investment. In the contemporary art scene—characterized by transnational museum exchanges, large cultural events, and biennials—it has become important to stimulate the public to adopt aspects of living not simply based on consumerism. The need has grown for innovative cultural institutions and for information on the most rapid processes of cultural, social, and political transformation; in consequence,

Above:
Matthew Barney,
Drawing Restraint 7
(Manual)
1993, video still.

Left:
John Bock
The Worm
2002, video still.

Below:
Jun Nguyen-Hatsushiba
Memorial Project,
Nha Trang, Vietnam.
For the Courageous, the
Curious, the Cowards
2001.

153

Above:
David Thorpe
*We Are Majestic in
the Wilderness*
1999, collage.
Rubell Family Collection,
Miami.

Right:
Tacita Dean
*The Sea with a Ship;
Afterwards an Island*
1999, blackboard
drawings.

*Page 152, counter-
clockwise from top:*
Robert Gober
Newspaper
installation, 1997.

Felix Gonzalez-Torres
Untitled
1993, installation.
Marieluise Hessel
Collection, on permanent
loan to the Center for
Curatorial Studies, Bard
College, Annandale-on-
Hudson, NY.

Gillian Wearing
60 Minutes Silence
1996, video still.
Hayward Gallery, Arts
Council Collection,
London.

Damien Hirst
*The Physical Impossi-
bility of Death in the
Mind of Someone Living*
1991, tiger shark, glass,
steel, formaldehyde.

Barbara Kruger
Untitled
2003. Spürth Magers Lee,
Cologne/Munich/
London.

Gabriel Orozco
Island within an Island
1993, Cibachrome.

Mark Dion
On Tropical Nature
1991, naturalists' display
cases, dried plants, insects.

Luc Tuymans
Leopard
2000, oil on canvas.
The Solomon R.
Guggenheim Museum,
New York.

Below:
Kimsooja
A Needle Woman
Nepal 2005, video still.

Antoni Muntadas
*On Translation:
El Aplauso*
1999.
"On Translation: Das
Museum," Museum am
Ostwall, Dortmund.

significant collaboration has been generated among artists, sociologists, anthropologists, city planners, and ecologists to relaunch hypotheses of "modernity" on an ethical level. Evidence of the surprisingly global nature of contemporary art is its unprecedented geographical decentralization and the success of artists whose lives straddle different cultures: the vitality of areas that till now have been marginal, such as the Near and Far East, Africa, and the Caribbean, today provides an element of invigorating novelty.

From top:
Thomas Hirschhorn
Les Plaintifs, les Bêtes, les Politiques
1995, page from the artist's book published in Geneva, Centre Genevois de Gravure Contemporaine.

Francis Alÿs
The Modern Procession
drawing for the MoMA brochure relating to the street performance in New York,
2002, pencil on tissue paper.

Top right:
Kendell Geers
Kendell Geers, Les Fleurs du Mal
2004, installation at the "Satyr:ikon" exhibition, Galleria Continua, San Gimignano, Italy.

Right:
Maurizio Cattelan
Untitled, detail
1998 (*The Interior with Mobile*, 1992, by Roy Lichtenstein appears in Cattelan's work with the permission of the Estate of Roy Lichtenstein).

Facing page:
Meschac Gaba
Contemporary Pain
2003, domestic objects, glass and aluminum panels, with collage globes. Contemporary Art Museum, Saint Louis.

Henrik Håkansson
Oct. 24, 2004
(Phoenicurus phoenicurus)
2004, video still.

Rirkrit Tiravanija
Untitled 2002
(He Promised)
2002, installation.
Wiener Secession, Vienna.

Olafur Eliasson
Your Spiral View
installation, 2002. Palacio
de Cristal, Madrid.

Susan Hefuna
Father, Son and
Daughter, Egypt
1969, hand-colored
photograph.

Zineb Sedira
Mother, Daughter and Me
2003, photographs on
aluminum, installation
created with the
Contemporary Art
Museum, Saint Louis.

Isaac Julien
True North
2004, video still. Victoria
Miro Gallery, London.

one thing, it has only ever meant one thing: ...
finition and at any cost. Nothing I can say ...
thing That's Comfy Like A Sofa But ...
much deeper than that. And no, ...
neck. It's like having the TV on, i...
kiss. Or rather, a whole load ...
I can give you is start small.
American and reproduces ...
won't put childish things a...
who make them. Becaus...

159

Olaf Nicolai
Large Training Shoe
(the Nineties)
2001, installation.
Migros Museum für
Gegenwartskunst, Zurich.

Cai Guo-Qiang
The Dragon Has Arrived
1997 (47th Venice
Biennial), ship's part,
Chinese flags, lights.
Deste Foundation,
Athens.

Gerda Steiner
Jörg Lenzlinger
The Invaders!
Botanic Gardens,
Geneva, 2004.

The Neo-Avant-Gardes

Joseph Beuys, 1977, photograph by Ute Klophaus.

Joseph Beuys
(Krefeld 1921–1986 Düsseldorf)

In World War II Beuys fought as a pilot but, wounded, he was made a prisoner of war by the British. At the end of the war he studied sculpture at the Academy of Fine Arts in Düsseldorf. From the early 1960s he met members of Fluxus. He created "actions" and performances and was interested in the experimental interaction between the visual arts, music, and literature. His civic, political, and pedagogical commitment became more intense: he supported reform of the education system and direct democracy. In 1972 he founded the "Free International University" and in 1979 was a founding member of the Green Party in Germany. He reflected on how art could play a broader role in society (he referred to art as "social sculpture") and participated in numerous public debates. For Beuys, teaching was an integral part of his artistic activity.

Joseph Beuys
Untitled (Nude)
1957, pencil and watercolor.
Joseph Frölich Collection, Stuttgart.

In the early 1950s Beuys devoted himself mainly to drawing and reading literary, philosophical, and esoteric texts. He returned several times to the theme of the female nude, which he interpreted as both arcane and grotesque. He was well versed in Secessionist graphic art: his *Witches* (the title of several drawings) dialogue remotely with the nudes of Klimt and the young Klee. At the same time, almost providing the artist with a female alter ego, they echo German drawing from the period of the Reformation, in particular in their combination of elegance and starkness.

Joseph Beuys
Mother and Son
1961, pencil, wax, hook.
Van der Grinten Collection, Museum Schloss Moyland, Kleve.

The small assemblage works as a function of the contrast between the "psychological" qualities of the materials used: the wax is hot and can be modeled; the metal is cold, rigid, and shaped to be sharp.

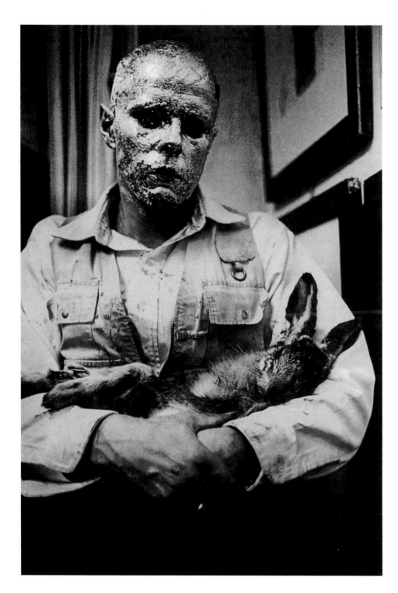

Joseph Beuys
How to Explain Paintings to a Dead Hare
1965, performance.
Galerie Schmela, Düsseldorf.

Beuys's performances were generally typified by a complex rituality that required costumes for the artist and use of organic materials such as earth, oil, fat, and felt. In *How to Explain Paintings to a Dead Hare*, held in Düsseldorf in 1965, Beuys covered his face with honey and gold leaf and held a dead hare in his arms. The "action" gave a holistic reinterpretation of the Christian theme of the Pietà. Through the dead animal, the sense of cultural production, technological and scientific development, and social organization in the West were questioned from the viewpoint of the living and their vulnerability.

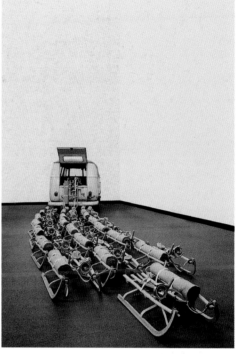

Joseph Beuys
The Pack
1969, installation.
Neue Galerie, Staatliche Museen, Kassel.

A large number of sleds pour out of a Volkswagen van. The sleds seem to have a life of their own: they move away from the vehicle and each is fitted with a flashlight, a supply of fat, and a felt blanket—the basic kit for survival in the mountains. Beuys stages an escape: the sleds seemingly slide quickly away in a never-ending stream. Imagine a mountain scene: snowy peaks, high-altitude forests, crisp air. Note that the equipment on the sleds is light and simple: the artist is suggesting that an excess of goods and commodities is superfluous, and that it prevents us from following our real desires.

Andy Warhol, 1968.

Andy Warhol
(Pittsburgh 1928–1987 New York)

Warhol (born Andrew Warhola) studied design and the history of art at the Carnegie Institute of Technology. In 1949 he went to New York, where he worked for *Vogue* and *Harper's Bazaar*. He designed advertisements, shop windows, and theater sets. In 1952 he had his first solo exhibition. Male nudes, roses, and shoes were his preferred motifs. He produced drawings that featured gold leaf. In 1960 he moved on to compositions using advertisements and comic strips. In 1962 he started making silkscreen prints of stars, disasters, and everyday consumer items such as soft drinks and soup cans. In 1963 he made the films *Sleep* and *Empire*. In 1964 he exhibited *Flowers* at the Sonnabend Gallery in Paris, and in 1967 the Velvet Underground (the band he managed) released its first LP. He was seriously wounded in 1968 by Valerie Solanis, a woman who frequented his legendary studio, the Factory. In 1975 he published *The Philosophy of Andy Warhol*. In the 1980s he developed professional partnerships with young artists.

Andy Warhol
Large Electric Chair
1967, silkscreen print.
Joseph Frölich
Collection, Stuttgart.

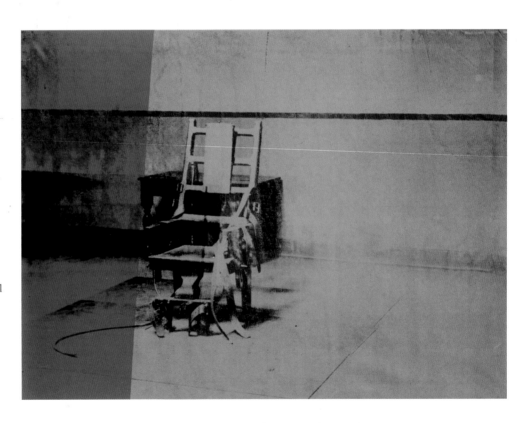

Warhol's series *Disasters* shows images of car and plane accidents, suicides, the electric chair, poisonings, hospital scenes, and racial disturbances; the images are ambiguously participative and arousing, in part informed by our knowledge of their historical, social, and civil contexts. Warhol dwells on the nameless, faceless victims, the news of whose deaths fills the pages of the local papers for just a day. He had a detached, impersonal style: he did not paint, preferring to use images taken from the media, which he often repeated set against monochrome grounds. In evoking the tribute to death demanded by the consumer society, Warhol went way beyond the Modernists in their discourse on the subject: his account has a decisive importance, execution is mechanical. The repetition of his images never renders them banal or reductive but instead creates a subtly obsessive dimension. Unaccompanied by text (such as a newspaper article), the image (i.e., the event) takes on the uniqueness of a personal story and its mystery. The interference created by news or superfluous comments diminishes and the noise of the world is silenced for a moment. It is significant that the first image of a car accident made by Warhol was a picture of James Dean lying dead beside his overturned car: done in the style of the young Jean Cocteau, the drawing (c. 1950, not shown here) is a sort of homosexual Pietà dedicated to the young Hollywood star.

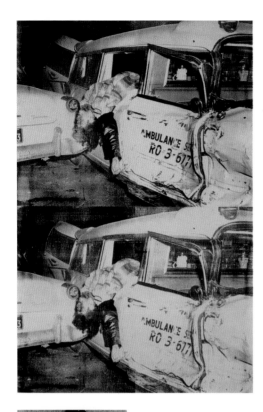

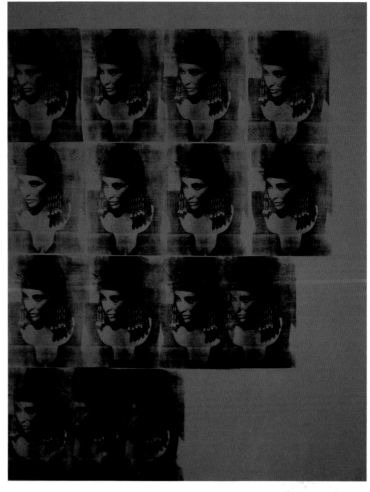

Andy Warhol
Ambulance Disaster
1963, silkscreen print.
Marx Collection, Berlin.

Andy Warhol
Blue Liz as Cleopatra
1963, silkscreen print.
Robert and Adriana Mnuchin Collection, New York.

Andy Warhol
Elvis
1963, silkscreen print.

A hidden continuity existed in Warhol's career before and after Pop. Whether serialized or single, for him the image was most importantly an illustration: the frank representation of individual obsessions and desires, a malicious yet demure self-revelation, the reflection of melodramatic dependencies, a fetishistic game. Thus the shoes, tarot cards, and male nudes of his youth, and the stars of the cinema and rock scene later on: "little girl ingenuousness, chewing-gum ingenuousness," confided Warhol in his sibylline manner. Subjugated equally by youth and fame, fortune and decadence, splendor and vulnerability, the artist portrayed Troy Donahue, Elvis Presley, Warren Beatty, Marlon Brando, Marilyn Monroe, and Elizabeth Taylor from a standpoint of ambivalent adoration, desire and aggression, fusion and rancor, just like a real fan. His notably antitheoretical point of view in part reacted to the excess of normative criticism typical of the art scene in New York in the 1950s: to Warhol, whose reticence and terseness about himself and his art were not unintentional, images are neither "culture" nor "theory," at least not in the reflective and socializable sense of the term. His work is as surprising as a pointed gun.

Robert Rauschenberg
(Port Arthur, Texas 1925)

Rauschenberg studied art at the Academy in Kansas City. In 1948 he visited Paris, then studied on an intermittent basis during 1948–52 at Black Mountain College in North Carolina, where his teacher was Josef Albers, formerly at the Bauhaus. He met Merce Cunningham and John Cage, with whom he worked. He traveled in Italy, France, and Spain, and exhibited in Rome and Florence. From 1953 he was in New York, where he met Jasper Johns. He painted red monochromes, made assemblages, and in 1954 started on the series *Combine Paintings*. His first solo show was held in Leo Castelli's gallery in New York in 1958. In 1959 he exhibited at Documenta 2 in Kassel and in 1964 won the painting prize at the Venice Biennial. From 1962 he produced silkscreen prints on canvas: the compositions were enhanced with photographs, three-dimensional objects, and the addition of paint, and referred to the worlds of the media and popular culture.

Robert Rauschenberg as a young man.

Robert Rauschenberg
Untitled
c. 1953, stone and wood box.
Cy Twombly Collection, Rome.

During his early period in New York, Rauschenberg made a series of black monochromes and assemblages of found objects similar to the *Personal Boxes* he exhibited in Italy, but plainer and more severe in their execution. He produced variations on the theme of memory: each sculpture was created by the assembly of autobiographical fragments, and the motif of the box was rich with symbolism. Each work became a metaphoric container of memories.

Robert Rauschenberg
Untitled
1955, gold leaf and newspaper clippings on canvas, wooden frame, and glass.
Collection of the artist.

As with his *Red Paintings* of the same period, Rauschenberg's gold compositions marked a decisive move away from the constrictive black and white of his early monochromes. The emphasis falls on the dimensions of experience or individual emotion and collective history: the "painting-box" is like a story. It is not a place in which a series of reflections on painting can be formalistically organized.

Robert Rauschenberg
Monogram
1955–59, oil, paper, fabric, prints, metal, wood, tire, shoe sole, Angora goat. Moderna Museet, Stockholm.

The *Combine Paintings* are part paintings, part assemblages that play on the hybridization of painting and sculpture. They may be considered devices for transforming everyday objects into art and are unquestionably heirs of the tradition of ready-mades, which they interpret histrionically in playful and affirmative terms (in a certain sense they are anti-Duchampian). Whatever is included in a *Combine Painting* becomes painting, or at least art. Rauschenberg seemed at times like a super-organism (even a machine) intent on sublimating the debris of our everyday lives, a virtuoso who added his signature or redemptive brushstroke to everything, for example the snout of a goat, or the plumage of a stuffed eagle. Typically he moved between subtle Modernist irony and the rhetoric of the gesture or authorial performance.

Left:
Robert Rauschenberg
Canyon
1959, oil, fabric, metal, cardboard, prints, photograph, wood and mirror on canvas, with eagle and cushion.
Sonnabend Collection, New York.

Cy Twombly, *Portrait (Rome),* 1962, oil, pastel and pencil on canvas.

Cy Twombly
(Lexington, Virginia 1928)

Twombly studied art in Boston, Washington, Lexington, and New York from 1948 to 1951. He met Robert Rauschenberg and enrolled at Black Mountain College, where he studied until 1952. He was a pupil of Franz Kline and Robert Motherwell. He held his first solo exhibition at the Kootz Gallery in New York in 1952. That same year he traveled in North Africa, France, Spain, and Italy. In 1955–59 he shuttled between New York and Italy, eventually settling in Rome in 1959. He drew, painted, and made small white sculpture-assemblages from found objects. In Italy his canvases became larger and more meditated. Numbers, signs, and geometric figures took on a structural character that suggest minimalism. He exhibited at the Venice Biennial in 1964 and gained international renown. In 1995 the Menil Collection in Houston opened a Cy Twombly Gallery designed by Renzo Piano.

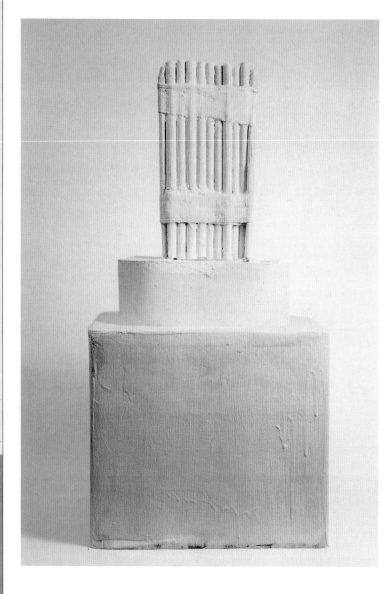

Cy Twombly
The Birth of Venus
1963, oil, pastel and pencil on canvas.

Cy Twombly
Untitled (Rome)
1959, painted assemblage.

The chance and quotidian aspects of the materials are played off against formal, narrative, and iconographic references to antiquity, the frailty of the object against the epic quality of what it represents. Archaeological (never mechanical) citations arrive at the end of a fantastic journey of self-knowledge, carrying with them intact the emotion associated with discovery. The artist interweaves the classical Mediterranean (or Middle Eastern) past and biography with strands never made explicit, and the erudite parody, at base a charade with an erotic charge, restores dynamism in ironic, personal, even idiosyncratic ways.

On Kawara
(Kariya, Japan 1933)

Having arrived in the United States in 1965, from 1966 Kawara painted canvases of different formats. These are the *Date Paintings* that only give the date they were executed. Kawara disappears behind his work, which he conceives as the meticulous and ritual recording of tiny acts of daily existence: reading a newspaper, moving around cities he visits, meeting people, waking at a certain time. The untranslatability of personal experience, time considered as simple duration, and "pure knowledge" (the title of an installation of 1997) are constant themes, as is the enigmatic relationship between the mind and history. Kawara does not publicize biographical anecdotes nor circulate photographs of himself: the only photo that exists shows him from behind and in the distance, as he walks down a track in the country talking to a fisherman. Since the late 1990s he has worked frequently with children and schools to observe processes of learning and progression.

On Kawara from Behind,
Walking with a Fisherman,
1996.

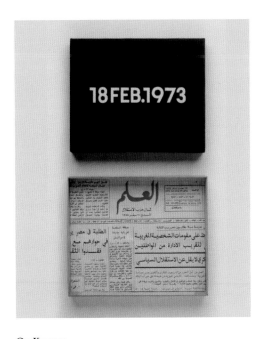

On Kawara
I Went
1968–79, page from a
book.

On Kawara
18 Feb. 1973
from the series *Today, from 1966 to today*
1973, acrylic on canvas, cardboard box, section of newspaper.

On Kawara
Pure Knowledge
1998, installation of the
Date Paintings.
The Reykjavik School of
Art, Reykjavik.

In his *Date Paintings*, Kawara inevitably places white characters on either a black, blue, or red ground. The language used is the one of the place where he is at the time. The execution is simple and repetitive: the image is the visible manifestation of what cannot be formulated directly. Every canvas is scrupulously catalogued with details of the colors, size, and date, given a subtitle, and then placed in a specially designed cardboard box. Inside the boxes of the less recent *Date Paintings* is also a scrap of a newspaper from the same day and place the painting was executed. The subtitles contain personal notes or newspaper headlines that alternate on an apparently casual and arbitrary basis. Kawara might write one day, "Taeko kissed me. I asked her, 'Are you ok?'" then, the next day, there might be a laconic news announcement, "New violent earthquake 125 miles south of Beijing." The limits of language are ironically suggested in both examples: private and public speech do not achieve the sphere of significance, and can only communicate futility or brutally simplified collective events.

Jasper Johns at Stony Point, NY, 1980, detail of a photograph by Arnold Newman.

Jasper Johns
(Augusta, Georgia 1930)

Johns studied at the University of South Carolina. During the Korean War he was in Sendai in Japan. He moved to New York in 1953 and met Robert Rauschenberg. They formed a partnership that was to last many years. Together they decorated shop windows and discussed art on a daily basis. Johns's first *American Flags* date from 1954. He had his first solo exhibition at Leo Castelli's gallery in New York in 1958. The Museum of Modern Art bought three of his paintings. He produced engravings, lithographs, and works showing the images of bodies. In 1961 he was Paris and in 1964 exhibited at the Venice Biennial. He worked with John Cage and Merce Cunningham. In 1973–74 he illustrated several texts by Samuel Beckett. From the 1970s he has varied the range of techniques and materials he uses: photographs, three-dimensional objects, metal, and ambiguous images taken from psychology manuals on perception.

Jasper Johns
Flag
1954–55, encaustic, oil, and collage on fabric mounted on plywood.
The Museum of Modern Art, New York.

Right from the start of his career, Johns's notoriety was linked to the subtle ambivalence of his most famous paintings: the Stars and Stripes, targets, and maps, which straddle the boundary between the painting of texture and color on one side, and figurative Pop on the other. The sensuality of the application of color, the delicacy of the tonal passages, and the two-dimensionality of the composition are un-

questionably typical of a formalist involved in a dialogue with the modern painting tradition, indifferent to the motif, and versatile and inventive with regard to technique. The conventionality of the motifs compels the observer to concentrate on the intrinsic qualities of the painting. From this standpoint it is significant that when Alfred H. Barr, the director of the Museum of Modern Art at the time of Johns's solo show at the Leo Castelli Gallery, was interested in buying four of the young artist's canvases, he was certain the panel of experts appointed to evaluate the purchase proposal would find the *Flag* unpatriotic: which is in fact how it appeared to his contemporaries. The motif, however, has an immediacy that cannot be ignored, an obviousness that is in some way identifying: despite the refinement of the execution of the painting, or perhaps because of it, the American national flag opened the painting up to nonartistic interpretations along the dimensions of collective history and biography that found wide favor among the next generation.

Below:
Jasper Johns
Target
1958, oil and collage
on canvas.
Collection of the artist,
on loan to The National
Gallery of Art, Washing-
ton, D.C.

Jasper Johns
Painted Bronze
1960, oil on bronze.
Museum Ludwig, Cologne.

The small sculptures Johns made towards the end of the 1950s—
first in plaster or resin mixed with aluminum powder, later in
bronze—were striking for their absence of literary or narrative
implications. Johns seemed interested in the simple literalness of
the thing he was replicating, thus forestalling any attempt at
appropriation or interpretative misunderstandings. With its
attention-drawing painted section, the bronze sculpture of the
two beer cans moves ironically between the mundane and the
museum piece, a facet of the artist's private life and a national
myth. It is above all a reminder of the collages, assemblages, and
painted sculptures of Picasso, suggesting a playful imitation
drawn from an artistic daily life marked by simple pleasures.
However, the reality is in fact the reverse: Johns takes objects
from real life, potential ready-mades, and turns them into works
of art simply by casting copies of them in bronze in the fashion
of traditional sculptures.

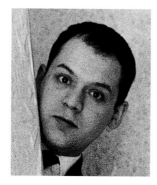

Piero Manzoni, 1959, detail of a photograph by Ennio Vicario. Archivio Opera Piero Manzoni.

Piero Manzoni
(Soncino, Italy 1934–1963 Milan)

An *enfant prodige* of Italian art in the late 1950s and early '60s, Manzoni was one of the first to understand the importance of the art of Lucio Fontana and interpret his legacy. More than his friend and master, Manzoni made manifest his desire not to work in any fashion characterized by recognizability or formal coherence, instead experimenting with techniques, materials, and even different styles, allowing his creativity to flourish purely rather than as an adjunct of the professional artist. He stressed the importance of the character and physiology of the artist in art, refusing to dissociate the dimension of the work from the artist's most real experiences. He produced monochrome canvasses, assemblages, performances, and installations, all of which were informed by a sharply comic and theatrical sense. However, the pauses in his cabaret performances were moments charged subtly with emotion.

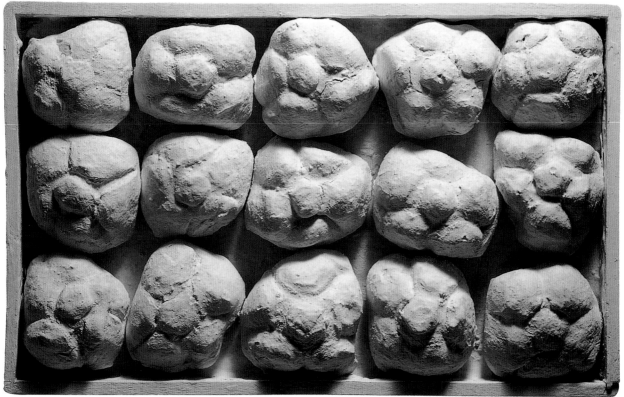

Leading Figures Piero Manzoni

Piero Manzoni

Achrome

1961–62, bread rolls, kaolin on canvas.
Paolo Consolandi Collection, Milan.

This work has the impudence of a ready-made and the white geometric rigor of neoplastic compositions. Three lines of five bread rolls, fifteen in all, lie as though they are in a state of waiting, in a pure white cabinet. Are they waiting to be eaten in a meal we know nothing about? We cannot say, but this work, which Manzoni claimed originated by chance following a visit to a baker's shop, has a slight quality of decay that lies somewhere between a pharmacological and a funerary pallor.

Frank Stella
(Malden, Mass. 1936)

Stella enrolled at Princeton University in 1954 and there studied history and paint. He was in New York in 1958; the formal aspects of his work approximated Jasper Johns's flags and targets. In 1959 the exhibition of his *Black Paintings* at the Museum of Modern Art in New York created a lot of interest. He experimented with unusual formats and, from the early 1970s, color and surface characteristics. He used metallic colors, felt, paper, canvas, Masonite, aluminum, and plywood; he then moved away from the Minimalist tendency whose emergence he had contributed to. He is interested in non-Western traditions of ornamental polychromy and on several occasions has paid tribute to Islamic art. He attributes great importance to the titles of his work, which make references to history and geography, ornithology (like the series *Exotic Birds* from the mid-1970s), and racing cars.

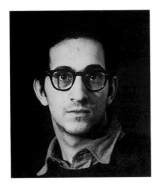

Frank Stella in the 1960s.

Frank Stella
Die Fahne Hoch!
(The Banner Raised)
1959, enamels on canvas.
Whitney Museum of American Art, New York.

Symmetrical black lines of constant, preestablished width divide the composition into four sections. The execution is regular and as much as possible removed from the emotion-charged, virtuoso gestures of the Abstract Expressionists. American art, Stella seems to suggest, is simple and transparent, does not attempt to deceive or create illusion, and is comprehensible in its procedures and easily communicable, whether abstract or ornamental: in this it has specific historic and civil justifications. The continuity of the work with the Abstract Concrete movements between the wars is evident: the title, which significantly is in German, evokes the horrors of recent European history and introduces a disjunction between civilization and culture.

Frank Stella
The Gate of Bassora III
1969, acrylic on canvas.
Museum Folkwang, Essen.

Hans Haacke, 2003.

Hans Haacke
(Cologne 1936)

Haacke studied art in Kassel, and visited Paris in 1960 and New York in 1962. In Cologne during 1963–65, he was attracted by kinetic sculpture. In 1965 he moved to New York where he created installations made with water, earth, wind, grass, and animals. In 1969 he participated in the exhibition *Earth Art*. In the 1970s his work examined artistic institutions and the economic and political distortion of cultural events. On account of his investigation into several property companies in Manhattan in 1971, the Guggenheim Museum canceled his solo exhibition only six weeks before it was due to open. Haacke then investigated the largest international collectors, for example Nelson and David Rockefeller, Peter Ludwig, Charles Saatchi, and multinational companies like Mobil, Mercedes, and Philips. In the 1980s he turned his attention to parodistic painting.

Above:

Hans Haacke
Ants' Nest
1969, installation with ants, acrylic containers, sand. Howard Wise Gallery, New York.

Haacke's interest in the living is at first abstract or metaphoric: a natural, self-sufficient system, however small, changes over time in relation to the surrounding climate, the availability of nutrients, and the demography of the species that inhabit it. It is a sort of self-generating sculpture, with its own metabolism and duration, that seems independent of the artist's actions, and whose cycle of growth and mortality is governed entirely by its own system. Haacke aims to demystify the artistic process, first of all its emphasis on originality, authoriality, and eternity. He therefore attempts to "articulate the natural," as he has himself written, to offer alternatives to the prevalent narrations of art and the market system.

Right:

Hans Haacke
News
1969, installation.
Städtische Kunsthalle,
Düsseldorf.

Several teleprinters await visitors to an art exhibition: the machines are connected to the most important international news agencies, and the visitors are invited to read political and economic news announcements in real time. Current affairs irrupt into the gallery or museum, usually detached from everyday events, but Haacke is not interested in journalism as a form of art: instead he prefers to modify the relationship between the work and the public, to differentiate between participation in a cultural event and simple consumerism. The work is not a mere "product," an artifact among many "others": it presupposes insightful, questioning observers willing to take part in an experience to the extent they understand themselves to be its co-authors.

Hans Haacke
Taking Stock (unfinished)
1983–84, oil on canvas,
gilt frame.

In the early 1980s Haacke
took an interest in painting:
he used outdated and in
some way debased styles
that could be assimilated
to the socialist realism
(still being taught in East
Germany) and official
Soviet painting of the
1930s. He glorified paint-
ings as items of consump-
tion by mounting them in
very obvious, carved, gilt,
neo-Renaissance frames
and created cuttingly satir-
ical works of the virtuoso
manner in fashion at the
time as exemplified by
Julian Schnabel. This
painting of Margaret
Thatcher is filled with
political and political-
cultural references. One
of Schnabel's foremost
sponsors was the collector
Charles Saatchi, an adver-
tising tycoon whose effigy
is on the plate at the top.
On three occasions Saatchi
masterminded Margaret
Thatcher's election cam-
paign advertisements.

Hans Haacke
Monument to Beach Pollution
August 1970, Carboneras Beach, Spain.

Around 1968–69 strong ecological references began to emerge in Haacke's work; he
designed green areas in cities that he prohibited from being maintained by gardeners or
landscape architects, and he exhibited piles of grass in galleries. For his *Beach Pollution*
monument he collected objects and waste washed up on the shore or left by the public
and built a mound, almost a pyre. It offers an image of the environment unlike any tra-
ditional view or landscape.

Robert Smithson on the Roof of the Dakota Apartment Building, New York, c. 1968–70.

Robert Smithson
(Rutherford, New Jersey 1938–1973 Amarillo, Texas)

Smithson studied art in New York, painting and writing critical texts. From 1964 he produced Minimalist sculptures using mirrors and fluorescent lamps, and was contact with Sol Lewitt and Robert Morris. From 1966 he explored industrial areas of New Jersey and described excavations and piles of earth as the contemporary equivalents of ancient beauty. His first *Non-Site* works date from 1968. These are metal containers filled with earth and rock taken from a particular place and placed in a gallery. His involvement with the Earthworks movement (later Land Art) was accompanied by a series of critical texts. Smithson began working on large-scale projects in open spaces and a land reclamation project in Holland. In 1973 he died in a plane crash while exploring a site for a new project.

Robert Smithson
Mirror Shore
1969.
Sanibel Island, Florida.

With his installation of mirrors in the landscape, Smithson's work seems slightly ambivalent on the formal and symbolic level. This unequivocal and invasive act fragments the places chosen and alters the observer's relationship with the aesthetic transposition. Our gaze on the site and our openness to escapism that it creates within us are made inaccessible.

Now an element exists that constantly modifies the internal organization of the image, creating a succession of shifts in perception, a simultaneous condition (in accordance with a logic that might be called Cubist): the center becomes periphery, the periphery center. The subtle restlessness of our gaze reveals, to the artist, the possibility of perceiving what cannot be represented: "Only when art is fragmentary, discontinuous, and incomplete can we experience that empty eternity that excludes objects and certain meanings." The images reflected from the mirrors are only changing shadows and unreal forms: the mirrors in the landscape are like a sort of modern *vanitas*.

Facing page:
Robert Smithson
Upturned Tree
1969, installation, Alfred, New York.

In *Upturned Tree* (pg. 174), the image is the apocalyptic double of the Garden of Eden. An uprooted tree is set in the ground upside down, almost as though flung like a thunderbolt by an angry deity. The roots extend pathetically upwards in search of nutrients while the bare, eroded soil shows signs of recent mining activity. The slope behind is waterlogged and subject to slippage. This is either an abandoned quarry or the site of a landslide. In showing such an exhausted and violated example of nature, Smithson is not worried about receiving environmental complaints—quite the opposite. He has created a sublime, anti-utopian inverse, and is thus reacting negatively to the decorative tendencies he feels are increasing around him. To his eyes art is not part of the natural order; he writes that it presupposes a clean separation from "the biomorphic order….Cruelty is the final product of evolution."

Above:
Robert Smithson
Spiral Jetty
April 1970 (photograph taken in 2002), installation,
Rozel Point, Great Salt Lake, UT.

The spiral was suggested by the configuration of the site, the crystallization processes of salt, and symbolic associations. Rather like a monogram appended to the surrounding landscape, the creation of the spiral required an enormous amount of work by men and machines. (Roughly 7,000 tons of earth had to be moved.) Submerged by the lake, it reappears sporadically but is not easily seen: the processes of decay, disappearance, and decomposition however are not uncongenial to Smithson, even though they were not all foreseen. (*Spiral Jetty* was built at a time when the lake was particularly dry. Having recognized the situation, he thought of adding material to raise the spiral but this has not yet been done.) What is striking is the archaeological appearance of the spiral considering it required extensive engineering means. Dark and magnificent, like the unusual reddish-violet waters bereft of life in the lake it lies in, *Spiral Jetty* is formed by an immense stretch of black basalt rocks and rubble as both a monument and ruin at the same time; open to the processes of erosion that model the surface of the Earth on an incommensurable timescale, it has been created in spiral form to symbolize regeneration.

Alighiero Boetti, *Musical Instrument*, detail, 1970.

Alighiero Boetti
(Turin 1940–1994 Rome)

Born and trained in Turin, this elusive, complex artist moved to Rome in the early 1970s to flee the artistic and cultural world of the Piedmont capital. He experimented with numerous artistic and artistic-industrial techniques (drawing, weaving, printing, photocopying, photography) and broadened the scope of the visual arts to include letters and telegrams. Interested by the collaborative aspect of art—the compositions with stamped envelopes and postcards, and the rugs woven in Afghanistan are by him—he showed he was not keen on the emphasis placed in art on the notions of author and authorship. Rather than the figure of the cultural hero he preferred that of the traveler, the enthusiastic observer, and mildness and eccentricity marked his own personality. (He signed his works as Alighiero & Boetti.)

Alighiero Boetti
Addition
1984, embroidery
on canvas.
Archivio Boetti, Rome.

Boetti was entranced by classification systems, catalogues, and arbitrary and conventional taxonomies. He conceived his works as marvelous and secretly obsessive devices: virtually interminable, developing via internal mechanisms and processes of serial growth (by addition, as it were), with the apparent simplicity of a child's game, a lullaby, repetition.

Susan Hiller
(Tallahassee, Florida 1940)

After studying art and anthropology and making a trip to Latin America, around the middle of the 1960s Hiller gave up university research to dedicate her time to painting. She later explained, "I did not believe any 'objective truth' existed, and I did not want to observe detachedly what I was experiencing: I simply wanted to participate, nothing more." She moved to London in 1970 where she became interested in ultra-rational beliefs and processes. She took up performances and automatic writing, focusing on joint projects. She created groups to work on dreams, became interested in kitsch, collected and exhibited secondhand postcards (*Dedicated to the Unknown Artist*, 1972–76), and challenged the arts hierarchy and authoritativeness of cultural discourse. In later years she designed interactive multimedia installations.

Susan Hiller (Midnight Waterloo), 1987.

Right:
Susan Hiller
Grenades, 1969–72.

In the early 1970s Hiller destroyed all her painted work, and in part absorbed the discourses the feminist movement was giving on art and culture. The destruction of her paintings was ceremonial in nature and in several ways public: she burned the canvases and collected the ashes in glass bottles and bulbs, or she cut them up and then sewed them back together in ten "blocks of paintings," each marked with the date and size of the original canvas. She searched for a more interactive dimension than that allowed by traditional painting.

Left:
Susan Hiller
From Freud's Museum
1991–97.

Like an ethnographer of the consumer society, Hiller collects objects, reveals relationships, and establishes taxonomies that, unlike scientific classification, are fluid and to a great extent subjective. The boxes that hold the objects seem like archaeological containers: in them we find period objects, samples of earth and water taken while traveling, games, and small kitsch objects. However heterogeneous each collection may be, each box tells its own story, in the manner that an anthology of pictures illustrates an essay. The artist alludes to the relation between power and untruth, the manipulation that lies behind the cultural construction of the sexes, and reflects on herself and her interest in historical memory. However, the text of the "essay" is missing, and the box, rather like a Surrealist symbolic photograph, prompts the observer to create the connections between the parts.

Bruce Nauman, *Self-Portrait as a Fountain,* detail, 1966.

Bruce Nauman
(Fort Wayne, Indiana 1941)

Following his studies in mathematics and physics at the University of Wisconsin, then art at the University of California, in 1966 Nauman moved to San Francisco where he taught at the Art Institute. In the studio he produced a series of performances and video documentaries based on everyday activities and gestures, or dedicated to tasks of varying difficulty, such as throwing two balls in different ways, modeling heaps of flour on the floor, painting one's own face white or trying to deform it, or attempting to play a violin. He produced molds of his own body and installations using fluorescent tubes. He was one of the first artists to move constantly among different materials and techniques: video, photography, drawing, and sculpture. He has experimented with the potential of sound installations and created luminous environments with words. He aims to create "works that arrive in a rush" as he himself writes, and that have the power of a "blow on the back of the neck."

Bruce Nauman
Art Makeup No. 1. Black
1967–68, video still.
Leo Castelli Gallery,
New York.

The art of the young Nauman arose partly naturally and partly from a decision to abandon painting in 1965. "I asked myself the basic question: What does an artist do when he is let loose in his studio? I was an artist and I was in the studio: therefore whatever I was doing had to be art." In an attempt to deform his own face, perhaps even to imitate "primitive" masks, he places emphasis on the mental and physiological processes of the body.

Bruce Naumann
Corridor with Green Light
1970–71.
The Panza Collection, The Solomon R. Guggenheim Museum, New York.

In his use of neon tubes, Nauman radically altered the Minimalist (or anti-form) approach with which they had been used in the 1960s. Slightly claustrophobic and perverse, the installation swallows up the observer, who is both welcomed and rejected by the corridor of green light. The light is dazzlingly bright, the entrance is small (the width of the artist's shoulders), and the walls are high and oppressive.

Bruce Nauman
Clown Torture
1987, video installation, First exhibited in 1987 at the Leo Castelli Gallery, New York.
Donald Young Gallery, Seattle.

Two videos show clowns attempting to balance objects unsuccessfully. Two more show a clown trying in vain to end an elliptical story, "Pete and Repeat are sitting on a fence. Pete falls off. Who's left? Repeat. Pete and Repeat are sitting on a fence...." A fifth video projected onto the wall shows a clown sitting in a public toilet: the space is narrow, the situation vaguely mocking, as the video seems to be filmed by a closed-circuit camera. Only two of the monitors are placed correctly; the other two stand on their sides or are upside down, although these alterations do not automatically change the sense of the pictures (which were clearly filmed by a camera turned either through 90° or 180°). Incorporating humor and absurdity, the project remains ambiguous, elusive, and reticent. It touches on strong themes like sadism, madness, degradation, and control, but without referring exclusively to any one of these. The sound, which is very loud, assails the observer.

Bruce Nauman
Human Nature/Knows Doesn't know
1983-86. Stoccarda, Fröhlich Collection.

Nauman uses texts as immediately expressive materials and not, unlike other conceptual artists, as occasions to reflect on statutes, modalities, or artistic operations. He prefers verb infinitives and often creates ambiguous pairings to introduce shifting meanings. He likes to demonstrate the fallibility and violence of language: he coins slogans, word-plays, and repetitions.

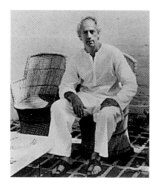

Robert Morris.

Robert Morris
(Kansas City, 1931)

Morris studied engineering at Kansas University and frequented the Academy of Fine Arts. He was enrolled in the US Army and sent to Korea to fight. Discharged, he lived in San Francisco where he painted, danced, and did theater. In New York in 1961 he studied the history of art at Hunter College, presenting a thesis on Brancusi. He gave up painting and produced a series of small installations, then adopted Minimalist techniques and styles. He executed sculpture installations made from gray-painted plywood. Morris was very aware of the work-spectator interaction: differences in scale, light, and color help create conscious perception. From the late 1960s, he created anti-form installations using tractable or unstable materials like felt, earth, and steam. He designed environmental reclamation projects, investigated the relations between form and memory, and time and knowledge, and explored the changeability of the Self. In 1983 he took up painting again.

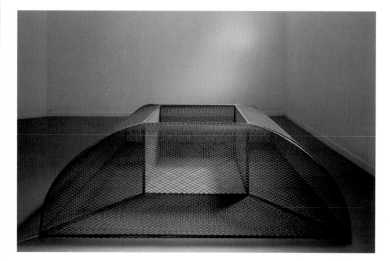

Robert Morris
Untitled
1967, steel grate.
The Panza Collection, The Solomon R. Guggenheim Museum, New York.

A sharp-edged polygon stimulates a sense of danger in the observer. The work is transparent and hides nothing regarding its construction. The geometric design and neutral color elude any psychological or symbolic interpretation. Unlike with other Minimalist sculptures, the form of the object does not seem inert but on the point of breaking up or changing itself. The lines of the sculpture are predominantly curved and the arched structure is subjected to tension.

Right:
Robert Morris
Place
1964, performance at Stage 73, New York.

Interested in experimental dance revolving around daily movements and actions, Morris offered a performance in which he is the interpreter. Dressed in white and wearing a white mask, he dismantles a structure made from white plywood. All of the action is accompanied by the sound of a doorbell ringing. When he removes the last panel, he reveals the nude body of Carolee Schneemann, a performer and body artist close to the feminist movement, who is also painted white. Schneemann poses like Manet's *Olympia:* her body introduces social, political, and sexual aspects that the sacredness of pure form either hides or evades.

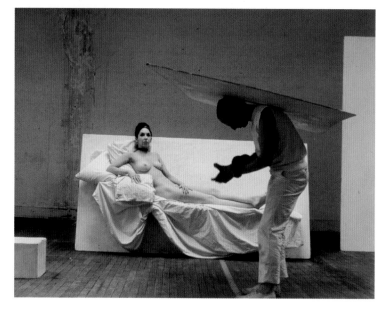

Leading Figures | Robert Morris

Richard Long
(Bristol, United Kingdom 1942)

Long studied at St. Martin's School of Art in London, and from 1967 his work was closely connected with walking. He crosses large, uninhabited territories, often in remote areas. Generally these trips last several days and are conceived as performances in both a physical/athletic and ritual sense. During the journey he makes sculptures using natural materials. He considers these creations temporary and non-invasive. He uses texts, maps, and photographs to record each of his performances. In 1968 he took part in Earth Works, an exhibition held in the Virginia Dwan Gallery in New York dedicated to early environmental and anti-form art. Long was one of the first to introduce an environmentalist agenda into art. In 1972 he exhibited at Documenta in Kassel. During the 1970s he also offered sculptures for display inside museums and galleries. He made drawings directly on the wall with his hands covered with soil.

Richard Long on the Road to Las Hazuelas, Spain 1990.

Richard Long
A Walk Along all the Roads and Paths Intersecting an Imaginary Circle
Somerset, England, 1977 map and drawing.

In his use of a map, Long is not offering a contemporary version of a view. On the contrary: he is arguing against the inadequacy of traditional models of representation that have been inherited from the Western figurative tradition consisting in part on visual supremacy. The map is a graphic simplification of a territory; its conventions are transparent and do not aim to represent in images towns, rivers, or hills that we do not already know.

Richard Long
A Circle in Africa
Malawi, 1978,
b/w photograph.

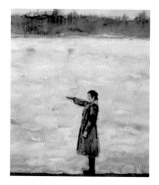

Anselm Kiefer Gives a Nazi Salute, detail from a picture taken from the artist's book *Occupations,* 1969.

Anselm Kiefer
(Donauschingen, Germany 1945)

Kiefer studied art at the academies of Freiburg, Karlsruhe, and Düsseldorf where, in 1970–72, his teacher was Beuys. Kiefer was interested in his country's history and considered what remained unresolved in the past of his country. He thought of himself as a modern miracle worker. Recorded in photographs, his *Occupations* date from 1969; in these performances, the artist gave the Nazi salute beside the Rhine, the river that played an important role in German nationalism. Beginning in the same year Kiefer produced books that were also sculptures and paintings. In 1971 he moved to Holmbach, near Heidelberg. He traveled in Europe, the US, and the Middle East. His first wood engravings date from 1978. He was invited to Documenta ("Museum of 100 Days") in 1977 and 1988, and in 1980 exhibited at the Venice Biennial. He left Germany in 1991 and traveled in Mexico, China, and India. In 1992 he moved to the village of Barjac in France.

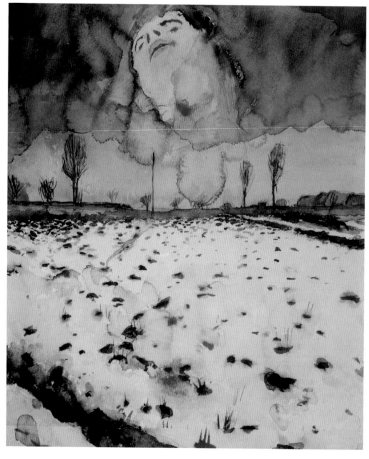

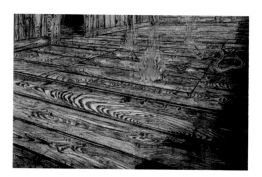

Anselm Kiefer
Quaternity
1973, oil and charcoal.
Modern Art Museum, Fort Worth.

In 1974 Kiefer began painting enormous canvases on the tragic aspects of German history. He adopted a neo-Expressionist style charged with national cultural implications and included references, both direct and indirect, to the German masters of the Reformation. In general it is the ethical and laically religious aspects of Kiefer's art that connect him with the painters and theologians of the German past. *Quaternity* is a reflection on Evil in history, in particular German history. The serpent Satan slithers against a background of a theatrical stage that suggests Wagnerian sets, and appears in his elementary, archaic monumentality in other paintings by the artist. The image is disturbingly ambiguous: Satan appears equally powerful but at the same time intimately bound up with the Father, Son, and Holy Ghost by a secret design, an arcane necessity.

Anselm Kiefer
Winter Landscape
1970, watercolor, tempera, and pencil.
New York, Museum of Modern Art.

The head of a beheaded woman, perhaps an allegory of Germany, appears among the clouds. Earth and sky dialogue through the blood from the wound that stains the snow. Desolate, the scene conjures up feelings of death and suffering, rather like a battlefield.

Francesco Clemente.

Francesco Clemente
(Naples, Italy 1952)

"In 1968 I was sixteen, at night I would fall asleep in front of [the work of] Luca Giordano, in the morning I used to look at the covers of the LPs of Jimi Hendrix, Bob Dylan, and Pink Floyd." These were the early eclectic figurative experiences of Clemente, born in Naples and now residing in New York. Having arrived in Rome in 1970, he met Cy Twombly and Alighiero Boetti. He took photographs and convinced himself he could be an artist if he focused his attention on the inventive exploration of techniques and images, and combined popular and high-brow, individual and community themes. He began visiting India in the late 1970s and learned about the local mythology and art. They added a complex, sensual world of motifs to his own range. One of the first to show new interest in painting (he joined Transavanguardia), Clemente achieved broad international fame in the early 1980s.

Francesco Clemente
from the series *Francesco Clemente Pinxit*
1980–81, watercolor on ancient paper.
Virginia Museum of Fine Arts, Richmond.

Francesco Clemente
Seeds
1978, tempera on canvas paper.
Alessandro Grassi Collection, Milan.

Aspects of Neapolitan painting are mixed with folkloric and ethnographic motifs in Clemente's work; he shows an interest in variously composed religious symbols, and a fondness for the human figure specifically in a promiscuous and erotic dimension— self-portraits are also frequent. His compositions are often enigmatic: individual figures are not shown as part of a unitary scene, such as a landscape, but create, as the artist writes, "an ideogram."

Roni Horn
(New York 1955)

Roni Horn studied art at Rhode Island School of Design, then Yale University. In 1979 Horn visited Iceland for the first time; from then on he would visit it each year. From 1983 he won widespread international fame and had exhibitions in New York, Munich, Tokyo, Amsterdam, Basel, and Paris. He created installations with pairs of almost identical objects. He was interested in exploring the ways we usually establish our identity and differences. Bisexuality, desire, and language were recurrent themes. He executed three-dimensional presentations of the poems of Emily Dickinson. In 1990 he began publishing books on the projects he had realized in Iceland: drawings, maps, texts, and photographs documenting a process of growing familiarity with the place and its inhabitants. Each book, titled *To Place* and numbered in increasing order, is autonomous and complete on its own.

Roni Horn, Iceland, 1991.

Roni Horn
Picture Taken from "Verne's Journey (Book V of To Place)" published by Walter König, Cologne 1995.

The sequences of images in Horn's Icelandic series of books tell the story of the discovery of a particular aspect of the landscape of the island or the customs of its inhabitants, for example the bizarre configurations of the volcanic rock, ancient livestock enclosures similar to Land Art installations, or the crowded bathing resorts. His ability to find connections and unexpected meanings, and to ignore the easy and sensational for the intimate and local, is constant. "To see a landscape as it is when I am not there": this statement—in *Thicket No. 1*, a Minimalist and textwork sculpture installation—entails calm, expectation, and silence on the part of the artist traveler.

Roni Horn
Thicket No. 1
1989–90, aluminum and plastic.
Installation presented at the Leo Castelli Gallery, New York.

Jeff Koons
(York, Pennsylvania 1955)

Jeff Koons, *Bougeois Bust –
Jeff and Ilona*, 1991, marble.
Fondation François Pinault,
Paris.

Koons studied art in Baltimore and Chicago, then worked on Wall Street as a broker. In 1979 he built his first Plexiglas cabinets containing inflatable objects; the cabinets are mounted on pedestals. He later included neon lighting and printed on canvas the advertising blurb about the object exhibited—for example, brand new models of vacuum cleaners or basketballs in water. He made ironic use of advertising fiction, shining surfaces, and the obsession with domestic hygiene. His choice of objects, which were "typically" for men or women, made reference to the social conditioning that governs the construction of our sexual identities. In 1991 he married porn star Ilona Staller and started a series of works on looks and pornography. Opinions about Koons in the art world are divided: for some he is cynical and trivial, for others sensational.

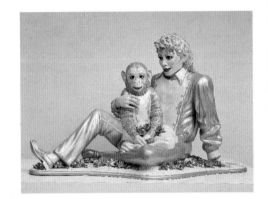

Right:
Jeff Koons
*Michael Jackson
and Bubbles*
1998, porcelain.
Astrup Fearnley Museet
for Moderne Kunst,
Oslo.

An ironic and prurient
reference to the rock
star's presumed sexual
inclinations. The wed-
ding-cake style of the
sculpture is rendered in
gaudy white and gold,
with the baby gorilla in a
compromising position.

Below:
Jeff Koons
Millepede in Chains
2003, polychrome
aluminum, steel, vinyl.

Jeff Koons
Rabbit
1986, steel.
Sonnabend Collection, New York.

Koons's sculptures are pastiches of "immortal works" found in museums. He is very choosy about his materials, using steel, glass, porcelain, and bronze: the deliberate, often invigorating futility of the themes of his works is matched by their shiny, polished, but cold surfaces. Having started as a Minimalist or Neo-Geo, he moved outside of the history of art and seems to be interested in making statements on the public and market. He is able and determined in his altering of the balances and norms that exist in the art world. He does not aim his work at connoisseurs: instead his world seems to be that of cheap entertainment, consumerism, and television celebrity. He takes his cues from mass culture—soft porn, rock, cinema—and strategically exhibits his conformism to middle-class expectations. His position is ambivalent: "the trick is to be outrageous without being offensive."

Bibliography

Alberto Giacometti: Sculptures, Peintures, Dessins. Exhibition catalog (Paris, Sept. 1991–Mar. 1992). Paris Musées: Paris, 1991.

American Art in the 20th Century: Painting and Sculpture 1913–1993. Catalog of the exhibition curated by Christos M. Joachimides, Norman Rosenthal (Berlin, Martin-Gropius-Bau, May–July 1993/ London, Royal Academy of Arts and Saatchi Gallery, Sept.–Dec. 1993). Prestel: Munich, 1993.

André Derain. Le Peintre du "Trouble Moderne." Exhibition catalog (Musée d'Art Moderne de la Ville de Paris, Nov. 1994–Mar. 1995). Paris Musées: Paris, 1994.

Andreas Gursky. Photographs from 1984 to the Present. Catalog of the exhibition curated by Marie Luise Syring (Kunsthalle Düsseldorf, Aug.–Oct. 1998). Schirmer/ Mosel: Munich, 1998.

Années 30 en Europe. Les Temps Menaçant 1929–1939. Exhibition catalog (Musée d'Art Moderne de la Ville de Paris, Feb.–May 1997). Paris Musées/Flammarion: Paris, 1997.

Anselm Kiefer. Exhibition catalog with texts by Massimo Cacciari, Germano Celant (Venice, Palazzo Ducale, May–Nov. 1997). Charta: Milan, 1997.

Arp 1886–1966. Catalog of the exhibition curated by Jane Hancock, Stefanie Poley (Stuttgart/ Strasburg/ Paris/ Minneapolis/ Boston/ San Francisco, 1986–1988). Hatje: Stuttgart, 1986.

Arte Italiana. Presenze 1900–1945. Catalog of the exhibition curated by Pontus Hulten, Germano Celant (Venice, Palazzo Grassi, spring–summer 1989). Fabbri Bompiani: Milan, 1989.

Bargellesi-Severi, Guglielmo, ed. *Robert Smithson, Slideworks.* Carlo Frua: Verona, 1997.

Belpoliti, Marco. *Crolli.* Einaudi: Turin, 2005.

Belting, Hans. *The Invisible Masterpiece.* Reaktion Books: London, 2001.

The Berlin of George Grosz. Drawings, Watercolours and Prints, 1912–1930. Catalog of the exhibition curated by Frank Whitford (London, Royal Academy of Arts, Mar.–June 1997). Yale University Press: New Haven/London, 1997.

Bhabha, Homi K., ed. *Nation and Narration.* Routledge: London/ New York, 1990.

Boettger, Suzaan, ed. *Earthwork: Art and Landscape of the Sixties.* University of California Press: Berkeley/Los Angeles/London, 2002.

Bois, Yves-Alain, and Rosalind Krauss. *L'Informe.* Bruno Mondadori: Milan, 2003.

Bonito Oliva, Achille. *Lezioni di Boxe.* Luca Sossella: Rome, 2004.

Bossaglia, Rossana. *Il Novecento Italiano.* Charta: Milan, 1995 (1st ed. Feltrinelli: Milan, 1979).

Bruce Nauman. Sculptures et Installations 1985–1990. Exhibition catalog (Lausanne, Oct. 1991–Jan. 1992). Ludion: Brussels, 1991.

Bruce Nauman. Work from 1965 to 1972. Exhibition catalog (Los Angeles County Museum of Art, Dec. 1972–Feb. 1973/New York, Whitney Museum of American Art, Mar.–May 1973). Los Angeles County Museum: Los Angeles, 1972.

Buchloh, Benjamin H.D., Alison M. Gingeras, and Carlos Basualdo, eds. *Thomas Hirschhorn.* Phaidon: London, 2004.

Burri. Opere 1944–1995. Catalog of the exhibition curated by Carolyn Christov-Bakargiev, Maria Grazia Tolomeo (Rome, Palazzo delle Esposizioni, Nov. 1996–Jan. 1997/

Munich, Lenbachhaus, Feb.–May 1997/Brussels, Palais des Beaux-Arts, June–July 1997). Electa: Milan, 1996.

Campany, David. *Art and Photography.* Phaidon: London, 2003.

Canto d'Amore. Klassizistische Moderne in Musik und Bildender Kunst 1914–1935. Curated by Gottfried Boehm, Ulrich Mosch, Katharina Schmidt. Öffentliche Kunstsammlung Basel/Kunstmuseum Paul Sacher Stiftung Basel, Benteliteam, Bern 1996.

Celant, Germano, and Anna Costantini. *Roma-New York 1948–1964.* Charta: Milan, 1993.

De Cézanne à Matisse. Chefs-d'Oeuvre de la Fondatione Barnes. Exhibition catalog (Paris, Musée d'Orsay, Sept. 1993–Jan. 1994). Gallimard/Electa/Réunion des Musées Nationaux: Paris, 1993 (Eng. ed. A. Knopf: New York, 1993).

Chakrabarty, Dipesh. *Provincializing Europe.* Princeton University Press: Princeton/Oxford, 2000.

Chave, Anna C., ed. *Constantin Brancusi. Shifting the Bases of Art.* Yale University Press: New Haven/London, 1993.

Christian Schad. Exhibition catalog (Paris, Fondation Dina Vierny-Musée Maillol, Nov. 2002–Feb. 2003). Schirmel/Mosel: Munich, 2002.

Christov-Bakargiev, Carolyn, ed. *Arte Povera.* Phaidon: London, 1999.

Cocteau, Jean. *Il Richiamo all'Ordine.* Edited by Paola Dècina Lombardi. Einaudi: Turin, 1990 (1st ed. Paris, 1926).

Compton, Susan, ed. *British Art in the 20th Century. The Modern Movement.* Royal Academy of Arts, London/Prestel: Munich, 1986.

Corrin, Lisa Graziose, Miwon Kwon, and Norman Bryson, eds. *Marc Dion.* Phaidon: London, 1997.

Cy Twombly. Galerie Karsten Greve: Cologne, 1997.

Dabrowski, Magdalena. *Kandinsky Compositions.* The Museum of Modern Art: New York, 1995.

Dantini, Michele. "Elogio della Leggerezza." *N.0.,* Centro di Arte Contemporanea Palazzo delle Papesse, Siena, winter 1998, 24–29 (Eng. ed. "Soap Bubbles: A Eulogy of Lightness," in Esse, Siena, Feb. 2000, 8–9).

——. *Klee.* Jaca Book, Milan 1999.

——. "Praterie di Città, Foreste da Camera. Estetiche (e Politiche) del Verde Pubblico e della Conservazione Ambientale nell'Arte Contemporanea." In acts of the conference *Arte e Mitologia nel XX Secolo* edited by Olivier Bonfait, Rome, Académie de France, Villa Medici, June 4–11, 2004), in print.

——. "Sindrome Frenhofer. Leggende d'Artista nel Cinema Americano Contemporaneo." *Linea d'Ombra,* 137, XVI (1998), 22–24.

——. "Tournée. Per un saggio sulla fortuna dei futuristi in Germania. 1912–1914." *Annali della Scuola Normale Superiore,* Quaderni, 1–2, IV (1996), 449–460.

——. "Tre Artisti per Tre Pratiche di Viaggio, Dion, Vitone, Lockhart." *Ipso Facto,* 11, September–December 2001, 30–40, 132–136.

Detheridge, Anna, and Angela Vettese. *Guardare l'Arte. Cultura Visiva Contemporanea: le Recensioni, i Temi e Gli Appuntamenti 1997–1999.* Il Sole 24 ORE, 1999.

Dresde Munich Berlin. Figures du Moderne. L'Expressionisme en Allemagne 1905–1914. Exhibition catalog (Musée d'Art Moderne de la Ville de Paris, Sept. 1992–Mar. 1993). Paris Musées: Paris, 1992.

Ed Ruscha and Photography. Catalog of the exhibition curated by Sylvia Wolf (New York, Whitney Museum of American Art, June–Sept. 2004). Steidl: Göttingen, 2004.

Expressionistische Bilder: Sammlung Firmengruppe Ahlers. Hatje: Stuttgart, 1993.

Fabian, Johannes. *Anthropology with an Attitude.* Stanford University Press: Stanford, 2001.

Felix Gonzalez-Torres. Exhibition catalog (Hanover, Sprengel Museum, June–July 1997/Kunstverein St. Gallen Kunstmuseum, Sept.–Nov. 1997/Vienna, Museum moderner Kunst Stiftung Ludwig, 1998). Cantz: Ostfildern-Ruit, 1997.

Fernand Léger. Le Rythme de la Vie Moderne. 1911–1924. Catalog of the exhibition curated by Dorothy Kosinski (Wolfsburg, Kunstmuseum, May–July 1994/Basel, Kunstmuseum, Aug.–Sept. 1994). Flammarion: Paris, 1994 (German ed. Prestel: Munich/New York, 1994).

A Fiction of Authenticity: Contemporary Africa Abroad. Catalog of the exhibition curated by Shannon Fitzgerald, Tumelo Mosaka (St. Louis, Missouri, Sept. 2003–Jan. 2004/Pittsburgh, Pennsylvania, Regina Gouger Miller Gallery, Purnell Center for the Arts, Carnegie Mellon University, Sept.–Dec. 2004/Houston, Blaffer Gallery, The Art Museum of the University of Houston, Sept.–Dec. 2006). Contemporary Museum of St. Louis/DAP: St. Louis, 2003.

Fietzek, Gerti, and Gregor Stemmrich, eds. *Lawrence Weiner.* Phaidon: London, 1998.

Fossati, Paolo. *Piccola Passeggiata tra Due Guerre, in Il Nudo. Eros, Natura, Artificio.* Edited by Gloria Fossi. Giunti: Florence, 1999, 230–248.

——. *Storie di Figure e di Immagini. Da Boccioni a Licini.* Einaudi: Turin, 1995.

Francis Alÿs. Exhibition catalog (Berlin, Martin-Gropius-Bau, Sept.–Oct. 2004). König: Cologne, 2004.

Francis Picabia. Singulier Idéal. Exhibition catalog (Musée d'Art Moderne de la Ville de Paris, Sept. 2002–Mar. 2003). Paris Musées: Paris, 2002.

Frascina, Francis, and Jonathan Harris, eds. *Art in Modern Culture.* Phaidon: London, 1992.

Friedel, Helmut, and Annegret Hoberg. *The Blue Rider in the Lenbachhaus.* Prestel: Munich, 2000.

Friis-Hansen, Dana, Octavio Zaya, and Zerizawa Takashi, eds. *Cai Guo-Qiang.* Phaidon: London, 2002.

Galassi, Peter, ed. *Philip-Lorca diCorcia.* The Museum of Modern Art: New York, 1995.

Gale, Matthew, ed. *Surrealism.* Phaidon: London, 1997.

Gary Hill, Selected Works. Exhibition catalog (Wolfsburg Kunstmuseum, Nov. 2001–Mar. 2002/Lisbon, Centro Cultural de Belém, Oct. 2002–Jan. 2003). Dumont: Cologne, 2002.

Georg Baselitz. Exhibition catalog (Musée d'Art Moderne de la Ville de Paris, Oct. 1996–Jan. 1997). Paris Musées: Paris, 1996.

Godfrey, Tony, ed. *Conceptual Art.* Phaidon: London, 1998.

Gohr, Siegfried. *Museum Ludwig Köln.* Prestel: Munich, 1986.

Gollek, Rosel. *Der Blaue Reiter im Lenbachhaus München, Katalog der Sammlung in der Städtischen Galerie.* Prestel: Munich, 1988.

Grasskamp, Walter, Molly Nesbit, and Jon Bird, eds. *Hans Haacke.* Phaidon: London, 2004.

Grazioli, Elio. *La Polvere nell'Arte.* Bruno Mondadori: Milan, 2004.

Greenberg, Clement. *Arte e Cultura.* Allemandi: Turin, 1991.

Grotesk. 130 Jahre Kunst der Frechheit. Catalog of the exhibition curated by Pamela von Kort (Frankfurt, Schirn Kunsthalle, Mar.–June 2003/Munich, Haus der Kunst, June–Sept. 2003). Prestel: Munich/Berlin/London/New York, 2003.

Henrik Håkansson. Exhibition catalog (Helsingborg, Dunkers Kulturhaus, Dec. 2004–Feb. 2005). Revolver: Frankfurt am Main, 2004.

Henri Matisse. A Retrospective. Catalog of the exhibition curated by John Elderfield (New York, The Museum of Modern Art, Sept. 1992–Jan.1993). The Museum of Modern Art: New York, 1992.

ID., *Invenzione o Imitazione? Il Ritratto da Ingres a Picasso, in Il Ritratto. Gli Artisti, i Modelli, la Memoria.* Curated by Gloria Fossi. Giunti: Florence, 1996, 269–304.

Les Italiens de Paris. De Chirico e Gli Altri a Parigi nel 1930. Catalog of the exhibition curated by Maurizio Fagiolo, Claudia Gian Ferrari (Brescia, Palazzo Martinengo, July–Nov. 1998). Skira: Geneva/Milan, 1998.

Jasper Johns. *A Retrospective.* Curated by Kirk Varnedoe. The Museum of Modern Art: New York, 1997.

Joseph Beuys. Catalog of the exhibition 186 Bibliografia (Zurich, Kunsthaus, Sept. 1993–Feb. 1994/Madrid, Museo Nacional Centro de Arte Reina Sofía, Mar.–June 1994/Paris, Centre Georges Pompidou, June–Oct. 1994). Editions du Centre Pompidou: Paris, 1994.

Kandinsky. Kleine Freuden. Catalog of the exhibition curated by Armin Zweite, Vivian Endicott Barnett (Düsseldorf, Kunstsammlung Nordrhein-Westfalen, Mar.–May 1992). Prestel: Munich, 1992.

Kastner, Jeffrey, and Brian Wallis, eds. *Land and Environmental Art.* Phaidon: London, 1998.

Kazimir Malevich. Una Retrospettiva. Exhibition catalog (Florence, Palazzo Medici Riccardi, Sept.–Dec. 1993). Artificio: Florence, 1993.

Kendell Geers. The Forest of Suicides. Catalog of the exhibition curated by Nicolas Bourriaud (Rome, Macro, May–Aug. 2004). Elemond: Milan, 2004.

Khan Magomedov, Selim O. *Rodchenko. The Complete Work* Edited by Vieri Quilici. Thames and Hudson/Idea Books: Milan/London, 1986.

Klemm, Christian. *Kunsthaus Zurich.* Museen der Schweiz: Zurich, 1992.

Kounellis. Catalog of the exhibition curated by Pier Giovanni Castagnoli (Bologna, Salara, June–Sept. 1995). Comune di Bologna/Gam: Bologna, 1995.

Krauss, Rosalind. *The Optical Unconscious.* M.I.T. Press: Cambridge, Mass., 1993.

——. *The Originality of the Avant-Garde and Other Modernist Myths.* M.I.T. Press: Cambridge, Mass., 1985.

Kunst und Macht in Europa 1930 bis 1945. Catalog of the exhibition curated by Dawn Ades, Tim Benton, Dadiv Elliott, Iain Boyd Whyte (London, Hayward Gallery, 1995–1996/Barcelona, Centre de Cultura Contemporània, 1996/Berlin, Deutsches Historisches Museum 1996). Oktagon: London, 1996.

Lampert, Catherine. *Francis Alÿs. The Prophet and the Fly.* Turner: Madrid, 2002.

Lanchner, Caroline, ed. *Joan Miró.* The Museum of Modern Art: New York, 1993.

Lippard, Lucy R. *The Lure of Local.* The New Press: New York, 1997.

Lowe, Sarah M., ed. *Tina Modotti & Edward Weston: The Mexico Years.* Merrell: London-New York, 2004.

Luc Tuymans. Catalog of the exhibition curated by Emma Dexter, Julian Heynen (London, Tate Modern, June–Sept. 2004/Düsseldorf, K21, Oct. 2004–Jan. 2005). Tate Publishing: London, 2004.

Man Ray. Catalog of the exhibition curated by Janus (Milan, Foro Bonaparte, Fondazione Mazzotta, Sept.1998–Jan. 1999). Mazzotta: Milan, 1998.

Marcel Duchamp. Catalog of the exhibition curated by Jacques Caumont (Venice, Palazzo Grassi, spring 1993). Bompiani: Milan, 1993.

Marcus, George E., and Michael M. J. Fischer. *Anthropology as Cultural Critique.* The University of Chicago Press: Chicago/London, 1986.

Mark Rothko. Catalog of the exhibition curated by Jeffrey Weiss (Washington, National Gallery of Art, May–Aug. 1998/Musée d'Art Moderne de la Ville de Paris, Jan.–Apr. 1999). Yale University Press: New Haven, 1998.

Markus Lüpertz. Retrospectiva 1963–1990. Exhibition catalog (Madrid, Museo Nacional Centro de Arte Reina Sofía, Feb. –May 1991). Fabbri/Ministerio de Cultura Centro de Arte Reina Sofía: Milan/Madrid, 1991.

Matisse/Picasso. Exhibition catalog (London, Tate Modern, 2002; Paris, Grand Palais, 2002–2003/New York, The Museum of Modern Art, 2003). Tate Publications: London, 2002.

Matthew Barney: the Cremaster Cycle. Catalog of the exhibition curated by Nancy Spector (Musée d'Art Moderne de la Ville de Paris). Paris Musées: Paris, 2002.

Max Beckmann. Catalog of the exhibition curated by Sean Rainbird (Paris, Centre Pompidou, Sept. 2002– Jan. 2003/London, Tate Modern, Feb.–May 2003, New York, Museum of Modern Art, June–Sept. 2003). Tate Publishing: London, 2002.

Metafisica. Catalog of the exhibition curated by Ester Coen (Rome, Scuderie del Quirinale, Sept. 2003–Jan. 2004). Electa: Milan, 2003.

Meyer, James, ed. *Minimalism.* Phaidon: London, 2000.

Musée de l'Orangerie. Catalog de la Collection Jean Walter et Paul Guillaume. Curated by Michel Hoog. Réunion des Musées Nationaux: Paris, 1990.

Neri, Louise, Lynne Cooke, and Thierry de Duve, eds. *Roni Horn.* Phaidon: London, 2003 (1st ed. 2000).

Olaf, Nicolai. *"Rewind" Forward.* Hatje Cantz: Ostfildern-Ruit, 2003.

Osborne, Peter. *Conceptual Art.* Phaidon: London, 2003.

Parr, Martin, and Gerry Badger. *The Photobook: A History.* I, Phaidon: London, 2004.

Passuth, Krisztina, ed. *Moholy-Nagy.* Thames and Hudson: London, 1987 (1st ed. 1985).

Paul Klee. Catalog of the exhibition curated by Piergiovanni Castagnoli, Michele Dantini (Turin, GAM, Oct. 2000–Jan. 2001). GAM: Turin, 2000.

Paul Klee, Leben und Werk. Exhibition catalog (Bern, Kunstmuseum, Sept. 1987–Jan. 1988). Hatje: Stuttgart, 1987 (Eng. ed. The Museum of Modern Art/The Cleveland Museum of Art: New York, 1987).

Picasso and Braque. Pioneering Cubism. Catalog of the exhibition curated by William Rubin. The Museum of Modern Art: New York, 1989.

Picasso e la Fotografia. Catalog of the exhibition curated by Anne Baldassari (Florence, Palazzo Vecchio, Sept.– Dec. 1997). Alinari: Florence, 1997.

Piero Manzoni. Catalog of the exhibition curated by Germano Celant (London, Serpentine Gallery, 1998). Charta: Milan, 1998.

The Pierre Berès Collection of Paintings and Other Works, Sotheby's: London, Nov. 30, 1993.

Pittura Italiana. Catalog of the exhibition curated by Giorgio Verzotti (Castello di Rivoli, Museo d'Arte Contemporanea, 1997). Charta: Milan, 1997.

La Pittura Metafisica. Catalog of the exhibition curated by Giuliano Briganti, Ester Coen (Venice, Istituto di Cultura di Palazzo Grassi). Neri Pozza Editore: Venice, 1979.

Pratt, Marie-Louise. *Imperial Eyes. Travel Writing and Transculturation.* Routledge: London/New York, 1992.

"Primitivism" in 20th Century Art. Affinity of the Tribal and the Modern. Curated by William Rubin. 2 vols. The Museum of Modern Art: New York, 1994 (1st ed. 1984).

Richard Long. Walking in Circles. George Braziller: New York, 1994 (1st ed. 1991).

Robert Rauschenberg: A Retrospective. Catalog of the exhibition curated by Walter Hopps, Susan Davidson (New York, Guggenheim Museum, Soho and Ace Gallery, Sept. 1997–Jan. 1998/Houston, the Menil Collection, Contemporary Arts Museum, The Museum of Fine Arts, Feb.–May 1998/Cologne, Museum Ludwig, May–Oct. 1998/Bilbao, Guggenheim Museum, Nov. 1998–Feb. 2000). Guggenheim Museum Publications: New York, 1997.

Schmalenbach, Werner. *Bilder des 20. Jahrhunderts. Die Kunstsammlung Nordrhein-Westfalen, Düsseldorf.* Prestel: Munich, 1986 (Eng. ed. Munich, 1990).

Schwarz, Arturo. *The Complete Work of Marcel Duchamp.* 2 vols. Delano Greenidge: New York, 1997.

Sensation. Young British Artists from the Saatchi Collection. Exhibition catalog (London, Royal Academy of Arts, Sept. –Dec. 1997). London, 1997.

Sironi. Catalog of the exhibition curated by Fabio Benzi (Rome, Galleria d'Arte Moderna, Nov. 1993–Feb. 1994). Electa: Milan, 1993.

Sonia & Robert Delaunay. Catalog of the exhibition curated by Sandor Kuthy, Kuniko Satonobu (Kunstmuseum Bern, 1991–1992). Hatje: Stuttgart, 1991.

The Spiritual in Art. Abstract Painting 1890–1985. Catalog of the exhibition curated by Maurice Tuchman, Judi Freeman (Los Angeles County Museum of Art, Oct. 1986–1987). Abbeville: New York/London/Paris, 1986.

Susan Hefuna. Xcultural Codes. Catalog of the exhibition curated by Hans Gercke, Ernest W. Uthermann (Heidelberger Kunstverein, Feb.–Mar. 2004/ Stadtgalerie Saarbrücken, Apr.–May 2004/Bluecoat Arts Centre Liverpool, May–July 2004/Cairo, Townhouse Gallery, Oct.– Nov. 2004/ Galerie der Stadt Backnang, Nov. 2004–Jan. 2005). Kehrer: Heidelberg, 2004.

Susan Hiller: Recall. Selected Works 1969–2004. Catalog of the exhibition curated by James Lingwood (Gateshead, Baltic, May–July 2004/ Porto, Museu de Arte Contemporanea de Serralves, May 2004–Jan. 2005/Basel, Kunsthalle, Jan.–Mar. 2005). Schwabe: Basel/Muttenz, 2004.

Tacita Dean. Exhibition catalog (London, Tate Britain, Feb.–May 2001). Tate Publications: London, 2001.

Tawadros, Gilane, ed. *Changing State. Contemporary Art and Ideas in an Era of Globalisation.* Institute of International Visual Arts: London, 2004.

Thomas Struth 1977–2002. Exhibition catalog (Dallas Museum of Art, May–Aug. 2002/Los Angeles, The Museum of Contemporary Art, Sept. 2002–Jan. 2003/New York, The Metropolitan Museum of Art, Feb.–May 2003/Chicago, The Museum of Contemporary Art, June–Sept. 2003). Schirmer/Mosel: Munich, 2002.

Traumfabrik Kommunism. Die Visuelle Kultur der Stalinzeit. Catalog of the exhibition curated by Boris Groys, Max Hollein (Frankfurt, Schirn Kunsthalle, Sept. 2003–Jan. 2004). Cantz: Ostfildern-Ruit, 2003.

Vettese, Angela. *A Cosa Serve l'Arte Contemporanea. Rammendi e Bolle di Sapone.* Allemandi: Turin, 2002.

Ward, Frazer, Mark C. Taylor, and Jennifer Bloomer, eds. *Vito Acconci.* Phaidon: London, 2002.

Watkins, Jonathan, and René Denizot. *On Kawara.* Phaidon: London, 2002.

Wols. Exhibition catalog (Zurich, Kunsthaus, Sept. 1989–Feb. 1990/Düsseldorf, Kunstsammlung Nordrhein-Westfalen, Mar.–May 1990). Kunsthaus: Zurich, 1989.

Zweite, Armin. *Joseph Beuys. Natur Materie Form.* Schirmer/Mosel: Munich/Paris/London, 1991.

Index

Note: Page numbers in italics include references to captions, and **bold** page numbers indicate biographical sketches.

Credits

© Archivio Giunti, Florence
© The Bridgeman Art Library/Alinari, Florence
© Erich Lessing/Contrasto, Milan
© Corbis/Photographers: Adrian Forty, Richard A. Cooke, Farrell Grehan, Scott T. Smith, Vanni Archive
© Cornell Capa Photos by Robert Capa-2001/Magnum/Contrasto, Milan
© Die Photographische Sammlung/Sk Stiftung Kultur-August Sander Archive, Cologne
© 1971 Aperture Foundation Inc., Paul Strand Archive
© Edward Weston/1981 Center for Creative Photography, Arizona Board of Regents
© Estate Brassaï-R.M.N., Paris
© Jeff Wall/Ydessa Hendeles Art Foundation, Toronto
© Kimsooja, videography Mahendra Maskey/Kewenig Gallery, Cologne
© Leni Riefensthal-Produktion
© Runa Islam; courtesy Jay Jopling/White Cube Gallery, London
© Kendell Geers, courtesy Galleria Continua, San Gimignano-Beijing/ Photo Ela Biallkowska
© Antoni Muntadas/Photo Sascha Dressler
© Gerda Steiner & Jörg Lenzlinger
The works conserved in the museums and galleries of the Italian State are reproduced by the kind permission of the Ministero per i Beni e le Attività Culturali.
The Italian publisher Giunti will be pleased to hear from those sources who could not be traced when permission was sought to publish certain photographs.

© Carl Andre, Hans Jean Arp, Francis Bacon, Giacomo Balla, Max Beckmann, Hans Bellmer, Joseph Beuys, Julius Bissier, Karl Blossfeldt, Alighiero Boetti, Louise Bourgeois, Constantin Brancusi, Marianne Brandt, Georges Braque, Daniel Buren, Carlo Carrà, Felice Casorati, Marc Chagall, Giorgio De Chirico, The Joseph and Robert Cornell Memorial Foundation, Salvador Dalí, Gala-Salvador Dalí Foundation, The Willem De Kooning Foundation, New York, Filippo Luigi De Pisis, Robert Delaunay, André Derain, Otto Dix, Oscar Domínguez, Jean Dubuffet, Marcel Duchamp, Max Ernst, Jean Fautrier, Dan Flavin, FLC, Fondazione Lucio Fontana, Milano, Meshac Gaba, Alberto Giacometti, Arshile Gorky, Walter Gropius, George Grosz, Andreas Gursky, Hans Christoph Carl Haacke, Raoul Hausmann, Erich Heckel, Thomas Hirschhorn, Marcel Janco, Jasper Johns, Donald Judd, Wassily Kandinsky, Frida Kahlo, Paul Klee, Yves Klein, Franz Kline, Fondation Oskar Kokoschka, Joseph Kosuth, Michel Larionov, Anton Mikhajlovich Lavinskij, Fernand Léger, Carlo Levi, Sol Lewitt, Roy Lichtenstein, El Lissitzky, René Magritte, Man Ray Trust, Piero Manzoni, André Masson, Succession H. Matisse, Roberto-Sebastian Matta Echaurren, Gordon Matta-Clark, Ludwig Mies Van Der Rohe, Successió Miró, Laszlo Moholy-Nagy, Giorgio Morandi, Robert Morris, Bruce Nauman, Barnett Newman, Olaf Nicolai, Meret Oppenheim, Francis Picabia, Succession Picasso, Jackson Pollock, Franz Radziwill, Ad Reinhardt, Albert Renger-Patzsch, Robert Rauschenberg, Aleksandr Mikhailovich Rodchenko, Kate Rothko Prizel and Christopher Rothko, August Sander, Alberto Savinio, Bettina Schad, Archiv U. Nachlab & Christian Schad, Karl Schmidt-Rottluff, Kurt Schwitters, Richard Serra, Gino Severini, Mario Sironi, Robert Smithson, Chaïm Soutine, Frank Stella, Antoni Tàpies, Wilhelm Wagenfeld, Andy Warhol Foundation for the Visual Arts, Lawrence Weiner, Wols, Frank Lloyd Wright: by SIAE 2008.